NeoHooDoo: Art for a Forgotten Faith

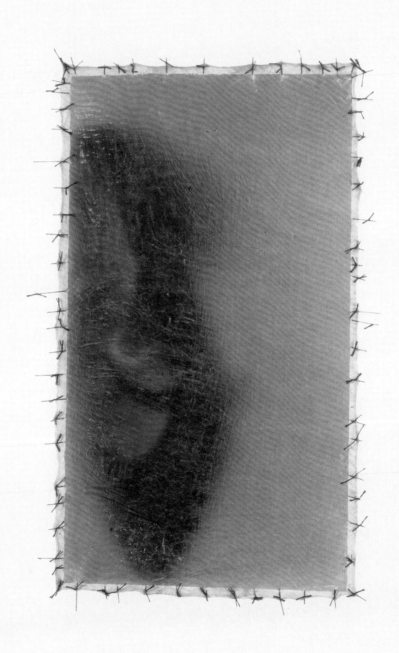

NeoHooDoo
Art for a Forgotten Faith

Edited by Franklin Sirmans

With contributions by Jen Budney,
Arthur C. Danto, Julia P. Herzberg,
Franklin Sirmans, Greg Tate, Robert
Farris Thompson, and Quincy Troupe,
and an interview with Ishmael Reed

The Menil Collection

Distributed by Yale University Press
New Haven and London

Published on the occasion of the exhibition
"NeoHooDoo: Art for a Forgotten Faith"
Co-organized by The Menil Collection and
P.S.1 Contemporary Art Center
Curated by Franklin Sirmans

The Menil Collection, Houston
June 27–September 21, 2008

P.S.1 Contemporary Art Center
Long Island City, New York
October 19, 2008–January 26, 2009

Miami Art Museum
February 20–May 24, 2009

The exhibition is generously supported
by The Brown Foundation, Inc., The Andy
Warhol Foundation for the Visual Arts,
Anonymous, William J. Hill, Beth and
Rick Schnieders, Sara Dodd Spickelmier
and Keith Spickelmier, Barbara and
Charles Wright, Nina and Michael Zilkha,
The Cullen Foundation, Houston
Endowment, and the City of Houston.

The presentation of the exhibition at
P.S.1 Contemporary Art Center is made
possible by The Friends of Education of
The Museum of Modern Art and with
public funds from the New York State
Council on the Arts, a State Agency.

Publisher: Laureen Schipsi
Curatorial Assistant: Mary K. Lambrakos
Assistant Editor: Erh-Chun Amy Chien
Text Editor: Susan F. Rossen
Graphic Designer: Sibylle Hagmann,
Kontour Design

Typefaces: Odile, Elido

Paper: Luxo Art Silk

Printing, reproductions, and binding:
EBS Editoriale Bortolazzi-Stei
Verona, Italy

Published by
Menil Foundation, Inc.
1511 Branard Street
Houston, Texas 77006

©2008 Menil Foundation, Inc., Houston

"Spirit and the Perception of Art"
©2008 Arthur C. Danto

Robert Farris Thompson's "Communiqué
from Afro-Atlantis" first appeared in *African
Arts* 32, 4 (Winter 1999), pp. 1, 4, 6, 8.

Distributed by Yale University Press
P.O. Box 209040
302 Temple Street
New Haven, Connecticut 06520-9040
www.yalebooks.com

ISBN: 978-0-300-13418-6
Library of Congress Control Number:
2008920806

Jacket front:
Marepe (Marcos Reis Peixoto)
Auréolas (Halos), 2004
See page 102.

Frontispiece:
Doris Salcedo
Atrabiliarios (detail), 1996
Sheetrock, wood, shoes, and animal fiber
in niches sewn with surgical thread
35 3/8 × 43 3/4 × 8 1/2 inches
(89.9 × 111.1 × 21.6 cm)
Private Collection, São Paulo
Courtesy of Alexander and Bonin, New York

Page 11:
Robert Gober
Untitled (Prison Window), 2003–07
Plywood, forged iron, plaster, latex paint,
lights, and window
48 × 58 × 36 inches (121.9 × 147.3 × 91.4 cm);
opening: 24 7/8 × 24 × 5/8 inches (63.2 × 61 × 1.5 cm)
The Menil Collection, Houston
(Example illustrated is courtesy of the artist
and Matthew Marks Gallery, New York)

Jacket back:
Adrian Piper
Food for the Spirit, 1971, printed 1997
See page 103.

CONTENTS

Foreword

"NEOHOODOO: ART FOR A FORGOTTEN FAITH" brings together an intergenerational group of contemporary artists from North, Central, and South America. Whether created in Vancouver, New York, or São Paulo, the works in the exhibition are united in their investigation of ritual and spirituality in contemporary art.

This exhibition was inspired by poet Ishmael Reed's "Neo-HooDoo Manifesto," which explores how artistic expression is a means of innovation and improvisation, akin to vernacular traditions of spirituality outside the practice of organized religion. It is fitting that this is the first major exhibition at The Menil Collection organized by Curator of Modern and Contemporary Art Franklin Sirmans, since it complements the belief of the museum's founders, John and Dominique de Menil, in art as a form of spirituality, grounded in the human condition. As the Rothko Chapel, which they sponsored, attests, they felt that artists possess unique abilities to connect to and reveal a spiritual and sacred center, whatever one's faith.

We are most grateful to the generosity of the participating artists, listed in the acknowledgments that follow. Many have lent works in their possession, and some have created new projects specifically for this exhibition. We also extend our gratitude to the numerous institutions, galleries, and individuals who have graciously loaned works in support of this project: Art Gallery of Nova Scotia, Halifax; Hirshhorn Museum and Sculpture Garden, Washington, D.C.; Kunstmuseum, St. Gallen, Switzerland; The Pulitzer Foundation for the Arts, St. Louis; Solomon R. Guggenheim Museum, New York; George Adams Gallery, New York; Peg Alston Fine Arts, New York; Arndt & Partner, Berlin; Luhring Augustine, New York; Thomas Erben Gallery, New York; Ronald Feldman Fine Arts, New York; Mary Goldman Gallery, Los Angeles; Inman Gallery, Houston; Catriona Jeffries Gallery, Vancouver; Anton Kern Gallery, New York; Galerie Lelong, New York; Pan-American Art Projects, Dallas and Miami; Galerie Michel Rein, Paris; Andrea Rosen Gallery, New York; Jack Shainman Gallery, New York; Franco Soffiantino, Turin; Galeria Luisa Strina, São Paulo; D'Amelio Terras, New York; Francesco Pellizzi; Sender Collection, New York; and Barry Sloane, Los Angeles.

We are also pleased to acknowledge that "NeoHooDoo" is the result of a fruitful collaboration between The Menil Collection and P.S.1 Contemporary Art Center, New York; we extend our sincere thanks to P.S.1's director, Alanna Heiss.

Last but not least, we wish to acknowledge the financial support of The Brown Foundation, Inc., The Andy Warhol Foundation for the Visual Arts, Anonymous, William J. Hill, Beth and Rick Schnieders, Sara Dodd Spickelmier and Keith Spickelmier, Barbara and Charles Wright, Nina and Michael Zilkha, The Cullen Foundation, Houston Endowment, and the City of Houston.

JOSEF HELFENSTEIN
DIRECTOR
THE MENIL COLLECTION

FOREWORD

WARM SPELLS, COLD SPELLS. P.S.1 has been no stranger to the mysterious ways of the spirit and the power of ritual. The enigmatic Italian artist Gino de Dominicis long planned to show his invisible walls at the museum, Chen Zhen's massive drum installation reverberated throughout the third-floor galleries, and the sculptures by David Hammons made from human hair, spareribs, and chicken wings were always infused with streetwise magic that went beyond their impoverished materiality. The 1986 group exhibition "Images of the Unknown" identified artists who made visible the intangible qualities of religion. While the show focused largely on abstraction, including examples by Brice Marden, Emmanuel Pereire, and Alan Saret, it also featured the naïve landscapes of the nomadic visionary Joseph Parker. While organizing this show, I realized that the work of nearly every artist has an element of mystery and spirituality. And so the organizing principle became a matter of whom not to include and of guarding against sentimentality and religious propaganda.

An abandoned schoolhouse converted into a contemporary art center in 1976, P.S.1 has always inspired, and even required, artists to go beyond the mediocrity of the white cube. A spirit of invention and adventure seems to steam its way up from the basement boiler room to the three floors above and out into the courtyard. With this same brash vision comes "NeoHooDoo: Art for a Forgotten Faith," an exhibition that eschews scientific rationale to highlight the intangible connections of faith and spirit.

Organized by Franklin Sirmans, The Menil Collection's Curator of Modern and Contemporary Art and P.S.1's Curatorial Advisor, "NeoHooDoo" partly mirrors the geographic focus of the show—with pieces by artists from North, Central, and South America—through its presentation in the near-tropical climes of Gulf Coast Texas and the much colder weather of New York. Rebecca Belmore's investigations of contemporary and historic Aboriginal experience, Regina José Galindo's physical and poetic engagement with the history of Guatemala, and Michael Joo's symbolically loaded swim through a sea of salt, among other works, all suggest encounters between native and foreigner, colonized and colonizer, insider and outsider. While the artists in the show represent different generations, races, and beliefs, what is arguably common in their concerns and practices is the history of cultural exchange—both violent and nonviolent—that has been experienced throughout the entire hemisphere.

The artists in "NeoHooDoo" deftly negotiate, weave through, and traverse borders, whether they are divisions of medium, geography, or culture. Resisting categorical pigeonholing, they are able to address their work to an audience beyond that of the art world. And with this comes the idea that art can do more—by creating a spell we can all fall under.

ALANNA HEISS
DIRECTOR
P.S.1 CONTEMPORARY ART CENTER

Acknowledgments

First, I wish to thank the artists participating in this exhibition: Terry Adkins, Janine Antoni, Radcliffe Bailey, José Bedia, Rebecca Belmore, Sanford Biggers, Tania Bruguera, María Magdalena Campos-Pons, William Cordova, Jimmie Durham, Regina José Galindo, Robert Gober, David Hammons, Michael Joo, Brian Jungen, Kcho, Marepe, Amalia Mesa-Bains, Pepón Osorio, Adrian Piper, Ernesto Pujol, Dario Robleto, Betye Saar, Doris Salcedo, Gary Simmons, George Smith, Michael Tracy, and Nari Ward. They generously welcomed me to their studios and initiated conversations that have served as the generative inspiration for this exhibition. I am grateful as well for the cooperation and support of Michelle Reyes for the estate of Felix Gonzalez-Torres, and the estates of Jean-Michel Basquiat, James Lee Byars, John Cage, and Ana Mendieta.

Thank you to The Menil Collection Director Josef Helfenstein for believing in this undertaking. The Board of Trustees and its president, Louisa Stude Sarofim, have been enthusiastic supporters of the project as well. Their passion for this museum has been matched by the dedication of the staff. My sincere thanks go to Assistant Curator Michelle White, who adeptly coordinated the show. Former Curatorial Assistant Miranda Lash gracefully balanced the research and logistics for this exhibition at its initial stage, while Christopher Y. Lew did the same at P.S.1 Contemporary Art Center from the project's inception. I am indebted to the consummate support of my other colleagues in the curatorial department: Associate Curator for Collections and Research Kristina Van Dyke; Chief Curator, Drawings Institute, Bernice Rose; Assistant Curator Clare Elliott; and Curatorial Administrative Assistant Ryan Dennis. Collections Registrar Mary Kadish was, as always, an invaluable resource. Curatorial Assistant Mary K. Lambrakos deserves special thanks for her tenacious research and organizational skills, which she employed on the exhibition and this publication. I would like to express my appreciation for the hard work of Interns Meredith Goldsmith and Rachel Green.

In addition to Alanna Heiss, who encouraged an idea that would later become this exhibition, I am grateful for the advice and counsel of numerous individuals at P.S.1, including Klaus Biesenbach, Yng-Ru Chen, Tony Guerrero, Jelena Kristic, Bob Nickas, Erica Papernik, Nick Stillman, Elna Svenle, Eugenie Tsai, Neville Wakefield, and David Weinstein.

Along with my colleagues in the curatorial department, I would like to thank staff of the Menil for their help in realizing this exhibition. Thanks to Chief Librarian Phil Heagy, Assistant Librarian Stephanie Capps, and Archivist Geri Aramanda for research support. I am grateful for the foresight and thoughtful presentation of Exhibitions Designer Brooke Stroud and Exhibition Design Assistant Kent Dorn. The expertise of Head of Art Services Thomas Walsh and Preparators Tobin Becker, Peter Bernal, and Tony Rubio has been invaluable. Chief Registrar Anne Adams and Assistant Registrar Judy Kwon beautifully choreographed the safe transport of the art, and Facilities and Security Manager Steve McConathy and his staff, including Ray Wiley, cared for the works' safety while on the premises. My thanks go to Chief Conservator Brad Epley and his staff for managing the unexpected and often demanding tasks required of an exhibition with such site-specific installation requirements. I express heartfelt appreciation for

the hard work of the development department: Director of Planning and Advancement Will Taylor and his staff, including Director of Development Tripp Carter; Manager of Special Events Elsian Cozens; Manager of Membership Programs Marta Galicki; Communications Director Vance Muse; and Director of Principle Gifts Mary Anne Pack. Thanks to Chief Financial Officer Tom Madonna and Manager of Finance Dawn Hawlcy for their administrative management. And thanks for the creative programming of Director of Public Programs Karl Kilian and Program Coordinator Anthony Martinez; and for the unfailing support of Kristin Schwartz-Lauster and Erma McWell in the director's office.

I am most grateful for the wisdom and guidance of Publisher Laureen Schipsi, who oversaw the development and production of this catalogue, and for the invaluable help of Assistant Editor Erh-Chun Amy Chien. Special thanks go to Rights and Reproductions Manager Amy Sullivan. I am also indebted to Susan F. Rossen for her careful editing of the texts, and to Sibylle Hagmann for her fresh and thoughtful catalogue design.

It was a great honor to work with my colleagues and contributors to this publication, Jen Budney, Arthur C. Danto, Julia P. Herzberg, Greg Tate, Robert Farris Thompson, and Quincy Troupe. I am thankful to Peter Boswell, Assistant Director for Programs and Senior Curator, Miami Art Museum, for his collaboration and for bringing the exhibition to a wide audience. His institution offers a valuable perspective via its geographic location: Miami as the gateway to Latin America.

I would like to recognize several other individuals for lending an ear and providing perspective or food for thought: first and foremost my wife, Jessica Plair

Sirmans, and our families, and Camilo Alvarez, Yona Backer, Rehema Barber, Anne Barlow, Koan Baysa, Naomi Beckwith, Dawoud Bey, Holly Block, Devin Borden, Isolde Brielmaier, iona rozeal brown, Rashida Bumbray, Hiram Butler, Steve Cannon, Nicole Cherubini, Doryun Chong, Huey Copeland, Romi Crawford, Ali Evans, Malik Gaines, Evonne Gallardo, Thelma Golden, Lea K. Green, Alison de Lima Greene, Jeffrey Grove, Leslie Hewitt, David Hunt, Kerry Inman, Sandra D. Jackson-Dumont, Kellie Jones, Eungie Joo, Toby Kamps, Lila Kanner, Janet Kaplan, Alitash Kebede, Christine Y. Kim, Leslie King-Hammond, Mary Leclère, Sarah Lewis, Courtney J. Martin, Shaheen Merali, Lorie Mertes, Melinda Mollineaux, Tumelo Mosaka, Valerie Cassel Oliver, Francesco Pellizzi, Elliot Perry, Janet Phelps, Athena Robles, Irit Rogoff, Trevor Schoonmaker & Teka Selman, Lowery Sims, Trevor Smith, Gilbert Vicario, Barry Walker, Darrell Walker, Hamza Walker, Alvia Wardlaw, Clint Willour, Deb Willis, and Lydia Yee.

Last, but certainly not least, thank you, Ishmael Reed. You have created unforgettable words that conjure ever-changing images. The experience of sitting with you for several hours over a memorable couple of days in your hometown of Oakland, California, during which you shared your wisdom about the past, present, and future, was a true gift. Thank you, too, for suggesting the subtitle of this exhibition.

Franklin Sirmans
Curator of Modern and Contemporary Art
The Menil Collection

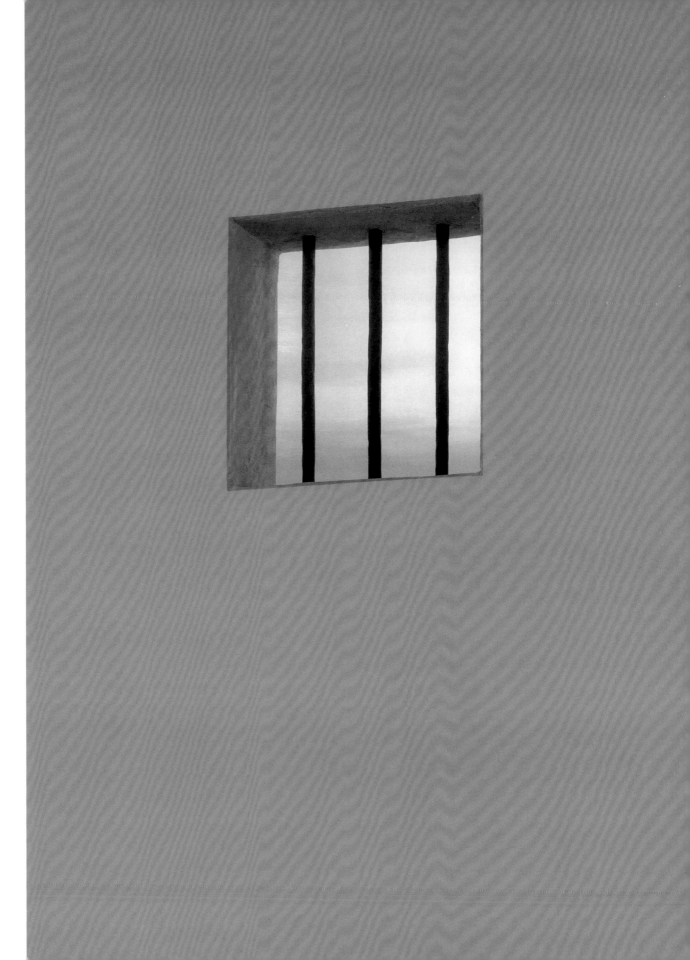

RECAPTURING SPIRIT IN CONTEMPORARY ART

FRANKLIN SIRMANS

"NEOHOODOO: ART FOR A FORGOTTEN FAITH" grew out of a desire to examine the multiple meanings of spirituality in contemporary art. While several exhibitions in the recent past have explored spirit, the subject has often been treated as ethereal, apolitical, and, at times, anti-intellectual, and form and composition alone are highlighted. But, in a world where religion has always informed issues both sacred and profane, its presence in contemporary art cannot be overlooked. As noted by art historians Richard D. Hecht and Linda Ekstrom, "Contemporary art is not just about the production of secular culture, hermetically sealed off from religion. ... Contemporary art can also be an act of religious creativity."[1] Many of the works in the exhibition intertwine religion and spirituality—and their attendant rituals—with the secular, both defining and dissolving the boundaries between the physical and spiritual worlds in which we live.

The artists in "NeoHooDoo" hale from the Americas—from Vancouver to New York, from Miami to Havana, from Guatemala City to Bahia. The decision to focus on this region of the globe is an attempt to address a "lost" spirituality, rooted in the Americas and influenced by the hemisphere's particular political and social history. Colonization, oppression, slavery, and the resulting diverse populations unite the Americas while setting them apart from the rest of the world. This complex and difficult history finds expression here in often subversive works by artists who unearth rich, unexamined aspects of the past that have a spiritual resonance in the present.

Much of the art in this exhibition, while rooted in African and indigenous practices, is also influenced by European culture. The violent acts of colonization ruptured, but did not obliterate, the traditions of displaced people. Sacred rituals were adapted to survive, which often meant going underground and integrating characteristics of European customs.[2] For example, the religion Vodun, which came from West Africa, became the basis of Vodou in Haiti, Candomblé in Brazil, Santería in Cuba, and Hoodoo in the United States.

The name for this exhibition was inspired by Ishmael Reed's poems "Neo-HooDoo Manifesto" and "Neo-HooDoo Aesthetic" and his novel *Mumbo Jumbo*, a body of writings that presents a pluralistic view of the history of the United States, with a focus on African American culture.[3] Reed coined the term in the late 1960s when many subverted rituals and practices came to the fore. Their expression in art—in works by Betye Saar and Joe Overstreet, for instance—played a distinct role in the formative issues of the times, such as civil rights and world peace movements. "Neo-HooDoo is a 'Lost American Church' updated," Reed wrote in his poem "Neo-HooDoo

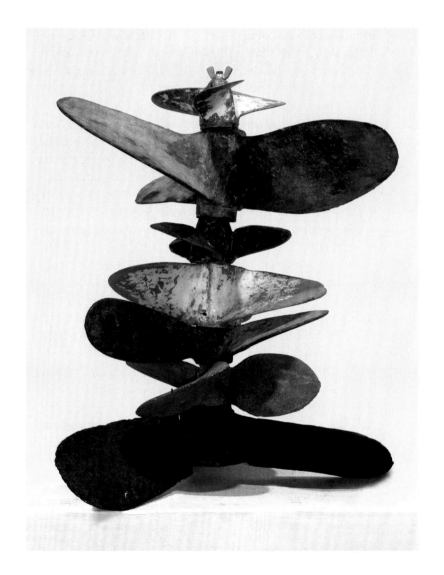

Kcho (Alexis Leyva Machado)
Columna Infinita, 2005
Metal propellers
H. 19 ⅝ inches (49.8 cm)
Collection Daniel Yankelewitz,
San José, Costa Rica
Courtesy of Pan American Art Projects,
Dallas and Miami

Manifesto," first published in 1969.[4] In *Mumbo Jumbo*, published three years later, he saw his own moment as a time of promise that recalled or perhaps signaled a return to the blossoming of African American culture of the 1920s, particularly in the Harlem Renaissance, the setting of the novel. Reed has qualified this Afrocentric emphasis: "When I say Afro-American aesthetic, I'm not just talking about us, you know, I'm talking about the Americas. People in the Latin countries read my books because they share the same international aesthetic that I'm into and have been into for a long time. And it's multicultural."[5]

The forty-eight works in this exhibition range from that pivotal time when Reed began asserting the idea of NeoHooDoo to the present and together engage in a dialogue on spirituality.

Many of the works in "NeoHooDoo: Art for a Forgotten Faith" were made to memorialize and evoke the lives and spirits of others and are elegiac in tone. Such is the oeuvre of Doris Salcedo. But rather than appropriate the memorial-like monument or altar often used to honor the dead, she has chosen to use architectural space or large pieces of furniture to create a physical manifestation of collective mourning for countless people. Salcedo's *Atrabiliarios,* 1992–93 and 1996 (frontispiece, pages 124–25) commemorates, on a large scale, those who have disappeared amid political violence in her native Colombia. Shoes inserted into a niche in the wall, like caskets encased in stitched animal skin, become the funereal remnants of lives lost. After extensive research into the stories of these individuals, Salcedo made a work that protests, remembers, and constitutes a reliquary for the victims' survivors. Although her minimal, colorless objects look mute, they clearly relay narratives of violence and fragility in equal doses, in effect restoring to these people something of their identities.

While recent history provides the backdrop for many artists' explorations of the spirit in contemporary art, others look specifically to earlier histories. Jean-Michel Basquiat's aesthetic interests were formed by his upbringing in a highly diverse immigrant culture, and his work has been dissected for its relevance to the legacy of Africa in North America. His Neo-Expressionist paintings literally address this conflicted history in image and text. In *Natives Carrying Some Guns, Bibles, Amorites on Safari,* 1982 (page 95), around two figures (a black native and a white settler) he wrote the words "colonialization" and "god," and cited the name of the early colonizer "Cortez," illustrating the interlocking presence of religion in the violent conquest of the Americas. The piece is crudely constructed with Basquiat's trademark crossed bars as stretchers for the canvas, revealing the importance of the materials to the potency of the piece.

While Basquiat's painting suggests the complex collective experience of colonialism, some of William Cordova's works, dating back to 2002, conflate violent events spanning time and place to reveal the cyclical

Brian Jungen
Prototype for New Understanding #10, 2001
Nike Air Jordans
11 × 14 × 23 inches (27.9 × 35.6 × 58.4 cm)
Rennie Collection, Vancouver
Courtesy Catriona Jeffries Gallery, Vancouver

Radcliffe Bailey took on history in his installation *Storm at Sea,* 2007 (page 110), in which a sea of found piano keys undulates under model ships and an African sculpture of Ogun, a Yoruba god of war. Clearly evocative of the Atlantic slave trade, Bailey's assemblage of found materials parallels the transport of the estimated twelve million Africans who, between the sixteenth and nineteenth centuries, survived the arduous crossing to the Americas. The prominent placement of the sculpture in Bailey's piece invokes the Atlantic as a transitional space for the art and religion of Africa, in addition to being the site of terrific horror that it was. Two works by Kcho—*Kayak,* 2002 (page 111), and *Columna Infinita,* 2005 (page 13), offer more recent narratives in which the sea is an allegory of transition and displacement. The skinny wooden form of *Kayak* hints at the shape of this type of boat. With nails hammered into the top surface, this non-functional vehicle references the Congo wood fetishes known as *nkisi nkondi* (see page 69) in which metal insertions signal the hope for justice in settling disputes. *Columna Infinita*—a title the artist has used several times, referencing Constantin Brancusi's *Endless Column,* 1918—is composed of rusted motorboat propellers. Neither of Kcho's constructions could be considered seaworthy, reminding us of the makeshift vessels that Cubans, Haitians, and others have used to flee their troubled island homes.

Summoning the belief and the power of the spiritual, Gary Simmons' Bottle Tree series (see pages 31,93) calls to mind a tradition that traveled from the Congo to the southern United States. Believed capable of capturing evil spirits, bottle trees were placed in front of homes as a kind of protection. The smooth, seductive surfaces of Simmons' pieces suggest a factory finish, and thus avoid the nostalgia that a fetish can evoke. Conveying a palpable immediacy, the works in the series embody a remnant or artifact of tradition but, at the same time, signal the degree to which the past remains viable in the

nature of oppression in political history. Cordova has created several works, including photographs, drawings, and installations, with variations on the title *the house that frank lloyd wright built for atahualpa*—sometimes in English, sometimes in Spanish—linking the sixteenth-century Incan ruler with the twentieth-century architect in a mix of concepts relating to colonialism, modernism, and the history of art. The Incas' last sovereign inspired Cordova's site-specific installation *the house that frank lloyd wright built for atahualpa,* 2008, which the artist created for this exhibition (not illustrated). Conjuring the beginning of colonialism, this new work evokes Atahualpa's death at the hands of the Spanish explorer Francisco Pizarro, despite the fact that the Incas had filled a "ransom room" in a house in Cajamarca, Peru, with gold to save their leader. In *la casa que frank lloyd wright hiso para atahualpa,* 2008 (page 100), fake gold drips out from underneath the house. In yet another work, Cordova juxtaposed the Incan structure with the townhouse in Chicago in which Black Panthers Fred Hampton and Mark Clark were murdered in 1969 (opposite).

present. Perhaps also referencing the tradition of bottle trees, David Hammons created a circle out of used Thunderbird bottles in his *Untitled*, a 1989 assemblage (page 91). Evoking a group of people who may have taken solace from the alcohol, the piece, like many other works this artist has made with used Thunderbird and Night Train bottles, is multilayered. It constitutes a respectful acknowledgment of jazz greats John "Trane" Coltrane and Charlie "Bird" Parker, the latter of whom drank to soothe and to inspire himself; and it commemorates those who drank the cheap wines that were developed for the so-called misery market of the poor. Exploring the consumption of alcohol as a rite of passage as well as an imposed social activity, Nari Ward invented the word "liquorsoul." Known for large-scale sculptures that often incorporate found objects such as discarded baby carriages, oven pans, and fire hoses, Ward arranged the letters of a broken, nonfunctioning neon sign to create *LiquorsouL*, 2007 (pages 116–17).

Questioning singular meanings of printed materials, Jimmie Durham in *A Street-Level Treatise on Money and Work,* 2005 (page 48), poetically juxtaposes found maps, advertisements, receipts, letters, and posters in an attempt to redirect and reinterpret language in a new context. His work, along with that of Rebecca Belmore (see pages 37, 41, 128) and Brian Jungen (see pages 15, 44, 98), is addressed in Jen Budney's essay, in which she discusses how the sacred signs, symbols, and language of oppressed people have been subverted, and how maintaining and integrating those artifacts into Western modes of representation is crucial.

The penchant of these artists to place found objects and artifacts in new settings brings to mind the writing of Greg Tate, who is represented in this catalogue. In "Hoodoo Is What We Do," Tate waxes poetic, as he is wont to do, on the subject of the African diaspora, citing George Clinton, Miles Davis, and Jimi Hendrix in a text that could easily be sung. Music plays an important role

as well in the works at hand. Terry Adkins's feather sculpture *Signature,* 2007 (page 123), plays on the trademark costume accessory of the great 1920s and 1930s vocalist Bessie Smith; her song "Preachin' the Blues" is a classic example of African tradition recast in a New World form. With its many references to Hoodoo, early Blues music represents a potent confluence of secular and spiritual ideas and culture.

In any discussion of the transatlantic voyage of African music, dance, and visual art forms, the research, writing, and lecture/performances of Robert Farris Thompson are essential to an understanding of the deep African roots of New World culture. In "Communiqué from Afro-Atlantis," an important article from 1999 republished here, Thompson noted the African-based origins not only of bottle trees but also of basket weaving in Halifax and marimbula instruments in Cuba, as well as mambo and the Kuba textile patterns found throughout the hemisphere. Recognizing contemporary musicians from Marc Anthony to the Wu-Tang Clan, Thompson's text captures, in its content as well as his incantatory writing style, the vitality with which the past infuses contemporary life. While criticism helps us find our way through the discussion of this project, poetry is something to be invoked and celebrated by a griot. Here Quincy Troupe fulfills that role in a poignant coda with the poem "An Art of Lost Faith."

In another essay in this catalogue Arthur C. Danto explores a possible universal meaning for spirit in art. Using Immanuel Kant's definition from his *Critique of Judgment* (1790) as both a basis and a point of departure, Danto suggests that within the pluralism of today's international culture, the artist's spirit or "creative power" would not be easily expressed in Renaissance-style tableaux. While this practice was apt for illustrating ideas central to Christianity hundreds of years ago, Danto asserts that today's artists may consider the found object and other unique materials more apt for conveying meaning.

Janine Antoni uses the visceral medium of animal skin in *Bridle,* 2000 (pages 114–15), one of a series of works that she created for her 2001 exhibition "The Girl Made of Butter." The title refers to a folktale of the Bahamas—the artist's birthplace—in which a girl melts away after her mother leaves her alone with two boys. In *Bridle,* cowhide—an emblem of the American cattle ranch—has been stretched taut and anchored to the floor and ceiling. Enough of the rawhide has been cut cleanly away to create a backpack. This work not only suggests the commodification and destruction of natural resources but also underscores the human body's primal need for animal skin as protection. When first shown, the piece was exhibited with a photograph of Antoni bathing in a trough filled with milk and a tagged cow feeding at her breast, evoking the Madonna and Child and alluding to the idea that the communion of humans and the natural world is akin to the presence of the spirit.

For Robert Gober, the domestic object is a source of enigmatic memory. In the sculpture *Untitled,* 1998–99 (page 92), a steel pipe pierces a handwoven basket. The basket, an example of Americana elevated to the status of artwork, has been violated by a symbol of industry and progress. Painstakingly crafted, Gober's sculptures explore cultural and sexual identity with a watchful eye on North America's puritanical colonial history. At the heart of that history is the U.S. prison system, which currently houses one of every hundred adult citizens. In Gober's *Untitled (Prison Window),* 2003–07 (page 11), a surreal, beautiful reddish blue sky beckons through the crossbars. Are we the jailed or the jailers? In another examination of colonization, Dario Robleto's sculptures signal the devastation wrought in war and in the name of Manifest Destiny (see right). *Deep Down I Don't Believe in Hymns,* 2001 (page 126), comprises a military blanket that has been "infested" with dust derived from a melted vinyl LP recording of Neil Young and Crazy Horse's song "Cortez the Killer." In this piece, the Spanish conqueror

Dario Robleto
Conjugal Sorrow, 2005–06
Handmade paper (pulp from letters to brides from soldiers who did not return from various wars, ink retrieved from letters, and cotton), colored paper, rosary of Saint Francis of Assisi (patron saint against dying alone), World War I chaplain's metal rosary beads, carved-bone knitting needles, braided hair flowers, silk, poplar, and ashes
13 × 17½ × 4½ inches (33 × 44.5 × 11.4 cm)
Courtesy of the artist and D'Amelio Terras, New York

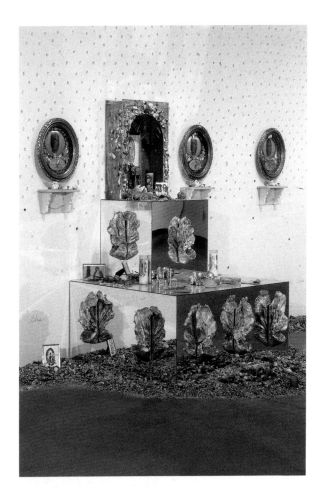

Amalia Mesa-Bains
Queen of the Waters, Mother of the Land, 1992
Mixed media
144 × 240 × 72 inches (365.8 × 610 × 182.9 cm)
Installation view at the Yerba Buena Center
for the Arts, San Francisco

of Mexico becomes a surrogate for the smallpox with which U.S. soldiers deliberately infested the blankets distributed to American Indians with the intent to wipe them out.

Pure form plays a key role as a sign of the spiritual or as a marker of ritual. Artists such as James Lee Byars, Marepe, and George Smith engage the circle as an abstraction of eternal rhythms. For Smith the circle signifies life as well as his travels in Africa; the curved shaped of his *Spiral to the Next World*, 1990 (page 112), suggests an eternal continuum. In Byars's *The Halo*, 1985 (page 94), and Marepe's *Auréolas (Halos)*, 2004 (page 102), the circle literally shines: Byars's piece is made of brass; Marepe's comprises a ring of loosely joined industrial lights. Both artists seem here to have fashioned objects of ambiguous interpretation. Hammons's circle of bottles (page 91), with its narrative suggestions, also resonates with this group of works. In John Cage's large abstractions on paper, such as *River Rocks and Smoke 4/10/90 #11* and *#16*, 1990 (pages 120, 121), Cage applied lines and washes of color with exacting care: an infinite circle here, an unending line there. But in fact, influenced by Zen philosophy, his creative process—in his graphic work no less than in his music—depended on the chance mix of elements, in this case, fire and smoke.

Eclipse, 2006 (page 101), a found African sculpture that the artist Sanford Biggers cut in half, questions the role of ritual objects in a museum, where they are distanced from their traditional functions. Half of the sculpture rests on a low pedestal, while the other is positioned higher. The artist's intent, it seems, is to make us think about whether such work can ever be displayed out of context and recapture its inherent meaning. *The Curandera's Botanica*, 2008, the piece created by Amalia Mesa-Bains for this exhibition (not illustrated), integrates formal elements from two previous works, *Perfume Laboratory: The Hall of Science*, 2000 (page 99), and *Curandera's Room*, 2007 (not illustrated). In these

works, as well as in the altarpiece *Queen of the Waters, Mother of the Land*, 1992 (opposite), the artist investigated distinctions between artwork and object. In her new mixed-media piece, she addresses rituals of mourning, exploring ideas about scientific and faith-based healing. Betye Saar's use of windows, shallow boxes, and altars also plays with our expectations of works of art by situating her creations between the aesthetic and the vernacular. Recently, Saar has referred to these works as "ancestral boxes," alluding to their link with traditional belief systems and objects of ritual importance. Her *Gris-Gris Box*, 1972 (page 127), contains charms, or talismans, to ward off evil and bring good luck (gris-gris). Michael Tracy's *Cruz de la Paz Sagrada* (*Cross of the Sacred Peace*), 1980 (page 118), similarly pays homage to the fetishized object, juxtaposing elements associated with the practice of North American Catholicism, in which Tracy was raised, with the Mexican reliquaries he admired. Multilayered and textured with natural materials and libations, this cross displays a patina akin to those of many African ritual pieces.

Whereas Biggers, Mesa-Bains, Saar, and Tracy use familiar elements of spiritual practice, the human body serves as a ceremonial object for other artists in the exhibition. Julia P. Herzberg's essay highlights the role of ritual and performance in the work of a number of Caribbean and Central American artists. Of particular importance to the exhibition is the late Ana Mendieta. Working in isolated natural settings that acquired ritual significance through her interaction with them, she constructed and destroyed her "earth-body" forms, which she created by imprinting her body in sand or mud or by painting its silhouette on various surfaces (see pages 64, 108–09). José Bedia is an initiate of Palo Monte (an African-derived religion practiced in Cuba) and a student of Native American beliefs; his work draws upon this religiously inflected, cross-hemispherical experience. A new version (not illustrated) of his

Michael Joo
Salt Transfer Cycle, 1993–95
Still from eight-minute looped video with sound
Commissioned by the Yerba Buena Center for the Arts, San Francisco
Courtesy of the artist and Anton Kern Gallery, New York

Regina José Galindo
Confesión (Confession), 2007
Performance commissioned by Galería Caja Blanca,
Palma de Mallorca, 2007
Lambda print on Forex
32 1/16 × 49 inches (81.5 × 124.5 cm)
Courtesy of the artist and Prometeo Gallery di Ida Pisani, Milan

SPIRIT AND THE PERCEPTION OF ART

ARTHUR C. DANTO

ALTHOUGH IMMANUEL KANT'S *CRITIQUE OF JUDGMENT* (1790) is incontestably the great Enlightenment text on the aesthetic values of that era, dealing as it does with good taste and the judgment of beauty, for the most part it has little to do with artistic beauty or with art as such. It is somewhat strange, accordingly, that the modernist critic Clement Greenberg should have claimed that the first part of Kant's book, *The Critique of Aesthetic Judgment*, "is the most satisfactory basis for aesthetics we yet have."[1] He used it as his text in teaching aesthetics at Black Mountain College, near Asheville, North Carolina, in the 1940s, and he praised Kant as the first modernist in his widely discussed article of 1960, "Modernist Painting."[2] Greenberg paid little attention, so far as one can tell, to the second part of Kant's book, *The Critique of Teleological Judgment*, though the message of the former is internally connected with the message of the latter. Crudely speaking, Kant wanted to connect natural beauty systematically with the assurance that nature is not indifferent to our fundamental hopes, an assurance to which artistic beauty would be largely irrelevant.

Greenberg admired Kant's effort to prove that the judgment of (natural) beauty is universal, and is accordingly objective. It is objective in the sense that, in judging something beautiful, we are in effect claiming that everyone should find it beautiful. So it is not, or not merely, "in the mind of the beholder." We are judging for everyone in judging for ourselves. That could not conceivably be true for artistic beauty, though Kant dealt with the relativity of artistic tastes in an interesting way, as I shall explain. He did introduce his philosophy of art late in *The Critique of Aesthetic Judgment*, by discussing a new concept, that of spirit, which has nothing to do with taste. Taste, he wrote, "is merely a judging and not a productive faculty."[3] When we speak of spirit, on the other hand, we are referring to the creative power of the artist. Asked what we think of a painting, we might say that it lacks spirit, "though we find nothing to blame on the score of taste."[4] Hence, the painting can even be beautiful, as far as taste is concerned, but defective through lacking spirit. Put next to a Rembrandt, almost any Dutch painting will seem without spirit, however tasteful.

In his book *Italian Hours,* Henry James wrote of the Baroque painter Domenichino as "an example of effort detached from inspiration and school merit divorced from spontaneity" (see opposite). That made him, James went on to say, "an interesting case in default of being an interesting painter."[5] There was nothing wrong in his work. He had mastered the curriculum of the art school. But spirit is not something learned, and there is no remedy for its lack.

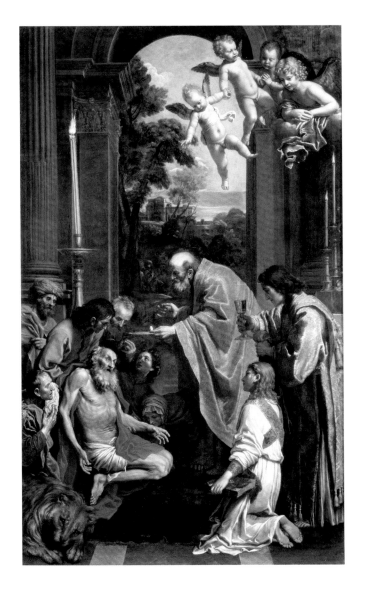

Domenico Zampieri, called Domenichino
Last Communion of Saint Jerome, 1614
Oil on canvas
165 × 100 ¾ inches (419.1 × 255.9 cm)
Pinacoteca, Vatican Museums, Vatican City

Saying that Domenichino's art lacks spirit, accordingly, is criticism of an entirely different order from the usual art school crit. It is not Domenichino's fault, merely his tragedy, that he did not possess what Kant called "genius": "the exemplary originality of the natural gifts of a subject in the *free* employment of his cognitive faculties."[6]

As it turns out, more or less all that Kant really had to say about art in his book is packed into the few pages given over to spirit; its presence in perhaps the greatest Enlightenment text on aesthetics is itself a sign that Enlightenment values were beginning to crumble and a new era was making itself felt. It is a tribute to Kant's cultural sensitivity that he realized he had to deal with Romantic values and a whole new way to think about art. It is striking that, in a very different part of Europe, the same line was being argued by the artist Francisco Goya. In writing out the program for the Royal Academy of San Fernando in Madrid, Goya declared that there are no rules in art: *No hay reglas in la Pintura*.[7] That explains, according to Goya, why we may be less happy with a highly finished work than one in which less care has been taken. It is the spirit in art—the presence of genius—that is really important. Like Kant, Goya considered himself an Enlightenment figure—a *Lustrado*—so it is striking that both philosopher and painter felt that they must deal with post-Enlightenment views of art. But people were beginning to appreciate that something more was being promised by art than that it be in good taste. They saw that art could transform viewers, opening them up to whole new systems of ideas. However, there were no rules for achieving that, as there are for making something tasteful.

WHAT THEN IS SPIRIT?

Kant spoke of spirit as "the animating principle of mind," which consists in "the faculty of presenting *aesthetical ideas.*"[8] This does not mean ideas about aesthetics. It means an idea presented to and through the senses; hence,

one that is not abstractly grasped, but rather experienced through and by means of the senses. This would have been an audacious and almost contradictory formulation in the classical philosophical tradition, according to which the senses were regarded as hopelessly confused. Ideas, so it was thought, were grasped by the mind alone, and knowledge was attained by turning away from the senses. To today's reader, "aesthetical idea" sounds exceedingly bland. To Kant's readers, it must instead have been an exciting composite of contraries. At the very least, it suggests that art is cognitive, since it presents us with ideas, and that a genius is able to find sensory arrays through which these ideas are conveyed to the mind of the viewer. We can put this another way. The artist finds means to *embody* the idea in a sensory medium. This does not exactly translate into slathering paint all over a surface. It requires first that there be an idea, and second that slathering constitutes an embodiment of that idea. A considerable amount of interpretation is involved, as we shall see.

Kant was never generous with examples, but I think we can get at what he was attempting to say by considering one of the somewhat impoverished examples he did offer. Imagine that an artist is asked to convey through an image the idea of the great power of the god Jupiter. The artist presents us with the image of an eagle that holds bolts of lightning in its claws. The eagle was Jupiter's bird, as the peacock was the bird of his wife, Juno, and the owl that of his daughter Athena. So the artist represents Jupiter through his attribute, the way another represents Christ as a lamb (opposite left). The idea of being able to hold bolts of lightning conveys an idea of superhuman strength. It is an "aesthetical idea" because it makes vivid the order of strength possessed by Jupiter, since being able to hold bolts of lightning is far, far beyond our capacities. Only a supremely powerful god is able to do something like that. The image does something the mere words "Jupiter is mighty" are incapable of. Kant spoke of ideas "partly because they

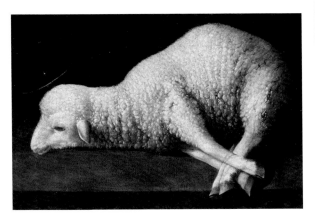

Francisco de Zurburán
Agnus Dei, 1636/40
Oil on canvas
15 × 24 ⅜ inches (38.1 × 62 cm)
San Diego Museum of Art
Gift of Anne R. and Amy Putnam

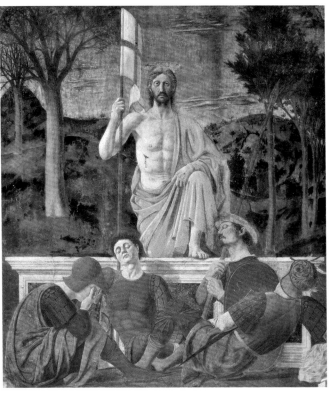

Piero della Francesca
The Resurrection, after 1458, before 1474
Fresco and tempera
88 ⁹⁄₁₆ × 78¾ inches (225 × 200 cm)
Museo Civico, Sansepolcro

at least strive after something which lies beyond the bounds of experience,"[9] but they are *aesthetical* ideas because we have to use what does lie within experience in order to present them. Art, in his view, uses experience in this way to carry us beyond experience.

Let us consider a work of art like Piero della Francesca's great *Resurrection* (above right). In this tremendous painting, there are two registers: in the lower one, soldiers, heavily armed, sleep beside Christ's sepulcher; above, Christ climbs out of his tomb, holding his banner, with what I feel is a look of dazed triumph on his face. He and the soldiers belong to different perspectival systems: one has to raise one's eyes to see Christ. The resurrection takes place in the "dawn's early light." It is, literally and symbolically, a new day. At the same time, it is also

literally and symbolically a new era, for it is a chilly day on the cusp between winter and spring. The soldiers were posted at the tomb to make sure that no one succeeded in removing the dead body of Christ. They form a living wall, so to speak; though asleep, they would awake quickly enough if disturbed by grave robbers. Little matter—Christ returns to life without their being aware of it. He does not even disturb the lid of the sepulcher. Though Christ is still incarnate—we can see his wounds—it is as if he were pure spirit. The whole complex idea of death and resurrection, flesh and spirit, the end of an era and a new beginning for humankind is embodied in a single, compelling image. We can see the mystery enacted before our eyes. Piero gave the central doctrine of faith a local habitation. Of course, it requires interpretation

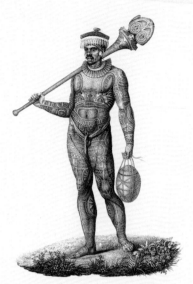

Ein Tatuirter aus Nukahiwa.

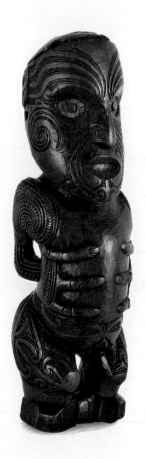

to understand what we are looking at. But as the interpretation advances, different pieces of the scene fall into place, until we recognize that we are seeing something astonishing and miraculous. The gap between eye and mind has been bridged.

Of course Kant and Goya were writing for audiences that had little if any knowledge of art outside the West. Presumably from anthropological illustrations he must have seen, Kant was aware that there are parts of the world in which men are covered with a spiral tattoo: "We could adorn a figure with all kinds of spirals and light, but regular, lines, as the New Zealanders do with their tattooing, if only it were not the figure of a human being"[10] (above left), he wrote in *The Critique of Judgment*. He obviously thought of tattooing as a form of decoration or ornamentation, as if the human body, made in the image of God, is not beautiful enough in its own right. It would have required considerable re-education for Kant to have been able to think of the tattoo as art, and hence as an aesthetic idea, connecting the person thus adorned to invisible forces in the universe.

What impresses me is that Kant's highly compressed discussion of spirit is capable of addressing the logic of artworks invariantly as to time, place, and culture, and of explaining why formalism is such an impoverished philosophy of art. The irony is that Kant's *Critique of Judgment* is so often cited as the foundational text for formalistic analysis, by Greenberg among others, though in truth the book that Greenberg must have had in mind in praising Kant as the "first Modernist" would have to have been not *Critique of Judgment,* but rather the earlier *The Critique of Pure Reason* (1781 and 1787). It is there, if anywhere, that Kant was "the first to criticize the means itself of criticism."[11] In "Modernist Painting," where Greenberg paid the philosopher this compliment, modernism generally consists of using criticism to criticize the means of criticism. It is in Greenberg's application of the principles of art criticism

Opposite top
Carl Brodtmann
Tattooed Man of Nukahiwa, 1827
Lithograph
13 × 9½ inches (33 × 24.1 cm)
www.finerareprints.com

Opposite bottom
Post Figure (Poutokomanawa), n.d.
New Zealand, Maori
Wood and abalone shells
14½ × 4½ × 4½ inches (36.8 × 11.4 × 11.4 cm)
The Menil Collection, Houston

Right
Chris Ofili
The Holy Virgin Mary, 1996
Acrylic, oil, resin, paper collage, glitter,
map pins, and elephant dung on canvas
96 × 72 inches (243.8 × 182.9 cm)
Collection of David Walsh, Tasmania, Australia
Courtesy Victoria Miro Gallery, London

that a given medium discovers what belongs essentially to it, namely, in the case of painting, *flatness*. Wrong answer if Greenberg had in mind the artists most closely associated with him: de Kooning, Kline, Newman, certainly Pollock, Rothko, Still, and even the critic's mentor, Hoffman, would have felt "flat" to be a critical insult and would have accepted "spirit" cheerfully as spot on.

What modernist formalism did achieve, on the other hand—and Greenberg recognized this—was the enfranchisement of a great deal of art that the Victorians, say, would have found, well, "primitive," meaning that those who made such art would have carved or painted like nineteenth-century Europeans if they only knew how. The Bloomsbury critics Roger Fry and Clive Bell came to appreciate African art for its "significant form."[12] This meant that it is ornamentalized, in effect, like the tattoo, according to Kant, rather than an embodiment of powers, as it would have been perceived by Africans themselves.[13] I often wonder whether those who celebrated Kant's aesthetics read as far as section 49 of his

book, where he introduced his exceedingly condensed view of what makes art humanly important. One would have had not so much to widen one's taste, as Greenberg expressed it, but come to recognize that African or Oceanic art is composed around aesthetic ideas specific to those cultures. When Virginia Woolf visited "Negro Sculpture," an exhibition that her cousin Roger Fry discussed with such enthusiasm, she wrote her sister, Vanessa: "I dimly see…that if I had one on the mantelpiece I should be a different sort of character—less adorable, as far as I can make out, but somebody you wouldn't forget in a hurry."[14] She meant, I suppose, that if she accepted the aesthetic ideas embodied in non-Western figures (see opposite bottom), she would not be quite the brittle Bloomsbury personage we believe her to have been, but instead someone responsive to the ideas of a culture very distant from that. Incidentally, it is said that Josette Coatmellac, Fry's mistress, was so agitated by an African mask Fry purchased in 1924 that she committed suicide![15]

Below
Joseph Beuys
Fat Battery, 1963
Mixed media
52 × 146 ¾ × 97 ½ inches (132 × 372.7 × 247.6 cm)
Tate Gallery, London

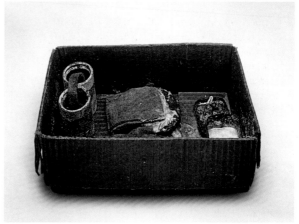

Left
Mark Quinn
Self, 2001
Blood (artist's), stainless steel, Perspex,
and refrigeration equipment
80 11⁄16 × 25 9⁄16 × 25 9⁄16 inches (205 × 65 × 65 cm)
Courtesy Jay Jopling / White Cube, London

Part of the pluralism of our culture has been the widening of means available to artists to embody aesthetic ideas—to convey meanings—not easily expressed through Renaissance-style tableaux, which were ideal for the brilliant embodiment of ideas central to Christianity. Spirit drives artists to find forms and materials quite alien to that tradition: for example, elephant dung, a substance hardly to be found in art-supply stores, became controversial a few years ago when Chris Ofili used it in a work displayed in an exhibition of new British art (page 27). Included in the same show was a self-portrait (above left) that another artist had sculpted from his own frozen blood (it was important that it be his own blood).[16] Some years before, Josef Beuys began using animal fat almost as a signature material, emblematizing nourishment and healing, as he employed felt to emblematize warmth (see above right). Today art can be made of anything, put together with anything, in the service of presenting any ideas whatever. This exerts great interpretative pressures on viewers to grasp the way the artist undertakes through spirit to present the ideas that concern her or him. The embodiment of ideas or meanings is perhaps all we require as a philosophical theory of what art is. But doing the criticism that consists in finding the way that the idea is embodied varies from work to work. *No hay reglas en las artes.*

NOTES

1 Clement Greenberg, *Affirmations and Refusals, 1950–1956*,
 vol. 3 of *The Collected Essays and Criticism*, ed. John O'Brian
 (Chicago: University of Chicago Press, 1986), p. 249.

2 Greenberg, *Modernism with a Vengeance, 1957–1969*, vol. 4
 of idem (note 1), p. 85.

3 Immanuel Kant, *The Critique of Judgment*, trans. J. H. Bernard
 (New York: Hafner Publishing, 1951), section 48, p. 156.

4 Ibid., section 49, p. 156.

5 Henry James, *Italian Hours* (New York: Horizon Press, 1968),
 p. 289.

6 Kant (note 3), section 49, p. 161.

7 Francisco Goya, "Address to the Royal Academy of San
 Fernando Regarding the Method of Teaching the Visual Arts"
 (1792), in Janice A. Tomlinson, *Goya in the Twilight of the
 Enlightenment* (New Haven: Yale University Press, 1992),
 p. 191.

8 Kant (note 3), section 49, p. 157.

9 Ibid.

10 Ibid., section 16, p. 66.

11 Greenberg (note 2).

12 The expression "significant form" was mainly used by
 Clive Bell in his book *Art* (London: Chatto and Windus,
 1914), though it was in the air in Boomsbury circles. Roger
 Fry spoke of "significant or expressive form" in describing
 Paul Cézanne's work in *Vision and Design* (London: Chatto
 and Windus, 1923), p. 192. In the 1920s, both men were
 severe formalists; hence, my describing Fry's position as
 ornamentalization.

13 Roger Fry, "Negro Sculpture," in idem (note 12), pp. 100–03.

14 Virginia Woolf, *The Letters of Virginia Woolf*, ed. Nigel
 Nicholson and Joan Trautman (New York: Harcourt Brace
 and Jovanovich, 1976), 2: 429.

15 Frances Spalding, *Roger Fry: Art and Life* (London: Granada
 Publishing, 1980), pp. 243–45.

16 See *Sensation: Young British Artists from the Saatchi Collection*,
 exh. cat. (London and New York: Thames & Hudson, 1999),
 pp. 133, 147.

Hoodoo Is What We Do

Greg Tate

Hoodoo is what we do. That old black magic made anew. By who? By you, Fool—The master of that Jes Grew, The American (N)egro.

That (N)ew World Afrikan, That (N)igga. Master of the Jes Grew and The Tis What It Is and Making Something Out of Nothing. Who will power whole civilizations with That Monkey Rhythm and This Bridge Called My Back? The same one known to declare "I ain't no African." The same one also known to speak in tongues, keep bottle-trees in his front yard, scatter cracked pottery on the gravestones out back, dance the Juba, broomsweep spirits off dirt floors and toss salt over his shoulders, pour Thunderbird libations for the brothers who cain't be here, consult dreambooks for divination, and not only see dead people but openly conversate with them on the regular.

So what kind of African are you is the real mystery of history. ("Are you free or are you a mystery?") The DNA might say Zimbabwe, but when you came asking Richard Pryor about your roots, he told you, (N)igga, your roots are in Cleveland. And that was true too, because you were blessed or cursed with this whole double-consciousness thing—you're your own twin, your own masks of Janus, your own Bill Bojangles Robinson and Al Jolson too. You've learned to see yourself from the inside-out and from the outside-in and from the outside-out too.

It's why your champions are often given to talking about themselves in the third person like they're having an out-of-body experience. "Today's Serena was an angry Serena and she used that anger to win," says Serena. Bo knows Hoodoo. Call it the Blackman's theory of evolution. Call it funk, as so defined by the funk doctor George Clinton himself. As in "Funk means if you're in Chinatown, you learn to like Chinese food real fast." That's funky. About as funk as your ass not so fresh off the boat from Africa after ninety days heaving and hurling across the Atlantic in the form of chained, lashed, shit-and-piss-splashed cargo, a voyage best described by our man Arthur Jafa as an "Auschwitz on the water." Funkier still when you're then taken to Wall Street to the sounds of a marching band to be redistributed and renditioned to the land of Cotton for the rest of your daze—no time off for good behavior—where you'll learn to like table scraps real fast. Does it get any funkier than that? The Hoodoo comes in when you figure that while your fate is to be treated like a farm animal or garden tool, you're this strange sort of farm animal / garden tool who has a need to pray, and to love, and to plant, and to run away, and to rebel, and to read, and one day even to rule like rock and roll by de fault in dis uncultured nation you were supposed to only slave, stay Black (and blue), and die in.

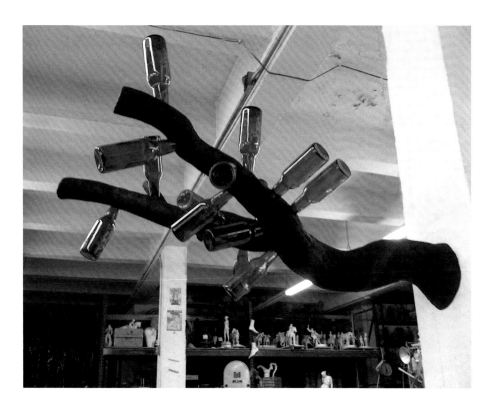

Gary Simmons
Wishbone **(from the Bottle Tree series),** 2008
Bonded bronze and glass
28 × 65 × 39 inches (71.1 × 165.1 × 99.1 cm)
Courtesy of the artist and Metro Pictures,
New York

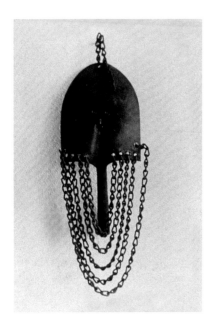

David Hammons
Spade with Chains, 1973
Mixed media
24 × 10 × 5 inches (61 × 25.4 × 12.7 cm)
Tilton Gallery, New York

Hoodoo is what you call hope, what you call medicine, what you call the nine billion names of God: a mojo hand, a gris-gris bag, High John the Conqueror Root, a Congo Square, a Madame Marie Leveau, the Witch Queen of New Orleans, a Nat Turner, and a Toussaint L'Overture too. Because who needs sorcery or secret societies more than a rebellious garden tool?

Who will have to also make myth, music, magic, muscle memory, race memory, and yeah, the English language do strange things, forbidden and unbidden things, unofficial and twisted creole things, thangs even, to steal a drink from freedom's cup? This is what we mean by Hoodoo.

Jimi Hendrix told you he was a Voodoo Child. Told you he stood right next to a mountain, chopped it down with the edge of his hand, picked up all the pieces, made himself an island, and how now he might even raise a little sand. Told you he made love to you in your sleep and yet you felt no pain because he was a million miles away and at the same time right there in your picture frame.

Miles Davis told you he was Running the Voodoo Down, but drummer Don Alias told you the song didn't come together until he put a rhythm on it he'd picked up in the streets of New Orleans a week earlier. This is what we mean by Hoodoo. George Clinton essaying how the Rhythm of Vision is a Dancer. George Clinton telling you he was one of five born to a mother, an older sister and three young brothers, who'd all seen it hard and seen it kind of rough, but how always with a smile, their mother would try to hide from them the fact that life was really tough and how this night he heard his mother call to the lord how it was for the kids and every thing and please don't judge me too strong. And how he heard the devil sing, "Would you like to dance with me? We're doing the Cosmic Slop!" And though the neighbors would stop and call her Jezebel, always she tried to hide the fact from them that she was catching hell. (Way before Two Live Crew, Mama was in Chinatown loving that Chinese food real good and loving it a long time.)

Check the books: The Souls of Black Folk. The Autobiography of an Ex-Colored Man. Cane. I Wonder as I Wonder. Their Eyes Were Watching God. Native Son. Black Boy. Invisible Man. Free Lance Pallbearers. All Night Visitors. Mumbo Jumbo. Nova. Dhalgren. Beloved. The literature of a people obsessed with affirming the somethingness of their nothingness, the Dada of their Nada, the Beep of their Bop, the Hep of their Hop, and the Re-ification of their Thingification. A people whose most eloquent defense of their humanity would be I Have a Dream; later distilled to I Am Somebody; distilled later still to It Takes a Nation of Millions to Hold Us Back. Forty million Somebodies still need to prove they're not Nobodies to Anybody who'll listen. And buy the T-shirt.

Still need to prove they're not ghosts in the flesh. Hence the reason why they gave their invisibility and insurgencies a fanciful name and thus became Freedom Riders, and members of SNCC and CORE, or joined the Lost and Found Nation of Islam, the Five Percent Nation,

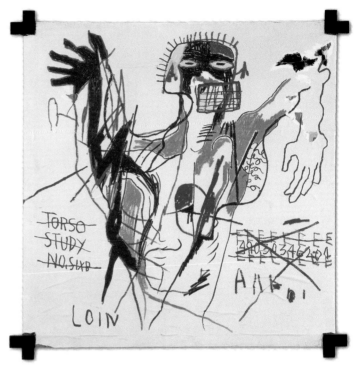

Jean-Michel Basquiat
A Next Loin and / or, 1982
Acrylic and oil on paper, mounted on canvas
72 × 72 ⅛ inches (182.9 × 183.1 cm)
The Menil Collection, Houston

or recruited for the Black Panther Party and the Simbas and US, or got jumped into the Bloods and the Crips and Blackstone Rangers and the Black Liberation Army and the Black Guerilla Family and the All African Peoples Revolutionary Party and the Republic of New Afrika, and they would all tell you they were all out for the block, or the people, or to free the land, except this was America and not Palestine, so the most you could ever hope to liberate was your dream name from your slave name, or your slave name from a slave's visceral terror of becoming visible. Benjamin Banneker style. Crispus Attucks style. David Walker style. Nat Turner style. Harriet Tubman style. Frederick Douglass style. Paul Laurence Dunbar Booker T. Washington style. Ida B. Wells Anna Julia Cooper Sojouner Truth style. Marcus Garvey A. Philip Randolph Paul Robeson Duke Ellington style. This is what we mean by Hoodoo too. Doing the thing on your name and taking it to the stage in the name of all the Invisibles and Nobodies from whom you came. Like the man born Little who became the man named X who became the man named Shabazz. Like the man named Blount who became the man named Ra. Like the man named Ramm who told us Ramm-El-Zee was not a name but an equation while ramming the elevated trains of the New York City subway system to their highest symbolic mathematical military formation, The Zee which variously means in various etymologies The Weapon, The Thing, The Devil, The Sleeper, The Zero. A mobile, style-obsessed army of spray-can thieves moving in stealth, deep underground, transforming train cars into two, four, six, eight, and ten-piece illuminated manuscripts, crypts, chapels, temples, and cathedrals. An army of Nobodies armed with Krylon spray cans making war on Invisibility with alphabetic geometries and wildstyle typographies. Bringing light to Stygian darkness like Bernini ripped on hashish, speed, Ripple, Mogan David, Boone's Farm, rum, coke, weed, speed, crystal meth, crack; like Caravaggio on freebase and Vaughn Bode, like Goya high off angel dust, LSD,

and Andy Warhol. Because self-determination rhymes with self-medication like Acid rhymes with Woodstock Generation. Free your Invisible mind, and your Nameless ass will follow. But follow it where? Not back-to-Africa nor back-to-slavery neither. Purgatory perhaps, though that may be too biblical an interpretation for some—though if Nobodies have to be going somewhere maybe the Rastafarian has the best answer yet in Zion. A promised land without a fixed location, more a state of mind than a destination, as elusive and constantly receding as an event horizon, as distant as the nearest star, an abstraction with radical politics, mad flow, and bounce, a rhythm with vision, a breakdancer, broken free of gravity, spinning across the heavens and star systems. Who knew? Who Do? The Shadow Do and Jes Grew. Bo knew too: That it ain't who you do but who you Hoodoo. So

one generation will call it Conjuration and another generation will call it Cultural Nationalism and another will call it the Hiphop Nation. A nation of tricksters and word magicians pretending to be gangsters and warriors, ballers and bankers, soldiers and simpletons, cannon fodder and hypercapitalist tools. Only just like in Mizoguchi's Kwaidan and Dunbar's We Wear the Mask, if you wear the mask that grins and lies long enough that mask will stick to you like a silk shirt on a ninety-degree day and people will see only the invisibility, the rhythm of vision, which you want them to see, and pay handsomely for the privilege. The question then becomes who or what now actually lives on the other side of that magical stuck-on mask? Who breathes and who dreams for the Hoodoo that's now been put upon you? The Soul-Man you sold to Viacom? The bluesicians you sold to Scorsese? The Jazz cred you sold to Coca-Cola and Ken Burns? The Rap Star you tricked out for a ride. Are you tax-free or are you still a mystery? A living captive joke or a runaway riddle? Busta Rhymes or Jean-Michel Basquiat? Elephant Man or Robert Nesta Marley?

This century the rhythm of vision will have to be an actual visualizer. If only because they're the only Negroes we got left who can't sell nigga clichés to survive. The Twentieth Century was the Age of Black Music, but methinks that day is about done, all that sonic Hoodoo capital we spent, or at least generously redistributed—the wealth of Hoodoo nations been translated into Norwegian Jazz, German Dub, Mumbai House, British Soul, French hiphop, Japanese reggae, Brazilian funk, European Improv—so that the Twenty-first Century could well become the Age of the Black Image. The Age of the Shadow Do. The Age of Hoodoo Hieroglyphics. The Age of David Hammons. Who like Roy DeCarava has long seen in the dark, In the Black, an infinitude of hues, forms, and formulations, as many or more as Inuit peoples are said to see in the driven Arctic snow. I think maybe my people about to get,

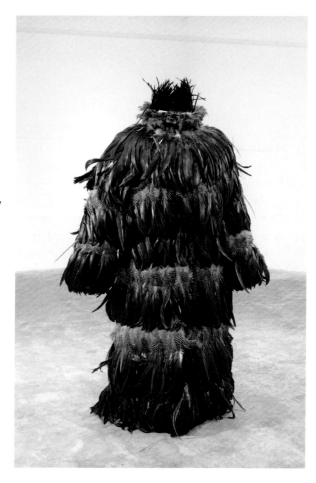

Sanford Biggers
Ghetto Bird Tunic (full length), 2006
Bubble jacket and exotic feathers
61 × 31 inches (154.9 × 78.7 cm)
Courtesy of the artist and Mary Goldman Gallery, Los Angeles

already been about getting, all Manichean out this furthermucker, about to bring forth more darkness from the light. Talking about Lorna Simpson out this piece. Talking about Carrie Mae Weems, Kerry James Marshall, Gary Simmons, Ellen Gallagher, and Kara Walker too. Talking about all conceptual negroes and New World Afrikan conceptualists I've been known to associate with, the likes of Lyle Ashton Harris, Chris Ofili, Satch Hoyt, Sanford Biggers, Wangechi Mutu, Adia Millet, and Deborah Grant. Kehinde Wiley, Xaviera Simmons, Marc André Robinson too. Not to mention all the conceptual negroes and New World Afrikan

conceptualists that I ain't never met, or just barely, but mostly admired from afar: the Laylah Alis, Demetrius Olivers, Kojo Griffins, Mark Bradfords, Edgar Arceneauxes, Nadine Robinsons, etc., etc.

My grandfather used to say, "Son, no matter where you go in this world and no matter what you see, somewhere up in there you will find a Negro." For a long time, this worldly truism was one I felt best described the Presence of the Black Imagist in the White Art World. But when you've got a whole mess of (N)egroes up in anything like we find up in the WAW of today, their populous presence becomes a political statement and a Hoodoo hollering political statement within itself, regardless of what one thinks of their work. Simply because a mess of New World Afrikans freely roaming and ranging spaces of power and privilege nominally or metaphysically deemed White automatically translates into a Hoodoo Police Action, a Mojosexual Cotillion, a You-Know-How-We-Do insurgency. The misedjamacated mongrel hordes of Negroes rolled up in there visually, poetically, conceptually, Hoodooistically doing the damn thang— could make for some other kind of drama.

Ishmael Reed, author of the Neo-HooDoo Manifesto and the ur-novels of NeoHooDooism, Yellowback Radio Broke Down, Mumbo Jumbo, The Last Days of Lousiana Red, and Flight to Canada, once wrote a poem called "Can a Metronome Summon the Thunder or Call the Gods," basically inviting invidious comparisons between European symphonic music and West African drumming. The young African American jazz pianist Robert Glasper recently declared that his generational jazz peers have no soul compared to New World Afrikan Church or even hiphop musicians, because the jazz cats of now don't make music capable of making people dance, shout, cry, collapse, or speak in tongues. That's what you call setting the bar high, drawing a line in the sand, raising expectations, and whatnot.

This, of course, begs the question: is there a contemporary Black Visual Art capable of dragging folk down to the floor, not to mention dragging them Poltergeist-style off to other dimensions, as actually occurs through African visual forms—akwaba, veve, ground drawings, masks, trance, visibly possessed dancers whose rhythms enable vision quests. Not to imply that there should be some sort of test of Black Authenticity or Black Magic grounded in Black Music for New World Afrikan visual culture, but to remind that community-based African artistic practice has established a remote and miraculous event horizon, an oblique phenomological point of cosmological and quantum regeneration, and musical and visual mechanisms for invoking vertiginous, convulsive possession, psychic and physiological transcendence.

Could such affects also become the target zone or even the provenance of our twenty-first century New World Afrikan imagists? Not likely, but a (N)egro, a (N)ew World Afrikan, a stone cold (N)igga even, still has dreams.

Other Ways of Knowing

Jen Budney

I am part of the sun as my eye is part of me. That I am part of the earth my feet know perfectly, and my blood is part of the sea. ... There is nothing of me that is alone and absolute except my mind, and we shall find that the mind has no existence by itself, it is only the glitter of the sun on the surface of the waters.
—D. H. Lawrence[1]

On the reserve in the town where I live and work in interior British Columbia, signs are written in English and Secwepemctsin, the language of many of the region's First Nations bands. The George Manuel Institute is taking the lead in Secwepemc language preservation, and its literature explains its inspiration: "Secwepemctsin contains the cultural, ecological, and historical knowledge which includes: values, beliefs, rituals, songs, stories, social and political structures and spirituality of the people. The Secwepemc view all aspects of their knowledge, including language, as vitally linked to the land."[2] Tania Willard, a Secwepemc artist and former editor of *Redwire* magazine, said, "Secwepemctsin developed from this *particular* land; the sounds of Secwepemctsin are as much a part of the natural ecology of the region as the plants and animals and rocks."[3] From the other side of the globe, Brother John Wright, principal of a Catholic school in Walgett, Australia, stated: "Aboriginal languages were here before we came, they are here now and they'll be here long after we've gone."[4] Language and place are inexorably connected.

Stories from all over the world tell us about the relationship between language and land:

> The First Father of the Guaranis rose in darkness lit by reflections from his own heart and created flames and thin mist. He created love and had nobody to give it to. He created language and had no one to listen to him. Then he recommended to the gods that they should construct the world and take charge of fire, mist, rain, and wind. And he turned over to them the music and words of the sacred hymn so that they would give life to women and to men. So love became communion, language took on life, and the First Father redeemed his solitude. Now he accompanies men and women who sing as they go: *We're walking this earth, We're walking this shining earth.*[5]

Kenyan (Kĩkũyũ) writer Ngũgĩ wa Thiong'o has described how the land, in its specificity, shapes the actions of people, how the repetition of such

actions creates "patterns, moves, rhythms, habits, attitudes, experience, and knowledge," and how these things are passed on through generations—*through* language, but also *shaping* language—becoming, for a people, the "inherited basis for further actions on nature and on themselves."[6] The values that accumulate through this process are all carried not by language in its universality, but rather, in its particularity as the language of a specific community with a specific history and knowledge. Or, as Hobbles Danaiyarri put it, "Everything come up out of ground: language, people, emu, kangaroo, grass. That's Law."[7]

But when modern European colonizers "settled" a territory, one of their first goals was always to teach the natives to speak in a European tongue. Inevitably, this could be accomplished only through considerable violence. The colonizers understood that the eradication of indigenous languages was as intrinsic to the success of their land-grabs as any of the extreme tactics deemed necessary to maintain sovereignty, whether expulsion or murder. Thiong'o elaborated, "The real aim of colonialism was to control the people's wealth: what they produced, how they produced it, and how it was distributed; to control, in other words, the entire realm of the language of real life. … But its most important area of domination was the mental universe of the colonised, the control, through culture, of how people perceived themselves and their relationship to the world. Economic and political control can never be complete or effective without mental control."[8]

The effect of the colonial imposition of a foreign language was to disassociate people, particularly children, from their natural and social environments. Since the colonial language was "a product of and reflecting the 'real language of life' elsewhere," it could never properly reflect or imitate the real life of that community. This resulted, according to Thiong'o, in "the disassociation of the sensibility of that child from his [or her] natural and social environment."[9]

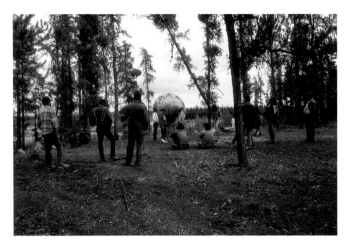

Rebecca Belmore
Ayumee-aawach Oomama-mowan: Speaking to Their Mother, 1996
Mixed media, wood, and loudhailer mechanism
Overall dimensions: l. 90 inches (228.6 cm)
Steel base: diam. 84 inches (213.4 cm)
Installation view
Walter Phillips Gallery, The Banff Centre

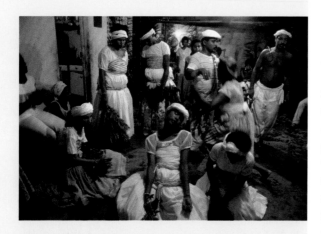

**Members of the Candomblé
cult dance themselves into a trance,
Salvador, Bahia, Brazil, April 23, 1985.**
Courtesy Getty Images

For some time in North America and many other colonized lands, the extinction of most indigenous languages has been considered a given. However, in impressive resistance, indigenous educators are today reinvesting in language programs, and more and more people are (re)learning native tongues. And even where English, Spanish, French, Portuguese, or another colonial language remains the language of everyday use, indigenous *ways* of talking are being taught. In Australia, for instance, Coral Oomera Edwards teaches young children in a Catholic school to call out to the land when they go camping: "Hello, only us mob coming up. OK if we camp here again?" or to address the classroom as they enter it for the first time in the new school year: "Hello, my name is Tommy. Is it OK if I spend a year with you here?"[10]

The practice of talking to the land (or a room) is intended to establish good relations with a place, and acknowledges that places and people are mutually transformative. Sometimes it is difficult to re-establish good relations after many years of disassociation. In 1991 Anishnibekwe artist Rebecca Belmore built a two-meter-wide megaphone through which First Nations people could speak to the earth (see page 37). In her own address, she said: "My heart is beating like a small drum, and I hope that you mother earth can feel it. Someday I will speak to you in my language. I have watched my grandmother live very close to you, my mother the same. I have watched my grandmother show respect for all you have given her. ... Although I went away and left a certain kind of closeness to you, I have gone in a kind of circle. I think I am coming back to understanding where I come from."[11]

And the land talks back to those willing to listen. As Salteaux artist and writer Robert Houle related, "There is a spiritual place in Manitoba known as the Narrows of Lake Manitoba where the water beating against the resonant limestone cliff and pounding along the pebbled shore creates the sound *ke-mishomis-na-ug* (literally,

our ancestors), believed to be the voice of Manitou [the Anishinaabeg Creator]."[12] By talking to or with a place, we acknowledge that it will change according to who comes to occupy it and what they do there, and similarly that people are changed by the places they inhabit—places comprising both their forms and all their potentialities. The kinds of relationships that happen between people and places can be mutual, parasitic, or competitive, depending, to a large degree, on the choices we make, including the ways that we choose to communicate with wherever we are.

In those cultures where the act of speech has long been known to be embedded in the land, people are usually also understood as speaking "from a position with an obvious, acknowledged, linguistically marked ancestral history, and the history and location of that position necessarily saturates any assertion made through language."[13] This "history" is not "history" as we conceive it in the West, but rather, under countless different names, is the knowledge of what Aboriginal Australians today poetically call "country." Country is not simply the place that we come from, but the place that nourishes us and gives us life: it is the place that *grows* us. It is not a generalized or undifferentiated kind of place. Rather, as Deborah Bird Rose stated, "Country is a living entity with a yesterday, today and tomorrow, with a consciousness, and a will toward life." She continued: "People talk about country in the same way that they would talk about a person: they speak to country, sing to country, visit country, worry about country, feel sorry for country, and long for country. People say that country knows, hears, smells, takes notice, takes care, is sorry or happy."[14] Houle wrote, "There is no word for 'landscape' in any of the languages of the ancient ones still spoken. In Ojibwa, whenever the word *uhke* is pronounced, it is more an exaltation of humanness than a declaration of property."[15] "In the Cherokee language," Jimmie Durham declared, "our word for the world and the word for history are the same."[16] Within such worldviews, history, likewise, is not limited to a recorded chronology of events, nor to the functional, nor simply to that which suffices for physical survival, but rather, "builds into specifically situated and literally wonderful cultural complexes."[17]

Knowledge of country can be transmitted through something as simple as a person's name. Marcia Langton remembered, "I once met a woman who lived in Alice Springs and her name translated as the green moss which grows at a waterhole as it is becoming stagnant."[18] Yet the complex arts of storytelling and ritual—spoken, danced, painted, carved, or played—remain the most important vehicles for ensuring that ties are kept to country through generations.

If I write at length about country, if I write slowly, it is to mirror, in a sense, the kind of attention that rituals make us pay to the bonds between people and other people, people and the earth, people and the seasons, people and animals, and so forth. Rituals slow us down; they postpone the speed of modernity that makes us forget everything. Rituals make time cyclical; they provide an opportunity for us to look and sense in a different way. They create (or re-create) people's bonds with country; they do not passively reflect them.

In the de-ritualized West, it has been argued, a "reified Time" has had "little or nothing to do with the cycles of organisms."[19] Human activity is thought to be independent from place in all but the most circumstantial ways, and time is thought to be constantly moving us forward—and in great haste. At high speeds, one's experience becomes increasingly visual, directed by the cerebral control necessary to stay on the road, as it were. Michel de Certeau famously remarked that, in the West, "the fiction of knowledge is related to this lust to be a viewpoint and nothing more." He called the twentieth century's coveted and fetishized "bird's-eye view" an "exaltation of a scopic and gnostic drive."[20] Although the term is much debated by epistemologists, in daily

Partial Figure of a Man on a Barrel
Gabon or Equatorial Guinea, Fang People,
North-central Group
Wood, bark, and cane
20 × 6 ⅝ × 6 ⅝ inches (50.8 × 16.8 × 16.8 cm)
The Menil Collection, Houston

life "objectivity" is still commonly opposed to the tritest notions of "relativism," rather than juxtaposed against the kind of embeddedness of knowledge—and multi-sensorial *knowing*—that more organic philosophies embrace.

Along with the Enlightenment came a denigration of other ways of comprehension and of transmitting knowledge. Likewise, the rituals that reinforced these other ways were viewed by colonial powers as malevolent, irrelevant, or both. In North America, we have banned some famous examples of ritual practices, including the potlatch and the Sun Dance. Until 1946 Candomblé (pages 38, 71) was disallowed by the Catholic Church in Brazil. In 1907 New Zealand enacted the Tohunga Suppression Act, which outlawed traditional Maori healing practices. Aboriginal rituals were forbidden in Australia, while other spiritual beliefs were simply transgressed: among countless examples, I can point to the fact that Australian private and state-run media have glibly ignored Aboriginal mortuary restrictions that prohibit reproduction of a deceased person's image or voice, chalking them up to "superstition." Like the imposition of colonial languages, such attitudes and policies have contributed to the erosion of nations, countries, and cultures, and to the misery of individuals belonging to them.

The museum, as we know, became the West's repository for much of the ritual and sacred objects that colonial agents looted, snatched, or bartered away from non-

Europeans (see above), whose cultures, they were convinced, were soon to be extinct. Once accessioned, the pipes, headdresses, totems, baskets, flutes, idols, shawls, grave markers, and other items were stripped of their purposes and spirits. Meant to be touched, played, worn, or otherwise known through handling and active use of some kind, in museums these objects have been displayed for edification through the eyes alone. The nineteenth century's creed of social Darwinism informed not only the ethnographic museum but also the art museum, with its equal devotion to the principles of competition, taxonomy, and hierarchy—and with its equally profound and unsettling silence.[21] It is not hard to understand why, in *Mumbo Jumbo*, Ishmael Reed called the museum a Center for Art Detention.[22] Therefore, it would seem curious—if not audacious—that an exhibition examining ritual and faith would be named, if you will, in his honor inside such an institution.

In his influential 1985 essay "The 'Primitive' Unconscious," Hal Foster was quite certain that the museum's "epistemological limits" preclude all formations but "a paternal tradition against the transgressive outside."[23] Within the constructs of "primitive" and "modern," art objects, ritual art, or any material manifestations of non-Western ways of knowing are, he argued, inevitably subsumed into the museum's bird's-eye view. There, the object's transgressive potential is transformed in such a manner as to support the Western, linear vision

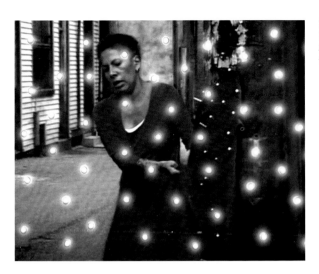

Rebecca Belmore
The Named and the Unnamed, 2002
Still from forty-five-minute video
Collection of the artist

of history and progress, which is the backbone of capitalism: "The ritual work becomes an exhibition form, the ambivalent object reduced to commodity equivalence."[24] Yet, however dour his assessment of Western narratives and institutions, Foster left the reader with a modicum of hope. "[R]ather than seek or resuscitate a lost or dead other, why not turn to vital others within and without—to affirm *their* resistance to the white, patriarchal order of Western culture?" he asked. "On this reading the other remains—indeed, as the very field of difference in which the subject emerges—to challenge Western pretences of sovereignty, supremacy, and self-creation."[25]

I like to think that in the twenty-three years that have passed since Foster made his analysis (and thirty-six since the publication of *Mumbo Jumbo*), that many artists are exceeding Foster's expectations, no longer content simply to challenge the West's pretenses, but successively bringing other ways of knowing into our institutions and changing, bit by bit, the collective conscience.

In the last twenty-five years, approximately seventy women have disappeared from the east side of downtown Vancouver. Most of them are or were impoverished, drug-addicted, and working as prostitutes; most are or were First Nations women. Today, one man is on trial for the murders of twenty-six of these women, but the whereabouts of the others remain unknown. In 2002 artist Rebecca Belmore performed *Vigil* for the women in a back alley in the neighborhood where they used to live, very close to where she lives.

The artist and her audience stood on a dirty square of asphalt. Belmore's arms were covered with the names of fifty of the victims, written with a black felt marker. Without a word, she seized a waiting bucket of soapy water and dropped to her hands and knees. After methodically scrubbing the pavement clean, she slowly lit fifty small white candles and placed them in a circle on the ground. When all the candles were aflame, she stood up and took a deep breath. She began to read the names that were written on her arms, first silently to herself, then crying them out at full volume. After calling out a name, Belmore put a dead rose between her teeth and, with her mouth closed, pulled on the stem, stripping off the blossoms and thorns, after which she spit the contents on the ground. The process, in intent and form, was excruciating. When she was done, she slipped a long red gown over her dirty T-shirt and jeans and began to nail the dress, and herself, to a nearby telephone pole. After pounding in the nails, she violently tore the dress from them, creating a line of jagged, rose-petal-like fabric shards running down the pole's length to the ground. Once the dress was completely destroyed, she sauntered to a waiting pickup truck and leaned exhaustedly against it. From within the truck's cab boomed the sound of James Brown singing: "This is a man's world, but it wouldn't mean nothing, nothing, without a woman or a girl."

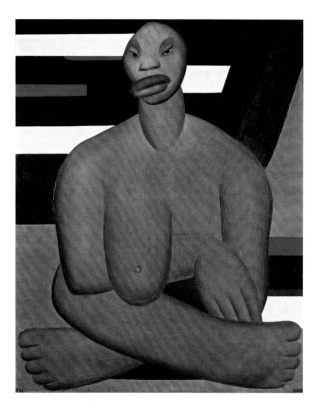

Tarsila do Amaral
A Negra (Black Woman), 1923
Oil on canvas
39 ⅞₁₆ × 32 inches (100 × 81.3 cm)
Museu de Arte Contemporânea da Universidade de São Paulo

Vigil was recorded on video; it has been shown on a few occasions in galleries as *The Named and the Unnamed* (page 41). In a gallery or museum space, the video is projected on a wall that is covered with fifty or more tiny, glowing bulbs, which interrupt the viewing of the performance. The softly burning lights not only symbolize the presence of each of the murdered or lost women, but their interruption of the wall's surface or "screen" also reminds us that what we are seeing is not the performance itself, but a mere re-presentation. The performance, in other words, was enacted "for real" and only once—much as a ritual devotion might be in a moment of extraordinary need.

The video installation's title, *The Named and the Unnamed*, refers of course to the status of the names of the women who have disappeared, lost from our collective unconscious until the trial began, deemed insignificant by almost all for years before the arrest of one white man. None of the missing First Nations women was publicly mourned. What happened to them is not surprising; it is simply more standard collateral damage in the ongoing project of Canada, where most people dare not acknowledge the reality of colonialism. We all know from the news, from history lessons, and from our own observations about broken treaties and unsettled land claims, about the poverty of reserves and desperation of many "urban Indians," but most of us pretend not to know. Instead, we celebrate the nation's official policy of "multiculturalism," sell postcards of Indians with feather headdresses in our tourist shops, and grow impatient with native politicians and activists who refuse to "get over it" and "move on." This is as much in the interest of those who benefit or hope to benefit from the system as it is to those who choose not to look too closely or learn anyone's names.

Belmore broke through this silence, as she shouted the women's names to the world. As Charlotte Townsend-Gault saw it, *Vigil* had all the elements of a classic ritual:

"Establishing a bounded, liminal space, cleansing—a purification which puts the protagonist in a vulnerable or dangerous position, their body marked out in some way identified by special clothing—endurance, repetitive action, release; a closing sequence with the returning to the 'real' world."[26] About the piece, Jolene Rickard remarked:

> The dress is both a scarlet mark and a symbol for the retraumatization of the body. In the area of the city where the alleged violations took place, Belmore nails the dress to a pole; each time she pounds [in] another nail, she struggles to free herself from this "skin." This act is intended to emphasize the violence committed against the body by pulling the fabric to shreds. Belmore's body becomes [a] "hinge" or "threshold between nature and culture" as the unprotected woman's body and a carnivorous society. By calling out and writing the names of the "unnamed" on her skin, Belmore becomes Foucault's "surface of the event"—droplets of [blood] from thorns of roses, drawn through her mouth pierce the illusion of a "unified self."[27]

I am interested in the way the missing women's names were broadcast: called out rather than monumentalized on a plaque or distributed in flyers. By shouting names to the city streets, Belmore seemed to be remembering the women not for her audience's sake but to establish communication with the missing themselves. In doing so, she reached out across time and space, looping back on both, and acknowledged that, though the women's bodies may have disappeared, their spirits have not left the country. They inhabit the streets of the neighborhood still, and whether they haunt or empower us will depend on how we talk to them.

In Canada it is only in the last twenty years or so that the contemporary art of First Nations people has

Emily Carr
Tsatsisnukomi, B.C., 1912
Watercolor and graphite on paper
21 ¾ × 29 ¾ inches (55.2 cm × 75.6 cm)
Collection of the Vancouver Art Gallery, Emily Carr Trust

Brian Jungen
Cetology, 2002
Plastic chairs
159 × 587 × 166 inches (403.9 × 1491 × 421.6 cm)
Collection of the Vancouver Art Gallery

Brian Jungen
Beer Cooler, 2002
Plastic
16 ⅜ × 27 ¾ × 14 ¾ inches (41.6 × 70.5 × 37.5 cm)
Collection of the Art Gallery of Nova Scotia, Halifax, purchased with funds
provided by the Sobey Art Foundation, Stellarton, Nova Scotia, 2003

been allowed to coexist on any sort of equal plane with the work of non-Aboriginal artists. On the other hand, images of "Indians" have always been popular. Much as Tarsila do Amaral's *Negra*, 1923 (page 42), marked Brazil's entry onto the modernist world stage by harnessing the imagined authenticity of a black woman, the paintings of Emily Carr (page 43), depicting the totem poles, artworks, architecture, and countries of the Kwakwaka'wakw, Haida, Tsimshian, Tlingit, and other nations of the North-west Coast, are the *ur-pictures* of Canada. Without these paintings, the nation would have remained nothing but a frigid British outpost. Today, thanks in part to the formal dynamism of the art of Northwest coastal cultures, which Carr appreciated and profited from, but also to the cannibalizing process her art initiated, the designs of these indigenous peoples have become iconic representations of Canada, found everywhere in tourist shops. (I recently discovered in the gift store of the museum in which I work a silk scarf emblazoned with a Haida killer whale: "Made in China," the label said.)

It was against this heavy, hollow burden of colonial appropriation and traditional museology that artist Brian Jungen's *Prototypes for New Understanding*, 1998–

2005 (see page 15), first resonated, not as a simple critique of the commodification of native imagery, but as a sharp reflection on the power of icons or idols, and, as several critics have hypothesized, a peculiar form of potlatch (because the work involves the destruction of coveted goods).[28] By disemboweling and dissecting expensive Nike Air Jordans and meticulously restitching them into fine imitations of traditional coastal masks, Jungen positioned capitalism as a form of idolatry, simultaneously defacing and reinforcing the magic allure of a brand name. Although very different in style, his "masks" (which, of course, are not masks at all, as they cannot be worn and serve no ceremony) function in a similar fashion to the equally compelling "masks" of Yoruba artist Romuald Hazoumé. Hazoumé's objects (see opposite) "send back" to the West the refuse of consumer society that invades the streets of Porto Novo, Benin. Jungen's *Prototypes* return the idolatry that creates this refuse.

By encasing his *Prototypes* in glass vitrines, Jungen mimicked the display mechanisms of the museum. On the one hand, this can be read as a comment on the mistaken premise that first informed ethnographic displays, the notion that material culture demonstrates a single

Romuald Hazoumé
La Bouche du Roi, 1997–2004
Sound, film, and mixed media (plastic, glass, pearls, tobacco, fabrics, mirrors, cauris, and calabashes)
393 ¾ × 114 ¼ inches (100 × 29 m)
Collection of the artist

evolutionary movement toward greater complexity, with indigenous cultures representing the "past" and European cultures the "future." Certainly, some of the success of traditional coastal art can be attributed to the *frisson* it generates for non-Aboriginal consumers who imagine the "Indian" as alive and authentic only in a mythological past. More to the point, Jungen's framing of his art as museological displays is a kind of "unmasking" of Western ways of seeing and knowing, and of the debt modernism owes to indigenous peoples. In his seminal text *Manifesto Antropófago*, the Brazilian modernist Oswald de Andrade assumed the identity of an American Indian when he claimed, "Without us Europe would not even have its poor declaration of the rights of man."[29] What Jungen's *Prototypes* announce from within their vitrines is: "Without us, you would not have Breton, Aragon, Eluard, Tanguy, Miró, etc. No, you would not have Oswald de Andrade."[30]

The greatest irony of Jungen's *Prototypes* has been the series' own commercial (as well as critical) success. Many of Jungen's signature works—including *Prototypes*, *Cetology*, 2002 (opposite left), and *Collective Unconscious*, 2005 (not illustrated)—not only ride a razor's edge

between commodity and critique, but also, due to their physical allure, they re-enchant the magic of the *feitico*. This word was used in the late fifteenth century by Portuguese colonizers to describe both African wooden figures, stones, and other religious objects, and Catholic relics, rosaries, and holy medals. Meaning both "charm" and "made by men," *feitico* did not originally carry the note of denigration that now colors the term "fetish."[31] Jungen's works embrace the delight and power of the *feitico* while critiquing the intellectual and economic systems in which the sacred and ceremonial objects and animals of First Nations people have circulated since the arrival of Europeans in North America.

However, my favorite works by Jungen are the ones that operate against the museum rather than in its imitation. *Beer Cooler*, 2002 (opposite right), for example, is a disposable polystyrene picnic cooler whose sides and lid are carved in rather oblique reference to the beautiful bentwood storage boxes of Haida Gwaii. He first presented the cooler, full of cold cans of Budweiser beer, to initially bewildered guests at an opening in Edinburgh. Only after Jungen walked across the gallery and took a can from the cooler, opened it, and had a sip, did others

Jimmie Durham
Manhattan Festival of the Dead (Store), 1982
Recycled 2 × 4s, plywood, tanned animal skins,
paint, silver print photographs, beaded and
inlaid human, animal, and fish skulls, painted
twigs, shelf paper, and signage
96 × 48 × 28 inches (243.8 × 121.9 × 71.1 cm)
Kenkeleba Gallery, New York

in the room relax and accept the artist's gift. Jungen has explained this work, ironically, as "giving alcohol back to the Europeans."[32] Sadly, in his survey show at the Vancouver Art Gallery in 2006, *Beer Cooler* was cordoned off, its lid closed and, one could only presume, empty of beer. In this context, it seemed to have lost its spirit.

If Jungen's works can be said to challenge, as Foster had hoped, "Western pretences of sovereignty, supremacy, and self-creation," they do so primarily from within the system. Yet, just because his art is in great demand by collectors, galleries, and museums, this does not mean it is always understood. Although the West fetishizes the ocular, it often has trouble seeing. A *New York Times* reviewer described *Beer Cooler* as displaying carvings of "traditional native images."[33] In fact, Jungen carved into the chest images of fire and skulls; an eagle, spiderweb, goat, dreamcatcher, and phoenix; and the title of a 1983 feminist sci-fi film by Lizzie Borden, *Born in Flames.*

Jimmie Durham has been accustomed to such mis-recognition since before the mid-1980s, when he began showing painted and decorated animal skulls (see above) at the Kenkeleba Gallery and other New York venues. Intended partly as a provocative interruption of the era's "postmodern" fixation on sleekness, chrome, and glass, Durham's work had instead often been misinterpreted as "Indian Art."[34] Having devoted the better part of forty years to analyzing the structures of Western government, language, economics, science, mythology, and epistemology, Durham retains his sensibility by maintaining in his working process an intimate conversation with country, wherever he finds himself. By this, I refer to a kind of ethics, another way of knowing and communicating with place and history, and not to any pretensions of Process Art. It is this other way of knowing that in 1983 allowed him to write an interview with a ten-thousand-year-old artist, whom he called Og Mg Erk, wherein he mocked

Western supremacy, modernity, capitalism, patriarchy, and the art market and advocated an organic approach to the circulation of art within the realities of the metropolis: "As a traditionalist, I ... question the use of all this new material and media. I'm very suspicious of oil paint, especially when it is applied to this flimsy cloth they all love to use," says Og Mg Erk. "But this guy Keith Haring, his work might last, down in those subway stations. It reminds me of a guy I knew at Lascaux."[35]

Durham makes most of his objects from the things other people throw away: broken bits of machinery, rocks, wood scraps, cardboard boxes, wasted PVC pipe, and the occasional roadkill. In this he is like his peer David Hammons (see right), an artist he greatly admires. To this end, Durham is keenly aware of the land through which he travels, alert to the offerings of roadsides, beaches, alleys, riverbeds, and abandoned lots. He happily incorporates smudges, tears, glue stains, chips, and other "errors" of finding and making into his finished pieces. Text plays a huge role in most of Durham's works: a handwritten sign or note may be attached to a sculpture, while recent wall pieces have included mostly text, and his titles are always witty and surprising. In all cases, the visual aspects of the work and the various kinds of texts employed serve to complicate and interrupt one another, making meaning contingent upon the continuous reconstitution of the viewer's subjectivity through the acts of reading, looking, juxtaposing. Many works require the viewer to exit the "head space" of trying to know with the eyes alone. A recent sculpture, *Your Face and Science*, 2005 (page 48), forces viewers to squat or kneel in order to read about neutrinos while simultaneously regarding themselves in a tiny mirror.

A recent solo show that traveled in Canada—Durham's first in North America in more than a decade—featured several meditations on the interconnectedness of everything.[36] *A Forest Begins with a Single Acorn*, 2004 (not illustrated), tells the story of a piece of driftwood, found

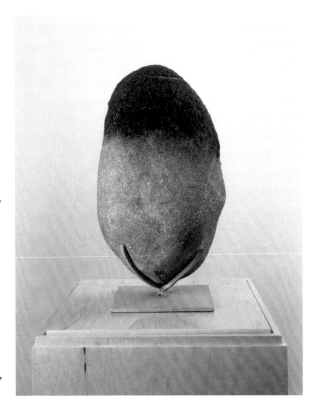

David Hammons
Untitled (Rock Head), 2005
Rock and found hair, mounted on pedestal
Sculpture: h. 15 inches (38.1 cm); pedestal: h. 46 inches (116.8 cm)
The Museum of Modern Art, New York, gift of the Friends of Education and Kathy and Richard S. Fuld, Jr.
Photo courtesy of Perry Rubenstein Gallery, New York

Jimmie Durham
A Street-Level Treatise on Money and Work, 2005
Fifty-three frames with found paper
Dimensions variable
Installation view, Walter Phillips Gallery, The Banff Centre, 2005
Courtesy of the artist

Jimmie Durham
Your Face and Science, 2005
Mixed media
56 × 30 × 9 inches (142.2 × 76.2 × 22.9 cm)
Installation view, Walter Phillips Gallery,
The Banff Centre, 2005
Collection of Robert Blackson

washed up on Lido Beach in Venice, Italy. Durham's text, displayed next to the driftwood in question, begins with the planting of an acorn by a Hungarian immigrant on what is now the Slovenian-Croation border during the period of the Ottoman Empire, traverses the world, experiences several wars, and ends with a gentle lecture delivered by the artist from a hospital bed in Berlin on the healing properties of coniferous trees. *Black Walnut,* 2005 (not illustrated), ponders the origin of the tree (with which Durham grew up in Arkansas) in Siberia, where he encountered the tree type on a visit. This work questions the theory that the first North Americans blindly followed migrating food sources from Asia over the Bering Strait; it proposes instead that they moved to this continent deliberately, carrying species like the black walnut with them. *Black Walnut* discusses Durham's self-exile from the United States and plays with common preconceptions of art (or even Durham as an "Indian artist") as premised on the artist's manual dexterity, juxtaposing an acorn, a strip of wood, a lathe-turned railing, and some carvings that Durham may or may not have made himself. Both these pieces broaden the perspectives through which Western art criticism has conceptualized "material," re-incorporating the histories, biology, economics, and countries of matter.

In all his work, Durham seeks to avoid what he calls the "heaviness" of monuments or architecture,[37] the former serving to reinforce a linear concept of time, the latter establishing a false dichotomy with nature, and both aligning themselves with national narratives and the state. To this end, many of his works involve alternative uses of stone, architecture's most privileged material. *A Street-Level Treatise on Money and Work,* 2005 (above), which involved no rocks in its making, can be read as another anti-architectural piece. Although it first appears as a random hanging of framed scraps of paper, posters, advertisements, letters, ledgers, receipts, and other documents, *Street-Level Treatise* has a tongue-

in-cheek architectural form. Its central pillar is twofold: first, a topographical map of "Europe" that includes North Africa, the Middle East, and much of Central Asia, an area that Durham calls Eurasia and that for the past fifteen years he has made his home; and second, a defacement of a negative symbol that brings the whole structure down, part of a corrugated cardboard box, marked with an icon for "no knives," which has been carefully cut out (with a knife). In some ways autobiographical, *Street-Level Treatise* is a record of Durham's thoughts on the capitalist economy in which he makes and exhibits his art, a paper trail of his travels, and an anti-structure, a subversion of the cold-blooded "rationality" that is the driving force behind our global insanity.

I have written that many artists' works, like that of the individuals featured here, have the power to change our collective Western conscience. But how much can they change a museum, or better, how can they live inside one?

Museums today are being pulled in two directions. More than ever before, these institutions—particularly large ones—are part of the capitalist system that Kenneth Coutts-Smith and other critics have blamed for the "vertical take-off" of art in Western society and its "total alienation from natural phenomenon [*sic*]."[38] Museums are influenced by corporate sponsors and the corporate interests of board members; works of art are acquired by museums within a commercial market; and the same works accrue market value with each exhibition. But even beyond the museum's dependence upon capitalism, there is the problem of the museum's perceived removal from the world. Expressing sentiments very similar to Reed's in *Mumbo Jumbo*, Paul Virilio expounded: "The problem of art today is one of delocalisation. Art is no longer found in galleries and museums; it is found wherever-changing social situations condense. Art is one of the elements of a world vision and this relationship with the world is a constantly changing one."[39] Certainly, as if to agree with this assessment, the artists in this

Pablo Picasso
Les Demoiselles d'Avignon, 1907
Oil on canvas
96 × 91 inches (243.9 × 231.1 cm)
The Museum of Modern Art, New York,
acquired through the Lillie P. Bliss Bequest

Jeff Koons
Puppy, 1992
Stainless steel, soil, geotextile fabric, internal
irrigation system, and live flowering plants
486 × 486 × 256 inches (123.4 × 123.4 × 65 m)
Installation view, Rockefeller Center,
New York, overlooking the Channel Gardens,
where it was on view June 6–September 5, 2000
Project organized by Public Art Fund
in association with Rockefeller Center
Photo courtesy Public Art Fund

exhibition—although, on various levels, established, widely recognized, and (critically if not financially) successful—spend a good deal of their respective practices working deliberately outside the museum system and institutions of all kinds.

And yet, despite the Guggenheim Museum phenomenon (and the "Bilbao Effect"), there is ample evidence that museums are changing and giving serious consideration to the very ancient notion of the museum as "a house of muses"—and by this I mean something less lofty than a place for poetic inspiration. The late Stephen Weil wrote extensively, and passionately, about the changing face of American museums. Today, he said, museums are beginning to understand that good management, outstanding collections, or even noble intentions are not enough to justify their existence. Now, he posited, museum directors need to ask: "When the day was over, the sun had set and the crowds gone home, what had you accomplished? What difference had you made? In what ways had the world been improved? How had somebody's life been made a little better?"[40]

I see evidence of a slow change, a protracted revolution. Many museums are reincorporating *all* our senses through installations involving sound, touch, and taste. Public programming is being devised in collaboration with communities. Educators are gaining status—

although not everywhere, and last of all in art museums. Indeed, the art museum may be condemned to change most slowly of all institutions because of the very identity of art and artists as shaped by modernism: individualist and uninterested in the collective.

To those concerned with the "advancement" of theory, a discussion of the museum's changing focus from means to ends might seem dreadfully prosaic. However, I would like to suggest that the art we are considering in this exhibition (let alone the exhibition's title!) demands that we talk about our institutions in such practical, bodily terms. Here is the thing: there is no bird's-eye view. As we are more than just our eyes, the museum is more than a theoretical space or a staging place for a curator's displays. Likewise, the art in this exhibition demands that we abandon the concept of undifferentiated, "universal" audiences and get to know the real people who walk in. It is not always fun to look at the institutions we work in (the institutions we help build) and to realize how much we may have to change them. But we cannot deny it: "[T]he glass of a show case gives both a transparent vision and a reflection of our own faces."[41]

I think it behooves us to recognize that, although capitalism has created potentially irreparable ruptures with country, the knowledge of that which binds us to it—

Willem de Kooning
Untitled, 1968
Charcoal on paper
18 ¾ × 24 ⅛ inches (47.6 × 61.2 cm)
The Menil Collection, Houston, gift of Janie C. Lee,
in memory of James A. Elkins, Jr.

indeed, our physical and spiritual inseparability from not only "the earth" but also "the sun" and "the sea"— was never entirely forgotten by the West's artists and writers, as this essay's opening words by D. H. Lawrence attest. On the contrary, these ruptures have been the crucial inspiration for much of the West's great art of the last century. In some cases, the inspiration manifests in expressions of overt longing for wholeness and re-union, as in Lawrence's writings. More commonly, however, we find it in cynical and pessimistic artworks. Lawrence understood this apparent contradiction well. His final book, *Apocalypse*, was a study of one of the darkest and most influential texts the West has produced, *The Book of Revelation*. He explained: "[T]he Apocalypse shows, by its very resistance, the things which the human heart secretly yearns after. By the very frenzy with which the Apocalypse destroys the sun and the stars, the world... we can see how deeply the apocalyptists are yearning for the sun and the stars and the earth and the waters of the earth."[42] This passage is striking, and seems to me applicable to more than the Bible's most ominous chapter, for a great deal of modern art has also sought to "destroy" the sun, the stars, and the world, and so on. I think of such phenomena as Pablo Picasso's *Demoiselles d'Avignon*, 1907 (page 49), painted "against everything— against unknown threatening spirits"[43]; the Russian

Futurists' opera *Victory Over the Sun* (1913), with its unwieldy, geometric sets designed by Kasimir Malevich; Willem de Kooning's alarming, Freudian portraits of women (see above); Hermann Nitsch's consciously Dionysian auto-crucifixions; and even the sardonic giant *Puppy*, 1992 (opposite), of Jeff Koons. In works such as these, connection to country or the possibility of spiritual renewal is rejected, torn apart, or mocked. Yet, in its very absence, such connection is the artwork's secret subject.

For many years, we have taken for granted the success of the modernist project. Other ways of knowing have been presumed vanquished and lost. Some museums even condescended to mourn this passing, but in more recent years they have met with surprises. In 1984 indigenous artists and scholars protested Lothar Baumgarten's infamous *Monument for the Native People of Ontario* at the Art Gallery of Ontario, Toronto. "We're not dead," they explained.

No, monuments are not what we need.

NOTES

1 D. H. Lawrence, *Apocalypse and the Writings on Revelation* (Cambridge, Eng.: Cambridge University Press, 1930), p. 148.

2 George Manuel Institute, 2004; see http://www.land-oftheshuswap.com/msite/lang.php.

3 Tania Willard, speaking in a panel discussion, "Stepping across Boundaries," at the Kamloops Art Gallery, Kamloops, B.C., Apr. 1, 2007. A video of this event is in the Kamloops Art Gallery library.

4 NSW Aboriginal Languages Research and Resource Centre; see http://www.alrrc.nsw.gov.au/.

5 Eduardo Galeano, *Memory of Fire: Genesis,* trans. Cedric Belfrage (Toronto: Random House, 1985), p. 11.

6 Ngũgĩ wa Thiong'o, *Decolonising the Mind: The Politics of Language in African Literature* (London, Nairobi, Portsmouth, N.H.: James Currey, EAEP, Heinemann, 1981), pp. 14–15.

7 Quoted in Deborah Bird Rose, *Dingo Makes Us Human: Life and Land in an Aboriginal Australian Culture* (Cambridge, Eng.: Cambridge University Press, 1992), p. 57.

8 Thiong'o (note 6), p. 16.

9 Ibid., p. 17.

10 Quoted in Stephen Muecke, *Ancient and Modern: Time, Culture, and Indigenous Philosophy* (Sydney: University of New South Wales Press, 2004), p. 69.

11 Quoted in Charlotte Townsend-Gault, "Kinds of Knowing," in Diana Nemiroff et al., *Land, Spirit, Power: First Nations at the National Gallery of Canada*, exh. cat. (Ottawa: National Gallery of Canada, 1992), p. 97.

12 Robert Houle, "The Spiritual Legacy of the Ancient Ones," in ibid., p. 62.

13 Michael J. Christie and Bill Perrett writing on the Yolngu, in "Language, Knowledge and the Search for 'Secret English' in Northeast Arnhem Land," as quoted in Muecke (note 10), p. 164.

14 Deborah Bird Rose, *Nourishing Terrains: Australian Aboriginal Views of Landscape and Wilderness* (Canberra: Australian Heritage Commission, 1996), p. 7.

15 Houle (note 12), p. 61.

16 Jimmie Durham, "A Certain Lack of Coherence," in idem, *A Certain Lack of Coherence: Writings on Art and Cultural Politics,* ed. Jean Fisher (London: Kala Press, 1993), p. 143.

17 Muecke (note 10), p. 166.

18 Marcia Langton, "Making the Land Speak: Aboriginal Subalterns & Garrulous Visuality," *Knowledge + Dialogue + Exchange: Remapping Cultural Globalisms From the South*, ed.

Nicholas Tsoutas (Sydney: Artspace, 2005), p. 120.

19 Richard Drinnon, *Facing West: The Metaphysics of Indian Hating and Empire Building* (New York: Schocken Books, 1990), p. xxiii.

20 Michel de Certeau, *The Practice of Everyday Life* (Berkeley and Los Angeles: University of California Press, 1984), p. 92.

21 Indeed, I believe it is because of this ocular centrism—Certeau's "bird's-eye view" that makes the senses of hearing, touch, and taste utterly irrelevant—that museums and galleries are so often places of discomfort for the uninitiated.

22 Ishmael Reed, *Mumbo Jumbo,* (reprint, New York: Scribner's Paperback, 1996), p. 42.

23 Hal Foster, "The 'Primitive' Unconscious," in idem, *Recodings: Art, Spectacle, Cultural Politics* (Port Townsend, Wash.: Bay Press, 1985), p. 191.

24 Ibid., p. 198.

25 Ibid., pp. 207–08.

26 Charlotte Townsend-Gault, *Rebecca Belmore, The Named and the Unnamed*, exh. cat. (Vancouver: Morris and Helen Belkin Art Gallery, University of British Columbia, 2002), p. 19.

27 Jolene Rickard, "Performing Power," in Jessica Bradley et al., *Rebecca Belmore: Fountain*, exh. cat. (Vancouver: Morris and Helen Belkin Art Gallery, University of British Columbia, and Kamloops Art Gallery, 2005), p. 72.

28 See Cuauhtemoc Medina, "High Curios," in *Brian Jungen*, exh. cat. (Vancouver: Vancouver Art Gallery and Douglas and McIntyre Ltd., 2005), p. 30; and Reid Shier, "Cheap," in *Brian Jungen*, exh. cat. (Vancouver: Charles H. Scott Gallery, 2000), p. 3. Jungen himself said that he did not have the potlatch in mind when creating *Prototypes*: "[A]lthough there is a parallel in an economic sense, there was no predetermined cultural link that I was trying to make." See "In Conversation: Brian Jungen and Simon Starling," in *Brian Jungen*, 2005 (above), p. 135.

29 Oswald de Andrade's *Manifesto Antropófago* was originally published in *Revista de Antropófagia* (São Paulo) 1, 1 (May 1928). For a translation from the Portuguese by Adriano Pedrosa and Veronica Cordeiro, see http://www.391.org/manifestos/1928anthropophagite.htm.

30 For a detailed study of the Surrealists' interest in Native American art, see Elizabeth Cowling, "The Eskimos, the American Indians and the Surrealists," *Art History* 1, 4 (1978), pp. 484–99.

31 Susan M. Pearce, "Collecting Reconsidered," in *Museum Languages: Objects and Texts*, ed. G. Kavanagh (Leicester:

Leicester University Press, 1991), p. 145.

32 Nancy Tousley, "Cool Cooler Coolest," *Canadian Art*, Summer 2003, pp. 38–44.

33 Murray White, "Finding Art in Sport and Sweatshops," *New York Times*, Feb. 8, 2004, Arts Section; see http://www. query.nytimes.com/gst/fullpage.html?res=9903E6DD153BF 93BA35751C0A9629C8B63.

34 See Durham's interview with Dirk Snauwaert in *Jimmie Durham* (London: Phaidon, 1995), pp. 6–29.

35 Jimmie Durham, "Interview with a 10,000 Year Old Artist" (1983), in Durham (note 16), pp. 80–81.

36 "Jimmie Durham: Knew Urk," curated by Candice Hopkins and Rob Blackson, opened at the Walter Phillips Gallery, The Banff Centre (Nov. 12, 2005–Mar. 26, 2006), and at the Kamloops Art Gallery (Apr. 1–May 13, 2007). A smaller version appeared at Western Front, Vancouver (May 27– July 1, 2006).

37 Durham's discussion of the heaviness of architecture spans at least a decade. "I already have an ongoing project of working with stone. I want to do different things with stone to make stone light, to make it free of its metaphorical weight, its architectural weight, to make it light," he stated in 1997; see *Fact and Fiction: arte e narrazione*, ed. Roberto Pinto (Milan: Comune di Milano, 1997), p. 57.

38 Kenneth Coutts-Smith, "Some General Observations on the Problem of Cultural Colonialism," in *The Myth of Primitivism: Perspectives on Art*, ed. Susan Hiller (London and New York: Routlege, 1991), pp. 28 and 27, respectively.

39 Paul Virilio, "Urban Armour," in *Lucy Orta: Refuge Wear*, exh. cat. (Paris: Jean-Michel Place, 1996), p. 64.

40 Stephen Weil, "Transformed from a Cemetery of Bric-a-Brac," in *Perspectives on Outcome-Based Evaluation in Libraries and Museums* (Washington, D.C.: Institute of Museum and Library Services, 2000), p. 14.

41 Pearce (note 31), p. 152.

42 Lawrence (note 1), p. 149.

43 Picasso, quoted in André Malraux, *Picasso's Mask*, trans. June and Jacques Guicharnaud (New York: Holt, Rinehart and Winston, 1976), p. 10.

Ritual in Performance

Julia P. Herzberg

The seven artists who are the focus of this essay—José Bedia, Tania Bruguera, María Magdalena Campos-Pons, Regina José Galindo, Ana Mendieta, Pepón Osorio, and Ernesto Pujol—all foreground ritual (defined broadly here) in their aesthetic and conceptual languages in distinguished and distinctive ways. Some—Bedia, Campos-Pons, and Pujol—refer directly to rites within and outside of prescribed religious contexts. Others—Bruguera, Galindo, and Osorio—embody practices or patterns that comment on the specifics of routine human behaviors. Finally, Mendieta interacts with nature to examine its powers of renewal and its relationship to human life.

> *My performative work right now is about the individual and social need to mourn in America: mourning will give America back its morality.*
> —Ernesto Pujol[1]

Ernesto Pujol's *Walk #1* (opposite and page 129) is a private performance enacted in 2005–06 in Magnolia Cemetery in Charleston, South Carolina, where thousands of identified and unidentified Civil War soldiers are buried.[2] Pujol was photographed taking a silent, contemplative walk in the old part of the cemetery, dating from 1850, in which obelisks, massive stone crosses, crumbling mausoleums, and fallen columns commemorate the dead. Acknowledging the historical value of the site, Pujol selected it as an appropriate place to express, through prayer, his moral outrage against this country's war in Iraq. During three mornings in the high heat of August, the artist walked in prayerful meditation through the burial grounds, stopping at various monuments. Twenty-one photographs document this event.

Dressed in a long, black clerical robe, Pujol enacts the role of a minister who offers solace to the bereaved at graveside. With his back to us so that we cannot see his face, he relies on his garment and comportment to confer moral authority. The artist's performance calls for reconsideration of our collective actions at a time when countless people have died in a war that has divided nations worldwide.

The walk draws on diverse traditions of many ancient faiths, including Western and Orthodox Christianity, Hinduism, and Buddhism. Pujol's own experience with meditative practices stems from the years he spent as a Trappist monk.[3] In that tradition, prayer is a means to and an expression of the monk's self-offering to God and affirms his awareness of the divine presence.

Ernesto Pujol
***Ascendancy* (from *Walk #1*)**, 2005—06
Archival digital image
16 × 20 inches (40.6 × 50.8 cm)
Courtesy of the artist

 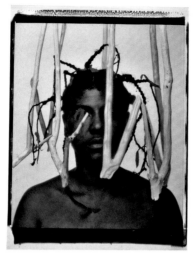 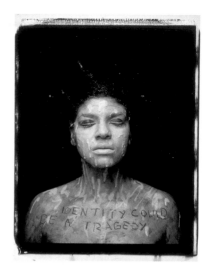

María Magdalena Campos-Pons
When I Am Not Here / Estoy Allá, 1996
Triptych
Polaroid Polacolor Pro 20 × 24 photographs
Ea. 24 × 20 inches (61 × 50.8 cm)
Purchase, the R. H. Norton Trust,
Norton Museum of Art, West Palm Beach, Florida

Walk #1 is the first in an ongoing series of similar thematic performances by Pujol that exemplify mourning and call for reconciliation.[4] Each of the photographs of the performance is a carefully composed tableau in which the elements of balance, proportion, and light ultimately define beauty, melancholy, and ruin.

> *I don't need to think of Africa as over there—*
> *it is already in me. It was present in the way my*
> *father talked. Africa is in the place where I grew up*
> [Cuba]*, and it affects how I perceive myself and*
> *how I relate to all these issues of territory and*
> *displacement and what they mean.*
> —María Magdalena Campos-Pons[5]

María Magdalena Campos-Pons's dialogue with Africa is a basic discursive element in her oeuvre. In the now iconic series of photographs *When I Am Not Here / Estoy Allá*, 1994–97 (see above and page 97), the artist addressed personal and collective histories, as well as identity, gender, and religion, all recurrent subjects in her practice.[6] In this series—non-public performances—the artist ritualistically enacted different narratives. Polaroid photographs provide glimpses of frozen moments, parts of a larger whole.[7] Such is the case with a 1996 triptych from the series reproduced here. In the image on the right, the artist's head and upper torso are covered in brown makeup; in the image on the left, in white. In the middle one, she is seen without makeup in the same position, but suspended in front of and around her head are *garabatos* (herbalists' staffs).

In formal terms, the images, with slight variations, draw on ritual for their theatrical presence. Campos-Pons's makeup-covered body becomes a set or prop in a staged performance. Her painted form is part of an important trend in late-twentieth-century art: the use of the human body to signify wide-ranging objectives. Among the images that come to mind are those of Bruce Nauman, who has employed his own body as a canvas (opposite right); Yves Klein, who used his models' bodies to apply paint to canvas (opposite left); and Cindy Sherman, who—radically transformed through cosmetics, wigs, and dress—photographs herself in various disguises to assume different personas.[8]

Yves Klein
People Begin to Fly, 1961
Oil on paper mounted on canvas
98 ½ × 156 ½ inches (250.2 × 397.5 cm)
The Menil Collection, Houston

Bruce Nauman
Art Make-Up, 1967—68
Still from forty-minute, 16 mm silent, color film
Courtesy Electronic Arts Intermix (EAI), New York

In Campos-Pons's work, formal issues, as important as they are in structuring the visual impact of each scene, function in tandem with thematic ones. *When I am Not Here* dramatizes complex concerns of exile: Campos-Pons moved from Cuba to the United States in 1991, a time when restricted travel between the two nations made it difficult for her to return to her native land until 2000. From the artist's vantage point, "here" and "there" (*allá*) are transmutable. In this private performance, she (re)identified her existential state as she (re)negotiated her notion of place. In two of the three photographs, Spanish and English texts appear across the artist's chest. One says "PATRIA UNA TRAMPA" (Homeland [is] an Entrapment), and the other, "IDENTITY COULD BE A TRAGEDY." These phrases may be interpreted in light of the charged issues embedded in U.S. / Cuban relations, or Campos-Pons's belief in the need to go beyond barriers imposed by nations, whether or not they are at political odds.

The middle image evokes the African diaspora. The *garabatos*—handmade, wooden pieces—simulate staffs, made of branches, that Santería herbalists in Cuba use to cut plants that are believed to contain spiritual and healing properties, a practice that can be traced back to Yoruba origins. The artist's father was an herbalist who gathered such plants for medicinal purposes. He always asked permission of the *orishas* (deities) by knocking his *garabato* on a tree or plant before removing anything from it.[9] In this way, the staffs also serve as emblems of Elegua, the messenger of all *orishas*. In addition to providing a striking formal composition, the *garabatos* represent worldviews that the artist believes define her. Through her references to Africa and its legacies in Cuba, Campos-Pons investigates the intersections of race, gender, and memory, as each in turn informs her being.

*What I am trying to establish are connections
with the cosmological forms of the Afro-American
world, which have not yet disappeared among us
and which serve us as symbols.*
—José Bedia[10]

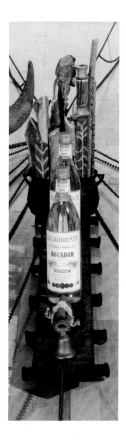

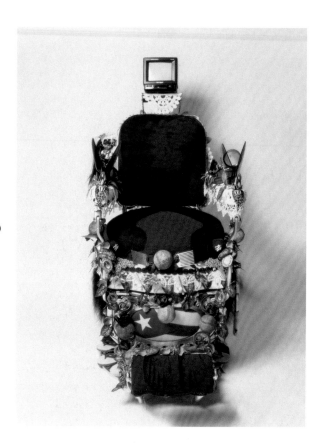

Few contemporary artists have developed an aesthetic and spiritual language informed by both African and Amerindian beliefs as masterfully and innovatively as José Bedia. The artist is an initiate of Palo Monte, an African diaspora religion practiced in Cuba; he has also spent years studying with Native American elders in the United States, Mexico, and South America.[11] Bedia looks at the world through the lens of Palo, yet at the same time understands the relationships among humans, animals, the spirits, and the cosmos as defined by Native American teachings. Seeing many commonalities between the two belief systems, the artist has developed a distinctive vocabulary to express these aesthetic and spiritual intersections.[12]

Bedia's *Things That Drag Me Along* is a new version of a 1996 installation of the same title. The new piece, included in "NeoHooDoo: Art for a Forgotten Faith," was a work in progress at the time of this writing. The earlier work (above left and page 119), exhibited at the George Adams Gallery, New York, incorporated

drawings, sculpture, and collage in an elaborate overlay of symbolic objects and forms that convey personal meanings and refer to ritualistic practices in both Palo and Plains Indian cultures.

The work features a cosmogram-like configuration that begins with a schematic drawing of a double-headed figure—signifying the artist— silhouetted on a wall. A toy bridge mounted on the wall closes the distance between the two heads (sources of enlightenment, faith, and knowledge), in effect implying that they function as one. The silhouetted figure is further distinguished by two archival photographic images collaged to its chest, that on the left featuring Lakota Indians inside a sweat lodge and that on the right, a Kongo priest. The photos mark the places on the body where ritualistic offerings of blood are made during the Plains Indian sun-dance ceremony and Palo initiation rites.[13]

Bedia moved from Cuba to Mexico in 1991 and then from Mexico to the United States in 1993, "an experiential journey" that is reflected in *Things That Drag*

Me Along.[14] Chains attached to the collaged images extend across the floor, where they anchor an assortment of boats and airplanes that, metaphorically speaking, "drag" or "pull" the figure on the wall. The boats on the left reference the slave trade, and the airplanes on the right relate to the flight of the American eagle.[15] Front and center, a toy bull, his forehead bearing a Kongo cosmogram, pulls a tanker. At the animal's side is a pair of crutches, which symbolize Saint Lazarus / Babalu-aye, an *orisha* who guides believers spiritually during a journey.[16] The toys and handmade vehicles have been transferred from a secular to a religious context by the addition of cloth-wrapped bundles imbued with magical properties, bottles of rum and firewater, cigars and cigarettes, and a bison skull and horns, among other things.

The most important object, however, is a three-legged cauldron, known as a *prenda* in Spanish and a *nkisi* in Kongo. It occupies a special place on the tanker behind a bottle of rum. A Palo priest (*tata*) keeps his *nkisi*, a receptacle of power at home, in a special place where it is replenished with offerings and sacred materials when necessary. Bedia filled this one with branches, earth from different places, feathers, a knife, railroad-track nails, small ex-votos, animal parts, small tools (hammer, saw, pick, shovel, anvil, bow and arrow, and machete), and other objects, all of which have significance for him.

Through the symbolic forms of *Things That Drag Me Along*, Bedia narrated an existential odyssey in which he acknowledged being controlled by forces greater than he. His artistic vision encapsulates the dialogue that he maintains with those forces.

> *Men don't cry.*
> — Pepón Osorio[17]

Pepón Osorio's subjects hold a mirror to the diverse social issues that he has experienced as a Puerto Rican immigrant in the United States. Like a cultural anthro-pologist, albeit one who privileges aesthetic goals, the artist explores ideas by talking with people in his community and listening to their stories. Then he weaves the numerous strands of their conversations into visual form, giving shape to their aspirations, fears, disillusionments, frustrations, and humor. The multilayered meanings of his work address a range of social issues central to many Puerto Ricans living in the States, such as crime, racism, and the need for better education. Osorio is motivated by several objectives, including a desire to look inward and ask questions both of himself and others with whom he engages regarding their concerns. Many find such issues difficult to admit, discuss, and resolve. Before their installation in museums or galleries, the artist's pieces take shape in such unexpected places as a vacant storefront, a taxicab, a public library, or a department store. Osorio's installations evoke different responses depending on whether they are seen in such settings or viewed in more traditional art venues.[18]

En la barbería no se llora (No Crying Allowed in the Barbershop), 1994, is an exceptional installation in which a theatricalized space, excessive detail, and imaginative accumulations of ordinary objects critique stereotypical notions of Latin machisimo. In this piece, Osorio transformed a boarded-up barbershop into a fictive setting that resembled the place it once was. The installation was commissioned by Real Art Ways, a contemporary art space in Hartford, Connecticut, known for presenting and producing new and innovative work. The barbershop was located on a busy street in the Puerto Rican neighborhood of Fog Hollow. During the summer, Osorio held a series of dialogues in the space, during which people from the neighborhood could discuss their feelings on the subject of male chauvinism. At the end of the summer, the installation was relocated to the gallery at Real Art Ways.

Photographs of Latino men—politicians, athletes, entertainers—forming a kind of Latino Hall of Fame,

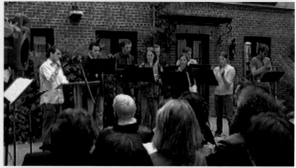

Tania Bruguera
Portraits: A Sound Installation
(first evolution), 2005–06
Wall text and sound
Dimensions variable
Stills from a video of the performance
at Instituto Cervantes, New York,
May 13, 2005
Courtesy Avenol Franco

covered the walls. On the ceiling was a screenprinted design featuring blown-up photographs of giant sperm. Mats were placed over the tiled floor; a red-velour car seat was displayed in one corner, and a statue of Saint Lazarus, protector of the sick, in another. Small Puerto Rican flags identifying the owner's ethnicity were placed throughout. Hundreds of figurines and objects referring to maleness adorned the reimagined space. Mirrors displayed photographs of men flexing their muscles and showing off their tattoos. Barbers' chairs—seats of comfort; places for joking, primping, boasting, and confessing—were upholstered in red velvet and embellished with images of male torsos (see page 58, right). Television screens were attached to the chairs' headrests, so that visitors could watch some older men telling stories of their past and others weeping.

The images of men crying relate to Osorio's memory of his first haircut. His father took him to the neighborhood barbershop. When the boy began to cry in the chair, his father admonished him, "Men don't cry."[19] Here, however, the sounds of weeping have been edited out. Osorio explained, "Traditionally, men have had the opportunity to speak out too much. It's time to look at their body gestures and take a close look at men with no voice. I'm not silencing them, I'm giving them another language."[20] Both the weeping and the silence suggest the hidden side of men's emotional makeup and constitute powerful reminders of human vulnerability.

Here Osorio questioned the truth of stereotypical notions of male behavior and the rituals that shape and reinforce gender identity not only among Puerto Ricans but also among many social and cultural groups. The barber's chair, seen in conjunction with the overload of objects and images that surround it, became a metonym that communicates an intimate view of male self-perception, an emotional depth, and an exploration of personal feelings embedded in the overall work but not always recognized or accepted by the community.

This piece is a sound portrait of several political figures who have had an impact on world events. In order to "picture" [each of] them, I selected one of their speeches. The choice was based either on the importance of the speech itself, or the access to recorded data.
— Tania Bruguera[21]

Portraits: A Sound Installation, 2005–06, grew out of Tania Bruguera's ongoing interest in the ways speeches affect audiences. Raised in post-Revolutionary Cuba, where Fidel Castro's dramatic, persuasive rhetoric captivated the population at large, Bruguera was sensitized from childhood to the power of speech as a political tool. *Autobiografía (Autobiography)*, a slightly earlier piece, explored the impact of political slogans on listeners (not illustrated). During the Eighth Havana Biennial in 2003, she installed it at the Museo Nacional de Bellas Artes. On a stage she constructed, empty but for a microphone and speakers, bodiless voices blared political epithets associated with Castro and the Revolution.[22] These included: "Revolucionario hasta el fin" (Revolution until the End), "¡Escogeremos siempre el sacrificio!" (We Will Always Choose Sacrifice), and "Libertad o muerte" (Liberty or Death). Approaching the microphone, one became increasingly aware of the power Castro projected through slogans that resounded at a decibel level high enough to make the stage vibrate.

In May 2005, when it was still a work in progress, *Portraits* was performed in the open-air garden at the Instituto Cervantes, New York, as a unique "concert soirée" (opposite).[23] Bruguera had begun *Portraits* by listening to recordings of speeches by such world-famous figures as Winston Churchill, the Dalai Lama, Albert Einstein, Adolf Hitler, Barbara Jordan, John F. Kennedy, Martin Luther King Jr., Pope Paul VI, Yitzhak Rabin, Ronald Reagan, and Eleanor Roosevelt. She recorded excerpts of these onto a CD and then used a computer

program to translate them into rhythmic sequences.[24] At the Instituto Cervantes performance, instead of verbalizing these sequences, eighteen students from New York's Juilliard School clapped their hands in distinctive beats, achieving a sense of the rhetorical power of the original delivery. The program listed the speakers but provided neither the titles of the speeches nor the texts of the excerpts being performed. Audience members had to intuit what they were hearing from the clapping sequences.

For example, for Hitler, the performers held their hands straight up while clapping to suggest the militaristic tone of the speech in which the *führer* defended Germany's invasion of Poland. For the pope's excerpt, they clapped two fingers against their palms to create a soft, subtle sound, appropriate to the pontiff's quiet speaking style. A quartet performed excerpts from Reagan's speech by clapping with cupped hands to suggest the tonal variations of the president when, at the Berlin Wall, he challenged the Soviet leader Mikhail Gorbachev to open the gates and tear down the barrier. A quartet also performed Congresswoman Barbara Jordan's historic 1976 Democratic Convention keynote address; they hit four fingers of one hand on the palm of the other, producing a soft sound reminiscent of her delivery when she asked the Democratic delegates, "Who will speak for the common ground?" Although *Portraits* was in its formative stage, it was nevertheless compelling, powerful, and innovative.

The completed work was presented in 2006 at the Kunsthalle Wien (page 96) and in the exhibition "Tatlin's Whisper" at the Kunsthalle of Kiel, Germany. The site-specific sound installation featured a series of stereo speakers that amplified a recording of a clapped performance of the excerpted speeches by professional musicians. Wall texts identified the authors, titles of the speeches, dates, and places of delivery.[25]

Portraits: A Sound Installation is an abstract aural project. When listening to it, some in the audience who have heard the speeches or were familiar with them may well recall how they were impacted by them. Those who do not know the speeches are challenged to figure out whose speech is being performed and to consider the nature of what is being said.

> *I am interested in investigating power relationships, they provide a vast field for reflection; for my part, I keep questioning my every action. Reality is everywhere in my work; I try to reinterpret it.*
> —Regina José Galindo[26]

In three performances documented on video, Regina José Galindo performed actions that dramatize different methods of physical abuse inflicted by captors on detainees or prisoners. The kinds of torture enacted in *Confesión (Confession)*, *Limpieza Social (Social Cleansing)*, and *150,000 Voltios (150,000 Volts)* are commonplace in many parts of the world, despite the United Nations Universal Declaration of Human Rights of 1948, the protocols of the Geneva Convention of 1949, and the Pentagon's rules for interrogation of prisoners.

In *Confession* (pages 19, 113), the artist's head is repeatedly submerged in water until she can barely breathe; this form of torture is known as the wet submarine (*submarino humedo*) or waterboarding. After a time, her subjugator—a large-bodied, muscular man—throws her to the floor, where she remains, gasping for breath. Appropriately, Galindo executed this piece out of sight, in the basement of a building in Palma de Mallorca, Spain. Galería Caja Blanca commissioned the work in the summer of 2007. People were invited both to the opening of an exhibition of Galindo's work at the gallery and to the building where she executed the piece. Those who went to the performance, which she enacted only once, were restricted to seeing it on a screen in the entrance

Regina José Galindo
150,000 Voltios (150,000 Volts), 2007
Video installation and performance
Courtesy of the artist and
Prometeo Gallery di Ida Pisani, Milan

foyer. Although she was hidden, a few people discovered a small window that opened onto the basement and from that vantage point surreptitiously watched the event, adding a clandestine feeling to the work. Galindo's focus on this method of torture was motivated by reports that Palma de Mallorca is a refueling point for secret flights from the United States that carry alleged terrorists to countries where this kind of brutality, among other forms of abuse, is employed.[27]

In *Social Cleansing* (not illustrated), Galindo is hosed down with high-pressure jets of ice-cold water. After a short time, she can no longer stand and falls to the ground on all fours. She performed this work in private before a blank wall on the patio of the Galleria Civica d'Arte Contemporanea, Trent, Italy, in 2006. The piece was videotaped and subsequently included as part of a group exhibition, "Il potere delle donne" ("The Power of Women"). Galindo's performance was motivated by protests in Paris in late 2005, during which demonstrators were hosed with water.[28] Jet-power hosing is commonly used by the police or military forces to stop or detain protestors and to break up demonstrations. A similar system is also used in Guatemala, the artist's country of birth, to shower down prisoners when they enter prison.[29] Performing nude, Galindo embodied the stripped down, humiliating vulnerability that detainees can experience.

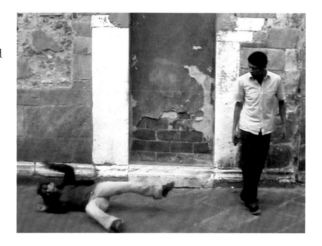

Performed on a street in Lucca, Italy, in 2007, *150,000 Volts* (right) imparts a sense of sudden terror. The perpetrator shoots a stun gun at the artist, and she falls. Police use such weapons to disable criminal suspects, thereby making it easier to control or subdue them.

In these performances, Galindo engaged in a kind of radical body art that forced her to the limits of physical endurance, much as Marina Abramović and other contemporary performance artists have done.[30] In challenging her own responses to unequal power relzationships as well as the perceptions others have of them, Galindo belongs to a tradition of artists who have focused on

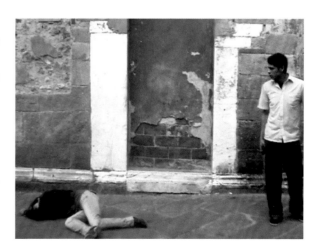

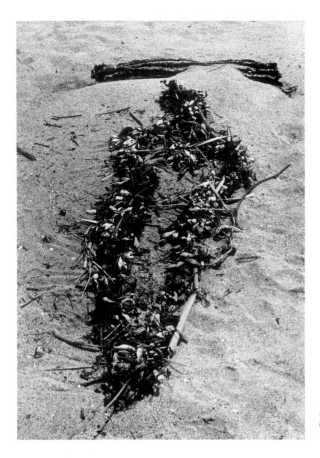

Ana Mendieta
Untitled (Silueta series, Mexico), 1977
Photo courtesy of Galerie Lelong, New York

inhumane actions, from Francisco Goya and Pablo Picasso to Leon Golub and Fernando Botero. Galindo's slow, measured, repeated actions demonstrate ritualistic patterns of perverse behavior. At a basic level, these performances are as much acts of resistance as they are commemorations of those who have been repressed or silenced through intimidation, maltreatment, or disappearance. In the liminal spaces between reality, fiction, and art, Galindo engages with acts in which human beings controvert their humanity.

> *I like the burning thing. ... Fire has always been a very magical thing for me.*
> — Ana Mendieta[31]

Ana Mendieta's earth-body sculptures feature the *silueta*, an outline or contour of the artist's body made out of a seemingly infinite variety of natural elements: wood, dirt, grass, snow, water, trees, flowers, leaves, stones, and fire (see above). To form the *siluetas*, the artist rearranged mushrooms on logs, algae near the water's edge, moss on rocks and fallen logs, flowers in a field, leaves on trees. She pressed the *silueta* image into the wet earth, leaving its imprint behind; she incised it around the opening of a cave, shaped it from moss, floated it in muddy waters, burned it on the ground. Mendieta documented her work in photographs, slides, and 35 mm film.

Mendieta perceived *la tierra*, Mother Nature, as a living organism that is reproductive and eternal. By inserting her own image into natural settings using diverse natural elements, she endowed *la tierra* with a human form. Among the most dramatic images in the Silueta series are those that involve fireworks, gunpowder, or a mixture of pyrotechnics. Drawing on the symbolism of fire and the effects of light, the artist imbued the burning *siluetas* with the trappings of ritual. As Guy Brett noted, "Fire is particularly impressive in the film records of her work because it is fast energy

that lives and dies rapidly, contrasting with much slower changes in the earth itself."[32]

Untitled (Gunpowder Work #1) 1980, (pages 108–09) is a time-based performance created in the "Dead Tree Area," a wildlife preserve near Amana, outside Iowa City. Mendieta often worked there because it was private and, as she noted, the earth contained a lot of clay, so that it was easy to work with when wet. It also had a "crackled effect" that she liked. The artist talked about this earth-body sculpture, which was filmed in Super-8 and then transferred to video and later to DVD, in a lecture at Alfred State College, Alfred, New York, in September 1981.[33] Near the Iowa River, she dug out an area of soft ground the size of her own body and built up the sides to create a relief sculpture. Mendieta probably let the piece set for a few days so it would dry and crack. The film shows us the *silueta* from the top of the head toward the feet. Near the head, Mendieta made a heart shape, referring to the Sacred Heart of Jesus. Her Catholic upbringing, especially on her mother's side, was steeped in devotion to the Sacred Heart.[34] The *silueta* began to burn from small holes filled with gunpowder at the bottom of the figure. During the six-minute film, Mother Earth, in the form of a burning effigy, comes alive. Using gunpowder enabled Mendieta to control fire in expressive ways in her work, and she had been experimenting with different mixtures for several years. In her lecture, she talked about making it herself: "I don't buy it. I buy the different ingredients that make gunpowder. And then I add [sugar] to those ingredients. … It is very strange because the chemical reactions I get are all different. I make different kinds of [mixtures] … each time. The chemicals and materials in the earth cause [different] reactions."[35]

Mendieta also discussed other time-based, combustible earth sculptures, all untitled and ritually executed. In 1979 she constructed one in Iowa in the shape of a volcano; she made another at Kean College, Elizabeth, New Jersey, in April 1980; and in August of that year, she produced a third, for the exhibition "Art Across the Park," in New York's Central Park. After she made the mounds, she filled them with gunpowder. At the top of the mound in the Iowa piece, she created a *silueta* in white to represent Mother Earth. She made the gunpowder *silueta* at Kean College, which featured three little volcano shapes, the same week as the devastating volcanic explosion of Mt. Saint Helen in Washington—the timing was accidental, if not prescient.[36] The *silueta* in the Central Park piece was similar to that in *Untitled (Gunpowder Work #1)*.

Mendieta's performative pieces have been called post-minimalist, self-reflexive, process-oriented earth-body work. In them she gave nature's life cycle a symbolic beginning, middle, and end, and offered a spiritual view of earth's regenerative forces.

Bedia, Bruguera, Campos-Pons, Galindo, Mendieta, Osorio, and Pujol address diverse forms of ritual. For some, ritual embraces spirituality from a particular religious perspective; for others, it is the mother lode of secular life; and for others it serves as a crossover between these realms. By understanding and incorporating ritual, these artists have elevated the repetition of performative acts to a transcendent state through concentration, intent, and aesthetic vision.

NOTES

1 Email from the artist, Nov. 11, 2007.

2 Administered by the Magnolia Cemetery Trust, the Magnolia Cemetery was once a thriving nineteenth-century rice plantation. Pujol first walked through the oldest section of the cemetery while working on a project for the Spoleto Festival / USA, curated by Mary Jane Jacob.

3 The artist spent four years in a cloistered Trappist monastery in South Carolina before receiving dispensation from his vows. Trappist monks follow the "Rule of Saint Benedict," according to which oral and contemplative prayer are integrated into daily work and other activities. See Hugh Feiss, O.S.B., *Essential Monastic Wisdom* (New York: Harper Collins, 1999), pp. 10, 12.

4 Subsequently, Pujol performed *The Water Cycle* in *Walk #2*. The artist took five-hour, silent walks along the Boston waterfront and on the Harbor islands on different mornings and afternoons in summer 2007. The Institute of Contemporary Art (ICA), Boston, commissioned the piece. In October 2007, the artist choreographed and performed *Memorial Gestures: Mourning and Yearning*, a twelve-hour indoor walk in the Grand Army of the Republic Rotunda at the Chicago Cultural Center. The performance was cosponsored by the Chicago Arts Commission, the Chicago Performance Network, and the School of the Art Institute of Chicago, where the artist is a distinguished fellow and lecturer in the sculpture department's graduate program.

5 This statement was included in the installation of the 1998 exhibition "History of People That Were Not Heroes: Part I, A Town Portrait," which included Campos-Pons's work, at Lehman College Art Gallery / CUNY, Bronx, New York. See Lisa D. Freiman, *Magdalena Campos-Pons: Everything Is Separated by Water*, exh. cat. (New Haven: Indianapolis Museum of Art in association with Yale University Press, 2006), p. 26 n. 55.

6 In addition to a large body of photographs documenting her performances, the artist is equally well known for live performances.

7 They are part of a larger series reproduced in Freiman (note 5), pp. 118–19. Campos-Pons used a 20 × 24 Polaroid camera funded by the Polaroid Artist Support Program. For an informative discussion of the artist's use of the Polaroid camera, see Freiman, pp. 51–52.

8 I am referring particularly to Bruce Nauman's *Art Makeup No. 1, 2, 3, 4* (1967–68), Yves Klein's Anthropometry paintings of the early 1960s, and the majority of Cindy Sherman's work over several decades. An artist featured here, Ana Mendieta, worked in this vein as well. In *Facial Cosmetic Variations*, 1972, she disguised herself with makeup and wigs.

9 Conversations between the artist and author in 1998, during the preparatory stages of the exhibition "History of People That Were Not Heroes" (note 5).

10 Quoted in Melissa E. Feldman, "Bedia's Bilingualism," in *Mi esencialismo: José Bedia*, exh. cat. (New York: Douglas Hyde Gallery; Dublin: Trinity College, 1996), p. 15.

11 Bedia was initiated in Palo Monte in 1983. He met with the Lakota in 1985 on the Rosebud Reservation, where the elder Leonard Crow Dog introduced him to the beliefs and lore of his people. For fuller discussions of Bedia's initiation into Palo Monte and his extensive Amerindian tutelage, see Judith Bettelheim, "His Essentialism," in *Mi esencialismo* (note 10), pp. 3, 5–7; and Robert Farris Thompson, "Sacred Silhouettes," *Art in America* 85, 7 (July 1997), pp. 66–69.

12 Bettelheim (note 11), pp. 6–7. Bettelheim continues to study the concordances between Kongo culture and aesthetics and Native American religion and aesthetics.

13 A sweat lodge is a place where one learns spiritual regeneration through self-purification. Leonard Crow Dog (see note 11) led Bedia through the purification ceremony. See Thompson (note 11), p. 69.

14 See note 16.

15 Conversations with the artist, Dec. 12–13, 2007.

16 Significantly, in 1992, during his various moves, Bedia executed the painting *San Lazaro (Yo soy la ruta)*, one of many works in homage to this *orisha*. *Yo soy la ruta* can be translated as "I am the way," or "I am the path to get you there." I thank George Adams for bringing this painting and its accompanying text to my attention.

17 Conversation with the artist, precise date unrecorded.

18 Osorio investigated the intersections between private lif and public policy in the foster-care system in two elaborately staged works, *Face to Face*, 2002, and *Trials and Turbulence*, 2004. They were exhibited at the Institute of Contemporary Art, Philadelphia, in 2004. *Face to Face* was first shown at Ronald Feldman Fine Arts in New York in 2002.

19 Osorio (note 17).

20 Quoted in Helen Urinas, *Northeast* (*The Hartford Courant Sunday Magazine*), Aug. 14, 1994.

21 Cited in "A Note from the Artist" in the May 13, 2005, program brochure for *Portraits*, performed at the Instituto Cervantes, New York.

22 See Julia P. Herzberg, "Eighth Havana Biennial," *Art Nexus* (Mar. 2003), pp. 82–88.

23 Program brochure (note 21). The performance was part of the Cuban Artists Fund's monthlong festival of cultural and artistic events. The Instituto Cervantes was one of eighteen arts and cultural organizations that participated in the festival. I am grateful to Avenol Franco, who lent me a CD recording of the videotape he made of the performance.

24 Julia Miller translated the recorded excerpts into rhythmic scores. The concert pianist Mirta Gómez kindly helped me understand rhythmic sequences.

25 The excerpted speeches were: Churchill's "Iron Curtain Speech," Mar. 5, 1946, at Westminster College, Fulton, Missouri; Einstein's "My Credo," fall 1932, before the German League of Human Rights, Berlin; Hitler's "Address to the Reichstag," May 4, 1941, Berlin; Jordan's "Keynote Address at the 1976 Democratic National Convention," July 12, 1976, New York; Kennedy's "Cuban Missile Crisis Address to the Nation," Oct. 22, 1962, from the White House, Washington, D.C.; King's "I Have a Dream," Aug. 28, 1963, at the Lincoln Memorial, Washington, D.C.; Pope Paul VI's "On the 20th Anniversary of the United Nations," Oct. 4, 1965, before the United Nations General Assembly, New York; Rabin's "Acceptance of an Honorary Doctorate," 1967, Hebrew University, Jerusalem; Reagan's "Address from the Brandenburg Gate," June 12, 1987, at the Berlin Wall; and Roosevelt's "On the Adoption of the Universal Declaration of Human Rights," Dec. 9, 1948, before the U.N. General Assembly, Paris. The artist was unable to locate the Dalai Lama's speech in her archives at the time of this writing.

26 Email from the artist, Nov. 28, 2007.

27 Among other sources, Galindo was familiar with the work of journalists Felipe Armendáriz, Marisa Goñi, and Matias Vallés. They investigated these alleged CIA flights and reported their findings to the European Parliament in Brussels. See http://www.pagina12.com.ar/diaro/elmundo/4-75273-2006-1-28.html. Email from the artist, Nov. 30, 2007.

28 Telephone conversation with the artist, Nov. 30, 2007.

29 Email from the artist, Nov. 16, 2007. Telephone conversation with the artist, Nov. 30, 2007.

30 Future studies will no doubt yield some of the artistic sources informing Galindo's work.

31 From a videotape of Mendieta's September 1981 slide lecture at Alfred State College, Alfred, New York, in Ana Mendieta Archives, Galerie Lelong, New York.

32 Guy Brett, "One Energy," in *Ana Mendieta: Earth Body, Sculpture and Performance, 1972–1985*, exh. cat. (Washington, D.C.: Hirshhorn Museum and Sculpture Garden, 2004), p. 168. For a discussion of Mendieta's works with fire and gunpowder, see the essays in this catalogue by Brett, Julia P. Herzberg, Chrissie Iles, and Olga M. Viso.

33 Mendieta (note 31).

34 In Roman Catholic belief, the heart crowned with thorns symbolizes Christ's love for humanity. Mendieta's own Catholic background was steeped in devotion to the Sacred Heart of Jesus. She and her sister went to El Apostolado del Sacrado Corazón de Jesus, a school run by nuns. As was customary, on the first Friday of every month, the Mendieta sisters went to mass and communion to express their devotion to the Sacred Heart. In 1973 Mendieta used an animal's heart, a specific reference to the Sacred Heart, in a body work on the rooftop of the Hotel Principal, Oaxaca, Mexico, in which she draped herself as the white-shrouded, dead Christ. This piece is but one of many by her that refer directly to Catholic beliefs. It is reproduced in *Ana Mendieta* (note 32), p. 160.

35 Mendieta (note 31).

36 Mendieta may have been inspired to begin volcanic imagery after having seen the exhibition "Pompeii, A.D. 79" on May 2, 1979, at the American Museum of Natural History, New York. The ticket and the diary entry are in the artist's archives (note 31).

Communiqué from Afro-Atlantis

Robert Farris Thompson

Turn on the radio. Rap everywhere. Reggae everywhere. Jazz everywhere. Tango in Finland. Mambo in Germany, where the national hit of summer 1999 was Lou Bega's *Mambo No.5 Buena Vista Social Club*: one million copies sold (see page 73). Ricky Martin: seven million female hearts destroyed. Marc Anthony and La India, closing in on Ricky's tail. Something is happening, Mr. Jones.

The cultural impact of Black Atlantic gets larger and louder. In a magazine article dating from the middle 1960s, Arnold Toynbee chided "victorious Africa" for causing a spread of Afro-influenced musics across the planet. Actually the process goes back further, to at least the late eighteenth century. Mechal Sobel, in *The World They Made Together*, documents a moment in the life of a young white man, Tom Sutherland. In 1776 Sutherland was hanging out with the slaves in Virginia, dancing a "Kongo minuet."

Theories make sense of collisions of culture, ancient to modern. But the *lived experiences* of African and African American artists provide sources for understanding too. I keep a copy of Walter Benjamin by my bedside, but also a copy of Ingrid Monson's *Saying Something: Jazz Improvisation and Interaction*, marked to page 205, where she said:

> Emphasis on ideology constructs an extremely exalted role for the…intellectual, whose knowledge of some of the…critical texts of the West enables him or her to "see through" the ideological overdeterminations that saddle the "mere" person on the street. [This] intellectual elitism inhabits its own extremely Western architecture.

Get me straight on this. I am *not* saying we give up on Marx or Hegel or Derrida and only focus on the lived insights of jazz women, Yoruba dancers, reggae singers, or masters of the textile art of the Kuba. I *am* saying that their lived experiences are equal to any ideology, anytime. Lived experiences stem from the people, choice memories of improvisation, choice memories of moral decision. They radiate common sense. As Paul Bohannan said years ago, you can't build a model without a folk model first.

Ricky Martin is a symptom. He stands for the ever-widening triumph of Latino music, itself African influenced. This means that time and demography are on our side. But this does not mean that we let down our guard. Nor should we think we now know something definitive about transfers of art and understanding from the Guinea Coast to the Black Americas.

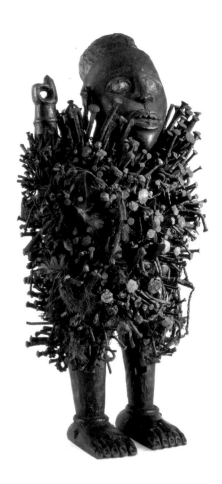

Standing Man (Nkisi Nkondi)
Democratic Republic of the Congo, Cabinda,
Republic of the Congo, and Angola, Western Kongo people
(Vili, Yombe, or Woyo sub-group)
Nineteenth / twentieth century
Wood with iron blades and nails, string, resin,
feathers, and glass
20 ⅛ × 10 ⅜ × 10 ½ inches (51.1 × 26.4 × 26.7 cm)
The Menil Collection, Houston

Linking Africa with the Americas involves translation. So it is useful to recall the perspective of Benjamin on this art: only when you love and respect another language as much as your own will you translate.

Try translating Afro-Atlantic fusions of dance-music-painting-song-and-spirit. *Kunstgesamtwerk?* No, that essentially means opera—seeing sets, hearing music, and watching motions from a seat in the theater.

But an Afro-Atlantic fusion of art, life, and spirit *can* mean, for example, painting with red ocher heated over a red fire, moistened with the red blood of an antelope, stirred by the light of a red full moon, creating in San rock art red-pigment figures so potent, so it is believed, they can magnetize an evil person to the rock where later we will find his skeleton. *Is* there a term for such power and presence in artistic motion? Yes, in Ki-Kongo. Art that brings spirit and image together is *ki-mooyo*. This is literally the idiom of the soul.

The concept *ki-mooyo* opens our eyes to hidden dimensions in the reinstatement of African objects in the Americas. Take, for example, the so-called thumb pianos—the *mbira,* the *kalimba,* the *sansi.* Captive Africans in the Americas could not live without them. They emerge as the "rumba box" of Jamaica, *mar'mbula* in Cuba and the Dominican Republic, *marimba* in Haiti, *marimba brett* in early-nineteenth-century New Orleans (in Kongo Square) and in an old maroon settlement, San Basilio, inland from Cartagena in Colombia, where I heard them played beautifully in 1994. The gifted *costumbrista* painter Rugendas showed African *sansi* players perambulating in the streets of Rio in the first half of the nineteenth century.

There is a saying in Kongo: "To play *sansi* is to take care of your people" (*Sika sansi i mu sansa ndonga*). Who knows if a wandering colonialist mistook the verb (*sansa*) for the noun (*sansi),* thus creating another well-known misnomer for this instrument—*sansa.*

In any event, *sansi* continued as *mar'mbula* in Cuba, where the object was more than a musical instrument. We know of a gifted *palero* (a priest in the creolized Kongo religion of Cuba) who, in the middle of the twentieth century, was playing a *mar'mbula* with spiritually named keys: bird (*núni*), skull (*konzóngolo*), and earth (*nsi*). Touching the bird key feathered his music with allusion to heaven. This mixed with horizon aspects when the earth key was sounded. Hitting the skull key called on the ancestors.

The musician was playing, as recorded sound, the basic ingredients of the *prenda,* the creolized form of Kongo *nkisi* (see page 69) which precisely bristles with feathers, earths, and sometimes skulls. The musician, outwardly "musicking," was inwardly tracing a line from God to the ancestors. The ideal gist of his musical message: here I am, between two worlds, blending their powers for community.

In the same religion, the players of protoconga drums (*bangoma*) often tied wrist-rattles to their hands. As they drummed, parallel vibrations sounded. Meaning: behind our sounds there are halos of being, musical notes italicized with spirit.

Similarly, a black carver at Itanhaém, on the coast of Brazil just south of Santos, fashioned in the eighteenth century a skull-like head at the top of his "slave violin" (*rabeca de escravo*). Kongo / Angola slaving was heavy in Itanhaém, so I took a photograph of the object (above) to Kongo, where a traditional leader felt that the carver was saying that music is a power, present in the living human body. In other words, this violin with head and torso (the pegs read powerfully as ribs) symbolizes the life of the spirit in the patterning of sound. The artist had combined what was new (a Portuguese fiddle) with what was always known (tradition).

That African visual presence in the Americas often links up with the spirit prepares us for today's ever-widening horizons of influence. Spirit does not date. Spirit needs no visa. Herskovits published a map in the late 1950s showing the western marches of what we call Afro-Atlantis. Afro-Atlantis is a world of migrations. The first two were forced—the Atlantic Trade and the repatriation of captive Africans to Sierra Leone and Halifax and elsewhere—but the rest were independent acts of initiative, hence Caribbean London, hence Caribbean Paris, hence Caribbean Amsterdam. As John Szwed has pointed out, the erstwhile colonized now colonize the capitals of their former masters. Essentially Herskovits's chart ran from the United States to Porto Alegre in the south of Brazil. Today the map is larger. There are hundreds of African-influenced Umbanda centers in Argentina; in 1980 there were none. Candomblé nagó also flourishes in Buenos Aires, as documented by the anthropologist Alejandro Frigerio. Argentine Umbanda pushes continuously south. Candomblé (opposite left and page 38) booms in Brazil and so does *lando* music in Peru. Meanwhile, in the far north, there is a tradition of Afro-basketeering among persons of African descent in Halifax, Nova Scotia, and reports of Kongo- and other African-influenced burial traditions in the western provinces, notably Alberta, to which blacks once fled from the United States in search of freedom and a better life.

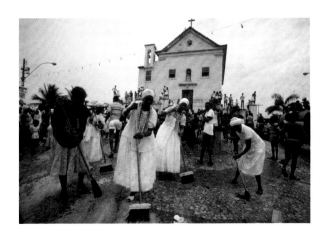

I end these remarks with further treasures of Atlantic continuity. But migrations were by no means limited to this ocean. In the movie *Topkapi*, black descendants of the Mediterranean slave trade fleetingly appear in a shot of Istanbul. As to Afro-Balkan visual history, refer to a charming article, published in *Man* in November 1958, by Alexander Lopashich, who served as curator of the Nigerian Museum Lagos in 1961–62. It includes his 1956 photograph of seven black men in Ulcinj, on the southern coast of Montenegro in Yugoslavia, and one example of their architecture. They lived among Albanians. Their ancestors were African.

The potent areas of Afro-Atlantis include Spain and Portugal. In the spring of 711, an army seven thousand strong, largely Berber, crossed the Straits of Gibraltar. From 711 to 1492, the south of Spain was Islamic. Moors left indelible traces in music. Witness heel stamping (*taconeo*), finger snapping (*pito*), and sharp handclapping patterns (*palmada*). Witness the strong syncopation.

The rural settlers of Argentina, many of whom were of Andalusian descent, continued these traditions, especially *taconeo*. Their percussion culture, colliding in Buenos Aires with Kongo and Mahi percussion, plus the beat of the Afro-Cuban *habanera,* brought to the city by Afro-Cuban sailors, lit the fuse of a cultural explosion. When the smoke cleared, *milonga* and tango had emerged.

Meanwhile, across the river, many blacks in the barrio Sur of Montevideo lived in Andalusian-influenced houses, originally built by whites. Many of these houses had flat terraced roofs (*azoteas*). In them they danced the *tango-habanera* on mosaic-tile floors of Moorish influence. Lima has Moorish-influenced architecture, too, a pendant to its lively Kongo nightlife, the music of the *peñas*. Here in barrios like Barranco, Afro-Peruvians make percussion with special boxes, cognate with the polished wood containers of the *rumba de cajón* in Cuba.

The art history of Mahi, the territory to the north of Dahomey, calls for comparison with the visual culture of the Mahi-Dohomean side of Vodun. Already Karen McCarthy Brown, the famous expert on Haiti, has trekked to Mahi. Dana Rush will be there soon. Suzanne Blier knows Agbomey cold. Expect new links and perspectives.

There is a wealth of Fon-influenced visual material in Cuba and Haiti—Arará and Rada art—waiting to be united with its spiritual heartland. The small gongs (*gan*) of Mahi have long since become the metal *ogan* of Haiti. Mahi basket-rattles (*assan*) return as the famed *asson* rattle held in the hands of *mambos* in the peristyles of Vodun.

Meanwhile, among the followers of the Fon-oriented Regla de Arará in Matanzas there is an amazing song, *Ago Mado,* which praises the redoubtable "smallpox diety" Sakpata, but under creolized names like Aso Yanya. The

Charo Oquet
The Two Queens—Elizabeth I and Yemayá, 1997
Acrylic on canvas
48 × 56 inches (121.9 × 142.2 cm)
Private collection, New Haven

song begs him to spare us of "the wounds" (*sasa*), updated to KS in AIDS. *"Kweyi Sogbo, Kweyi Olisa,"* they sing in Matanzas, "Come Sogbo, come Olisa," purify space, take away anything dangerous or contagious.

A Janus syndrome rules in the religious art of Ejagham (see page 71), particularly Ngbe, on the southernmost border of Cameroon and Nigeria. So it is not surprising that the famous Janus-drum, the *bongó,* emerged in Cuba, where Ejagham influence is strong. In fact the Ejagham term for the feminine force, in Ngbe, *ebongó,* almost certainly links up with the name of the Afro-Cuban instrument. On both sides of the Atlantic, Ngbe and Abakuá, the world is blessed by the messengers of God, *idem* in Calabar, *'reme* in Havana. They twirl and posture in their costumes blazing with myriad ideograms. Take heart, they mime. The truth, God's sound, backs our action. *We* move in silence. *He* speaks through cloth. He is walking in your midst.

When the Muñequitos de Matanzas, the famed Afro-Cuban rumba ensemble, sing *Baba mo dupe,* they are singing in Lucum' (creolized Yoruba) *el más viejo*ó to an ultimate ancestor: "Thank you for the whole experience of this life." And when the late and great mambo vocalist Tito Rodríguez sang the intense *palo* lyrics of Justi Barret-to's *Chenchere ngmoa* (roughly, "How beautiful our Kongo

drums are, how fine smelling like fresh pine"), he greeted the spirit with "good evening"—in the middle of the day. He was singing the Kongo cosmogram in New York in 1952. Because if it's day in our world, it's night in the world of ancestors. Greet them in terms of their time zone.

In addition, open one's *nkisi* to the spirits in the sky, so it drinks of their starlight, direct from the edge of cosmos. Mystic communication, a *palero* told me, happens faster in the night, like the streak of a meteorite.

If the surge of Latino music in the 1950s—and again in the 1990s—brought us all this lore, imagine what will happen in the aughts, the decade that begins the new century.

Meanwhile, the word *navigators,* the makers of rap like Wu-Tang Clan, are mapping the far reaches of Afro-Atlantis as fast as they can. And so are the dancers of North London, blending the panache of the Nicholas Brothers with b-boyin' and boogie. They dance hard and fast, shaping the style of the Beatles of mambo, Snowboy and the Latin Section.

Taught to think cosmographically, masters of Afro-Atlantic creativity provide their own antidotes to an age of great danger. Charo Oquet, woman artist of the Dominican Republic, now working in one of the capitals of Afro-Atlantis, Miami, painted Yemayá and Queen

Left
**Aníbal Vásquez performing
mambo step, the "Perfecta"**
New York, 1959

Above
**Lou Bega performing at the
Arena in San José, California**
February 5, 2000
Courtesy Getty Images

Elizabeth together, emerging from the waters, utterly equal (opposite). She put hearts around them. This is the work of a woman, the gender of peace.

Max Lerner wrote in 1957, "In the organic fusion of popular dance and music Americans reach closer to a mass exaltation and a native idiom of religious feeling than in any other aspect of their lives." This remains true at the edge of the century. Lerner spoke of mambo and jazz dance (see above). Today the scene is dazzlingly richer, with incoming Dominicans, Senegalese, Colombians, Haitians, Brazilians, Puerto Ricans, Ethiopians, Mexicans, Guyanese, and Jamaicans. God grant that musical fusion prevails over fission and that the world wakes up the message at the heart of the art of Afro-Atlantis: when you treat everyone equal, the world opens up. Somebody calls, you get a chance to respond. *Bilolo!*

This article first appeared in African Arts *32, 4 (Winter 1999), pp. 1, 4, 6, 8. The text is reproduced here as published except for minimal restyling.*

An Interview with Ishmael Reed

Franklin Sirmans

*Reed is among the most American of American writers, if by "American"
we mean a quality defined by its indefinability and its perpetual
transformations as new ideas, influences and traditions enter our
cultural conversation.*
—Joel Brouwer[1]

Ishmael Reed, one of America's leading literary figures, has written nine
novels and seven plays. He is also a poet, essayist, publisher, editor of
numerous anthologies, television producer and commentator, activist,
teacher, and lecturer. Born in Chattanooga, Tennessee, in 1938, Reed grew up
in Buffalo, New York. In 1995 the University of Buffalo, which he attended
between 1956 and 1961, awarded Reed an honorary doctorate. Moving to
New York's Greenwich Village in 1962, he became part of its avant-garde arts
scene. He cofounded The East Village Other (1965–72), known as "the mother
of underground newspapers." His first novel, *The Freelance Pallbearers*,
appeared in 1967, thanks to poet Langston Hughes, who brought it to the
attention of Doubleday and Co. (Garden City, N.Y.). In 1972 Doubleday
published what is perhaps his most influential novel, the highly experimen-
tal *Mumbo Jumbo*; that year two earlier poems, his important "Neo-HooDoo
Manifesto" and "Neo-HooDoo Aesthetic," were included in Reed's first
poetry collection, *Conjure: Selected Poems 1963–1970* (Amherst: University
of Massachusetts Press). The New York Times named Reed's *New and
Collected Poems, 1964–2006* (Berkeley, Calif.: Carroll and Graf) one of the
four best books of poetry of 2006. A collection of his essays, *Mixing It Up:
Taking on the Media Bullies and Other Reflections* (New York: Da Capo Press),
will appear this year. He collaborated with composers and musicians to
produce CDs, including *Conjure: Music for the Texts of Ishmael Reed* (1984).
Reed lives and works in Oakland, California.

This interview was conducted on October 15 and 16, 2007, in Oakland,
California.

Franklin Sirmans: You grew up in Buffalo, and moved to New York in 1962. Shortly after that you joined the literary group Umbra, founded by Tom Dent from New Orleans, David Henderson from Harlem, and Calvin Hernton who, like you, was originally from Chattanooga. Umbra became an integral part of the Black Arts Movement in New York. How did that happen? How did you hook up with those guys?

Ishmael Reed: I had been writing short stories in college and afterward, so in New York I looked for writers. Umbra was already established. I think they were on the Lower East Side by the late 1950s, but they formed their workshop around 1962. I heard about it in 1963. I was curious, and attended a meeting. Before that, there was something else, too, called the Young Men's Club, with Steve Cannon, Amiri Baraka (then known as LeRoi Jones), and some others. An African American community of writers, musicians, and painters was there, below 14th Street.

Sirmans: So it was sort of a natural progression for you, being a young writer and entering a scene in the making. Where did you live, and how did you support yourself?

Reed: Initially I lived in a rooming house on St. Marks Place, for $8 a week. Then I found an apartment on East 6th Street. That was when I attended Umbra meetings. I had all these odd little jobs, in hospitals and in a factory and doing market research. I even worked as a clerk in an unemployment office; when I was laid off, I would get paid unemployment! When I became a published author, I moved to the next street, the fancy block on St. Marks between First and Second Avenues. I lived in a brownstone with a garden in the back; my next-door neighbor was W. H. Auden, who, of all the modernist poets, influenced me most.

Sirmans: What was that like? What were you reading?

Reed: Oh, I was reading and writing and meeting well-known authors, artists, and musicians like Langston Hughes, Norman Mailer, Amiri Baraka, F. M. Esfandiary, Ralph Ellison, James Baldwin, Bob Thompson, Gerald Jackson, Sun Ra, Albert Ayler, and Cecil Taylor. Gloria Oden was very helpful to me. As was Jakov Lind, who influenced me a lot. He was a Surrealist, a Jew who lived in Germany throughout the Nazi period.

Sirmans: Was Hoodoo something all of you talked about?

Reed: No, but my mother, Thelma V. Reed, wrote a book, which I published in 2003—*Black Girl from Tannery Flats*—in which she discussed in detail a Hoodoo thing in her family. According to her, some woman put a hex on her mother that sent her to an institution. Her father, Mack Hopkins, was murdered by a white man; such was the value of black men in the 1930s that I can't locate records of the inquest. At the Erlanger Hospital in Chattanooga, my mother found her father lying unattended on a cot in a hall. A nurse said, "Let that nigger die." And sure enough, the death certificate, which I have, states that he bled to death. I couldn't make out the signature of the doctor, but when I have the time, I'll explore this further. So my mother became head of her family at age twelve. With that in my family history, of course, I was going to be interested in this thing called Hoodoo— a system that had to be hidden—because it was a force that united African captives. Conjure men played roles in key slave revolts in North and South America and in the Caribbean.

While Vodun could be a positive, regenerative force in other countries, here it became an instrument of revenge. People would say, "Don't put your hair in the garbage can." Hair, fingernails, and other body leavings could be used by a conjurer to harm someone. So my first impression of Hoodoo was that it was a negative force. It was only through research that I discovered it

Ishmael Reed, *Mumbo Jumbo*
(Garden City, N.Y.: Doubleday
and Co., 1972)

asks Judas to identify Jesus with a kiss, he kisses every-one on stage because they are possessed by the Orisha Jesus.

Sirmans: So, Hoodoo was something that was just there, around you, a part of growing up.

Reed: Something that I was curious about. I was interested in Vodun, and I wrote the "Neo-HooDoo Manifesto." But obviously I was also influenced by the Surrealists and the modernists, who also wrote manifestos.

Sirmans: Did you grow up going to church?

Reed: We went to church every week. Unlike that of white churches, our service involved possession. People would "get happy." I was once on a panel with some Ellisonians [followers of the African American writer Ralph Ellison]; they believe that blacks are Westerners, whatever that means, and I pointed to Martin Luther King's preaching techniques—call and response techniques that are obviously African derived.

Sirmans: *Mumbo Jumbo*, "Neo-HooDoo Manifesto," and "Neo-HooDoo Aesthetic" all appeared within a few years of one another.

Reed: Actually, "Neo-HooDoo Manifesto" first appeared in 1969 in the *Los Angeles Free Press.* "Neo-HooDoo Aesthetic" was published in 1971 in Addison Gayle Jr.'s *The Black Aesthetic,* and *Mumbo Jumbo* came out in 1972.

Sirmans: What, besides your mother's experience, precipitated these writings?

Reed: I came to use NeoHooDoo, which has a history in painting and literature, including magic-realist stories from folklore, including references to "two-headed men,"

to be a faith that, at its essence, involves possession. A *loa* (or spirit) can actually enter people and take control of their bodies. In the black Christian church, it becomes known as the Holy Ghost. Throughout the Caribbean and South America, it is called Vodun, Santería, Macumba, Candomblé. Whatever you call it, all of these African-derived forces are able to absorb.

I'm listening to a lot of gospel these days and have found some references to African religion hidden beneath some of the Christian phrases, such as the "Holy Ghost entering the room," or "Jesus is buried in my soul." Unlike Christianity, where one can never be a god, but rather, more often resemble a miserable insect (think about how Jonathan Edwards talked to worshippers in his sermons[2]),in Vodun, a *loa*, which can also be understood as a saint, exists within. My former Yoruba teacher, Ade Armoloran, says that it was easy to convert Africans to Christianity because Jesus sounds like the Orisha Eshu (one of the most important Yoruba deities). Both are crossroads figures; both say, "I am the way." In fact, in my Gospera *Gethsemane Park*, Jesus becomes a saint, or *loa*,who possesses the poor: he identifies himself [in Matthew 25] as "the least of these." Critics were completely baffled by the fact that in the piece there was no physical Jesus, like Charlton Heston or somebody. Instead, when Beelzebub, disguised as a Roman soldier,

Ishmael Reed at St. Louis
#2 Cemetery, New Orleans, 1971
Courtesy Ishmael Reed

conjure men and women, and so forth, because I was part of a movement whose aim was to use non-Western resources in our work.

Sirmans: You are often discussed within the confines of the Black Arts Movement in the late 1960s. Can you talk more about that?

Reed: The Black Arts Movement was responsible for many African Americans becoming interested in reading and writing.

Sirmans: Your writing and teaching careers over the last twenty years are identified with Berkeley and Oakland, California. When did you move to the West Coast?

Reed: I had gone out to Los Angeles in 1967 and then moved to Berkeley in the fall, because I knew I wanted to write a second novel and New York is too tempting, too distracting. I didn't want to fall into the trap of having produced only one novel. In New York, you could write one novel and then just party every night for the rest of your life. I know people who've done that. Nonetheless, I moved back to the city for the summer of 1969; but I settled permanently in California in 1970. I continue to visit New York on business about three or four times a year.

Sirmans: Your first novel, *The Freelance Pallbearers*, of 1967, is very much a satire biting at the traditions of Western European culture and religion; were you already heavily into thinking about Hoodoo?

Reed: I was struck by a painting by Joe Overstreet, a diagram, abstract geometric shapes [see page 79]. I remember asking Joe, "What are those?" They are called Ve Ve, and they've been described as landing strips for *loas*. This influenced my belief that there is a system much more complicated than the information provided

by tourist books I was reading about Voodoo in New Orleans. This led me to the study of books about Haitian Vodun and ultimately, Yoruba religion. I began to study the Yoruba language in 1991. I read books written by Haitians long before I had read Zora Neale Hurston [*Hoodoo in America*, 1931] and Maya Deren [*Divine Horsemen: The Living Gods of Haiti*, 1953].

I just got really interested in the idea of Hoodoo as an aesthetic, so even though in future works I abandoned obvious references to African religion, I continued with the abstractions and the aesthetics of the form. And you know how people would take different elements from different cultures and combine them? Well, that's what I have been doing in my work. For example, my novel *Japanese by Spring* [New York: Atheneum, 1993] includes Japanese and Yoruba.

Reading about Vodun helped me see how Hollywood despised and stereotyped it. I had to investigate it because I wanted to understand why there was such resentment and fear, like in the movie *I Walked with a Zombie* [1943] and all that Bela Lugosi *Voodoo Man* [1944] stuff. I wanted to challenge its image in popular culture.

Sirmans: When I encountered *Mumbo Jumbo* for the first time, I was immediately struck by the feel you have

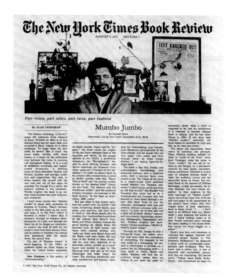

New York Times review of Ishmael Reed's *Mumbo Jumbo*, August 6, 1972. Courtesy Doubleday Broadway Publishing Group

for the visual. In the book, you mention a painting in a cathedral and then a photograph of the cathedral, evoking a kind of double image. And, as you say, you knew artists like Steve Cannon and Joe Overstreet.[3] I am curious about the extent to which you were involved with visual art.

Reed: Well, I hung out with collagists like Walt Bowart and Aldo Tambelinni, who were my collaborators. And I went to art galleries with people like Overstreet and Art Bevacqua, an Italian American artist. They taught me to look at painting the way a painter does. In *Mumbo Jumbo*, I used pictures and graphics as complements to the text, intermingling them to create a different form of storytelling. I always try to vary how I tell stories. I'm doing cartoons for the O. J. Simpson novel I'm currently working on, and I'm playing the piano. I have a CD out with the Ishmael Reed Quintet.[4] (Why theorize about the Jazz Aesthetic when you can be doing it?) You have to be interested in every possible way to tell a story. You have to do a full-court press. If you don't, you won't get through. So, if they—not just whites but blacks as well—are going to block you in one medium, you have to find another way to work. For example, I can turn to the stage. My play *Body Parts* ran in 2007 at the Nuyorican Poet's Café in New York. Among its themes is the historical exploitation of black people by the psychiatric

profession, which uses black patients to test new drugs; but the play also takes on blacks working for white-wing ideas and think tanks. The *New York Times* called my play "angry." Black male writers have been described as "angry" or as "men with a chip on their shoulder," for over one hundred years, so this is nothing new. What I do is take my anger to the stage. If I can't do that, I write a song, a novel, an essay, etc.

Sirmans: So you consciously worked against the grain, trying to push new forms, thinking about magic realism. I'm remembering reading that you once talked about being around musicians like the innovative composer and philosopher Sun Ra and that you said, "I could not have written a traditional novel."

Reed: Of course. Most of the novels we read in this country have the same form. One of my mentors, Brion Gysin, who taught William Burroughs the cut-up method of writing, applying painters' techniques to writing, said, "Writing is fifty years behind painting."[5] That's still true. So there's been a backlash toward the kind of novel I write. Now black and white critics alike are attempting to push us aesthetically back in time, to refried Faulkner. They're trying to erase all the innovations of the 1960s. Current plays resemble the old social-realist theater of the 1930s, which at least took on capitalism. In these plays, the black man is the foil to the delight of liberal audiences and white male critics.

A lot of young African Americans read my work, you know, hip-hoppers read my work. Tupac read my work. He quoted me in his song "Still I Rise," so you know, I'm hip, I try to keep up.

Sirmans: Speaking of popular culture and, in particular, the music of youth culture, in "Neo-HooDoo Manifesto," you said, "The Beatles failed to realize they were conjuring the music and ritual of a forgotten faith."[6]

Reed: Most of what we call popular music is based on African religion. The mambo, the rumba: all came out of those clubs in Cuba, but they had to be secularized so they could get past the censors, the bigots. So we have always had to use camouflage, like in the Blues, and double entendres. Gospel music is just a front for Vodun. Some popular dance and music—especially from Cuba, Puerto Rico, Haiti, and Brazil—includes Yoruba elements and references to West African *loas*: Shango. Ogun. Yemaja. In the United States, a protestantism, religion that sees other religions as satanic, forced African religion underground. Even in Louisiana, where it wasn't totally submerged. It survived as a result of Haitians who migrated there after the overthrow of the French in Haiti. But in other parts of the South, where Protestantism has been a force, it had to be coded just as language had to be coded.

Take, for example, the snake as a symbol. I just did a piece on Mark Twain's *Adventures of Huckleberry Finn*. Jim wants to meet Huckleberry. This escaped African American slave comes up to Huckleberry and says that there's a nest of moccasins "down there" that he ought to see, which signals that Jim would wait at a certain place to meet with him. And the snake is coded in religion as well. It occurred to me, after viewing a Vodun show in Paris, that the John the Conqueror root, which looks like a serpent, represents Damballah.[7]

With the migration of Caribbean people to the States, some African forms are being transmitted here. For example, there's a Yoruba entity called Iku who wears a top hat; the enforcer, he exists between heaven and earth, according to Yoruba storytelling traditions as transcribed by the great Nigerian writer D. O. Fagunwa. Iku metes out punishment on behalf of Olorun. This figure appears in Haiti as Baron Samedi, and now the Haitians have brought this figure to Miami, and before you know it, he appears in Brooklyn as Ghede. In Brooklyn they have a Ghede celebration!

Joe Overstreet
Hoo Doo Mandala, 1970
Acrylic on canvas with rope
90 × 91 inches (228.6 × 231.1 cm)
Collection of the artist
Courtesy Menil Archives
The Menil Collection, Houston

Sirmans: I guess it goes back to what you have said about the commingling of religion and art: "Every man is an artist and every artist a priest." This invocation of spirituality as it pertains to the act of creativity is something that I think the artists in this exhibition do with their work.

Reed: Well, it is very important to point out that talent is common, and access to the spirit doesn't cost anything. Auden said that he wrote poetry during high holy days of the spirit. At a writers' conference in Miami, a panel of white guys from New York were trying to divide the Cubans from the African Americans. I pointed out that white Cubans have something called African Religion Day, when they invoke Yoruba entities.

Sirmans: With so many different cultures in this country adopting one anothers' traditions, has your definition of NeoHooDoo changed in the last thirty years?

Reed: I'm not as esoteric about it as I used to be. After studying the Yoruba language, I think I've been able to distill that part of African religion that's useful to me. There's a parable in which a traveler visits a strange country and can't trust his *loas*. He can only depend on his mind. His mind is the *loa*. And so one has to feed the mind the way that followers of other *loas* offer drink, food, etc. The mind is the Ori, or the spiritual intuition that brings inner peace. If one doesn't feed it, one suffers ignorance, which might be the greatest curse of all. Moreover, the Yoruba religion practiced in this hemisphere is very absorptive. It can blend in with Hindu, Christianity, and other religions. It is unifying and the closest to what is a universal religion.

 I deal with Vodun in the libretto for my Gospera *Gethsemane Park*, which uses African religion to interpret the scripture. In this version, Lazarus complains about being brought back from the dead, and Judas is a hero. Jesus is an *orisha*, not a god. He is the patron of the poor and downtrodden. As a Brazilian temple mother said when an intolerant Catholic bishop attacked her faith, "All roads lead to God." Such is the power of African religion in Brazil that this bishop was charged with religious intolerance.

Sirmans: So, is NeoHooDoo about being conscious, about the ability to look at our situations personally and universally?

Reed: In art what I refer to as NeoHooDoo means that one can use a variety of materials the way that the artist Betye Saar does—modes of expression and allusions from many different cultures, both popular and traditional. Africans in America had few resources and had to make do with what was available. That's NeoHooDoo in a nutshell.

NOTES

1 Joel Brouwer, "A Cowboy in the Boat of Ra," *New York Times*,
 July 2, 2006, http://www.nytimes.com/2006/07/02/books/
 review/02brouwer.html.

2 The early eighteenth-century American theologian Jonathan
 Edwards was a fire-and-brimstone Congregational minis-
 ter infamous for his terrifying sermons about God's wrath
 against sinners.

3 Both Cannon and Overstreet have participated in Menil
 Foundation projects: Cannon contributed an essay to the
 catalogue for the 1971 exhibition "The De Luxe Show,"
 held at The De Luxe Theater in Houston's Fifth Ward, and in
 1972 Overstreet's work was shown at Houston's Institute for
 the Arts at Rice University in "Joe Overstreet."

4 The Ishmael Reed Quintet, *For All We Know*, Konch Records,
 © Ishmael Reed Publishing Company, 2007, compact disc.

5 Quoted in *Brion Gysin: Tuning in to the Multimedia Age*, ed. José
 Férez Kuri (London: Thames & Hudson, 2003), p. 153. Artist,
 writer, and poet Gysin, who for a while was associated with
 the Surrealists in Paris, discovered the power of scrambling
 words in order to create new sequences and meanings.

6 Ishmael Reed, "Neo-HooDoo Manifesto," in idem, *Conjure:
 Selected Poems 1963–1970* (Amherst: University of
 Massachusetts Press, 1972), p. 23.

7 John the Conqueror root is rubbed to create magic spells,
 and Damballah is a *loa* associated with snakes.

An Art of Lost Faith

Quincy Troupe

For Robert Farris Thompson, Maya Deren, & Ishmael Reed

1. Beginnings: A Place of Silence

in a place beyond our knowing silence reigns, darkness,
perhaps some light, echoes, in this vast space,
perhaps it is a never-world, an ether-world of maybe,
if spirits among us know what It is they have never spoken,
perhaps shadows have, over/underground, in some invisible space,
surrounded by air, water, where spirits of creation exist,
swimming or zooming around outside our comprehension,
a place where only imagination through prayer, can, maybe, take us,
to a road, perhaps a passageway stretching long & far, deep into
the past, perhaps a doorway leading to nowhere, or what,
nobody knows, only silence, maybe, knows the language echoes speak
in this vast place beyond our knowing, are bones, teeth, hair, ribcages,
skulls, toes, fingers there, are maggots there, too,
do they speak some kind of music in this beyond world,
do they understand silence, the twilight world of myth, the memory
of water, earth, sky, wind, the memory of fire, earthquakes, thunder,
the memory of storms, lightning, ice, the memory of creation,
birth, death, the memory of everything here & gone, everywhere
a mystery, is what we know is certain, an idea of something
without shape or form, pulsating with what we know is power,
It is a metaphysical presence, a blessing with what we know
is the ability to heal & destroy this space we live in
only by Its invitation, sanction, only by Its blessing,
this place we've been born into with so much amnesia

2. Looking through the Mist toward Africa

in the beginning was a sound, a crack of light, a fissure
in the sky, earth, perhaps from which a resonance of air

echoed, perhaps something like a note, a sudden
wind moving toward expression, a beginning, a seed of language,
perhaps a hum, a grunt moving toward something clearer, maybe
a voice, which became visible later as a stroke of whatever was needed
then, perhaps some kind of music beating like a heart
in time with a first act of gesture, imitating a shaking
in the ground, something close to a rhythm, maybe
a grain of language, something, like a word, perhaps a growl, something
the ears of earth, air & sky might hear & know what was coming was
a kind of improvisation, a phenomenal act of creation,
perhaps shadows in a garden, under what we know now are iroko trees,
moving like what we know now is the way humans would, fusing,
in a beautiful rhythm there, undulating, coming together,
moving apart, in an act of expression we know now as joy,
perhaps love, a feeling of ecstasy, an act of vital conception,
invention, making, in fact, an act of copulation
in the holy **Yoruba** city of *Ile-Ile,* where Olorun, god of the skies,
the vital force, neither male or female, but the ultimate embodiment
of *ashe*, spiritual command, the power-to-make-things-happen,
slithered down from the sky in the form of a royal python snake,
bringing with it *Eshu, Ifa, Ogun, Yemoja, Oshun, Oshoosi, Obaluaiye,*
Nawa Bukuu, Shango, Obatala, Orisha, Oko, Egungun,

the power to give life, take life away, *ashe, ashe, ashe,*
according to the purpose, is the embodiment of spiritual command,
the nature of spirit, *ashe* as an earthworm, a white snail,
a woodpecker, a gaboon viper, *ashe* in the form of a royal python snake,
ashe represented by iron staffs, long-beaked birds,
iron sculptures of serpents in the form of kings, chiefs,
wise old women who come in the form of birds,
sacred beads on the crowns of kings hang down from their masks,
cover their faces during times of prophecy
ritualized in moments of possession, *ashe, ashe, ashe,*

the vital force in these spirits who watch us through spiritual eyes,
who have the power to give life, take life away, *ashe, ashe, ashe,*
can be seen, too, as an act of great artistic expression with sacred force,
ashe on an old ceramic bowl depicted as thunder god Shango,
represented in images of meandering patterns of pythons,
gaboon vipers moving through sand,
lightning zigzagging through space, unzipping the air of the sky
above an iroko tree, its trunk tied with white cloth as an offering,
semen at its base, drops of blood sprinkled around, too,
is a gift to the gods, as a person dressed in red is *ashe,*
then everything was lost in a sandstorm of confusion, tribal rivalries,
blood spilling reduced to ashes civilizations of prophecy,
divinations began to lose images of faith after **Europeans** arrived
with greed in their eyes, storming off ships with guns spitting fire,
carried away priests, their faith across the middle-passage,
dropped them in an unknown new world, these chained holy men
whispering under their breath, *ashe, ashe, ashe,*
the rhythms of talking drums reduced to memory, *ashe, ashe, ashe,*
then kaboom, lightning, gunfire, *ashe e e e.......* then silence

3. Haiti and the New World

many priests died during the **atlantic** middle-passage, shot, whipped
dead, their bodies thrown to sharks in boiling salt water,
when survivors arrived in the new world *ashe* was a changed memory
under their breaths, rhythms of talking drums became petro beats,
gods changed, too, transformed through language
when **African** prayer fused with **Indian**, **French** & **Spanish** ones,
ashe became new animating forces, divinities, *loas,* hougans—priests—
holding powers of the soul, spirit, psyche, self, voodoo avatars of the old way
transformed into new ways of bringing down the spirit,

in the **Haitian** world all manner of tribes, races, metamorphosed into **creole**
culture, language, music, faith, old drum rhythms found new accents,
added them to their ancient rhythms, these measures fused into new tempos,
created different rhythmic voicing when *ashe* rituals married
new world time-signatures, congo rhythms became petro beats,
became music/dance of rara, compas, rada songs from **Dahomey**,
visual arts were expressed in voodoo flags, poetic rituals of *ashe* married
new world Catholic, indigenous **Indian** religious mantras

& the dead began serving the living, not the other way round,
ritual became reclamation of the soul, rebirth, everything transformed,
Olorun became *Bondieu, Eshu-Elegba Papa Legba, Ogun Papa Ogun,*
Shango Chango, Oshun Erzulie, Oshumare Dambala-Ayida, Orishanla
Lissa, veves invoked *loas* who retained supremacy of the vital force
of spiritual command, the power-to-make-things-happen,
to bestow life & take life away through possession

4. The Artists

the art of a lost faith is not lost when reinterpreted,
is everything the griots & shamans know to be real on earth,
surrounded by air, is phenomenological,
voodoo transformed to neohoodoo here, transplanted in the new world
space, magic fusing blues, jazz, salsa with rhumba, compas with zouk,
gospel with faith of the old world,
american fusion became iconography rooted in the new & the old,
transmogrification, where a green circle is a ring
of empty glass wine bottles with a hole
in the center of a basketball hoop, is a higher goal next to a tree trunk,
natives carrying guns, words on safari, a bible, things that drag
towards a halo, a hummer pyramid, a red composition,

a sound suit echoing itself, four prototypes for the new
understanding, a luna guitar pony is food for spirits,
spiraling to the next cross of the sacred peace,
the first holy communion, moments before the end
is an act of no return, a logo for **america**,
a sand stone without skin, honoring **dr. king**, deep down
I don't believe in hymns, *mti*, she can't dream for herself,
a sculpture defined, is self transfer cycle, tears from son's son sons
eclipse, the capture of mary march, a next loin and/or, ship
and keys to the house **frank lloyd wright** built,
anti-**brancusi**, a super-8 color silent film from **cuba**,
a poison stand, removing footprints, social purity,
a detail from the **hampton** project, rubber tires, metal,
wood, crystal, a jewelry case, a **victorian** form,
mlle. bourgeoise noire, the act of no return,
st. john the baptist, atrabiliarios, a big still,
an american robin on the beam of the cross where
a headless jesus is nailed, a logo for **america**, perhaps,
a pathway to the future of a new neohoodoo art

5. My Solo

eye have come to this text to sing the gospel of neohoodoo,
the re-discovery of self in this new, cruel whirl
of dilettantes still seeking greed through senseless wars, who machine
gun down any spirit who can dance words across empty white pages,
who refuse to recognize any culture save their own as a vital force
in the world, who speak with forked tongues,
who think they know everything when their history is so short

& bloody, charlatans who raze the world with bombs, spitting bullets,
whose religion is greed, who cannot hear wisdom or music,
whose time is finally short, whose storehouse of stolen ideas is empty,
whose rag-tag culture of hoboes went up in flames like so much of the west,

we are here now, have been transformed through ressurrecting
memory of *ashe*, its drum rhythms synonymous with our own beating
hearts, we know the lost faith—now recovered—as our own
vital force, its syncopations reborn in *Voodoo/Santería/Candomblé/*
Neohoodoo in the new world,

we got high john the conqueroo in lines of our poetry, got mojo
hands guiding brushstrokes of our paintings, *Papa Ogun* in our sculpture,
Yoruba/petro rhythms infusing blues, spirituals, ragtime, jazz, gospel,
merengue, salsa, rhythm n blues, rhumba, tango, zouk,
soul, rock n roll & rap we move our feet & bodies to dance to
entranced with recovered rhythms of a lost faith, infused here
in art of a new world expression, our solos probe deep,
connects us to an ancestral faith we embrace here as our own
magic, mystery, power, grace, faith, is expressed through our hearts
as an ever evolving, powerful, neohoodoo expression, voiced
through priests like **james brown, miles davis & marie laveau,**
voiced through every man, woman viewing themselves as sacred,
artists, priests, innovators, improvisers of the spiritual body dance,

we move throughout the new whirl now as reborn ***ashe***—vital
force, we move through this time & space as sacred griots, thinkers,
create our new art rooted in the holy power of ***ashe***—vital force

PLATES

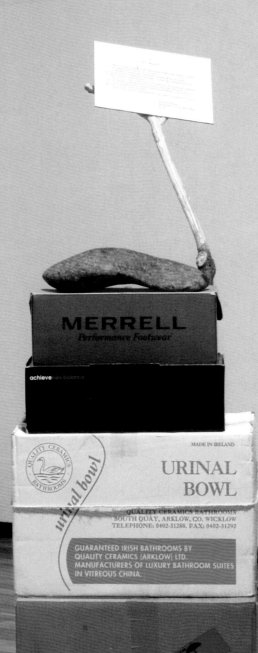

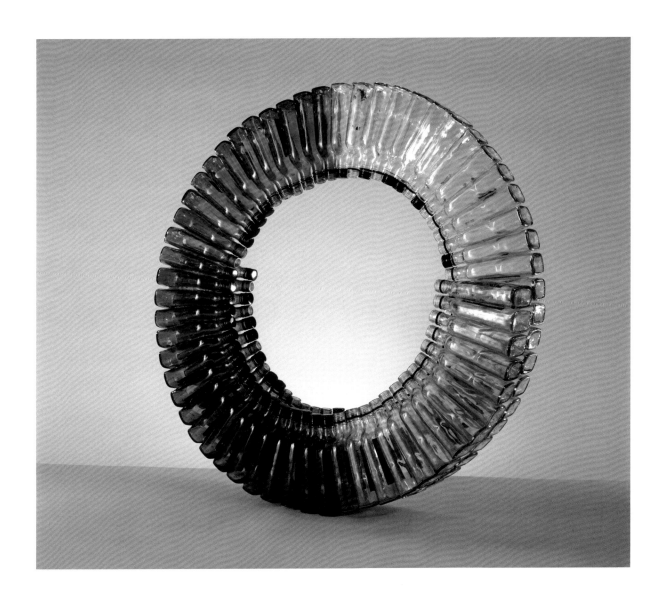

Opposite
Jimmie Durham
Anti-Brancusi, 2005
Cardboard, wood, serpentine stone, rope,
and text panel on paper
48 × 17 × 31 ⅛ inches (121.9 × 43 × 79 cm)
Installation view, Walter Phillips Gallery,
The Banff Centre, 2005
Courtesy of the artist and
Galerie Michel Rein, Paris

Above
David Hammons
Untitled, 1989
Glass wine bottles and silicone glue
37 ¼ × 37 ½ × 7 ¾ inches (94.6 × 95.3 × 19.7 cm)
Hirshhorn Museum and Sculpture Garden,
Smithsonian Institution, Washington D.C.,
Joseph H. Hirshhorn Purchase Fund, 1990

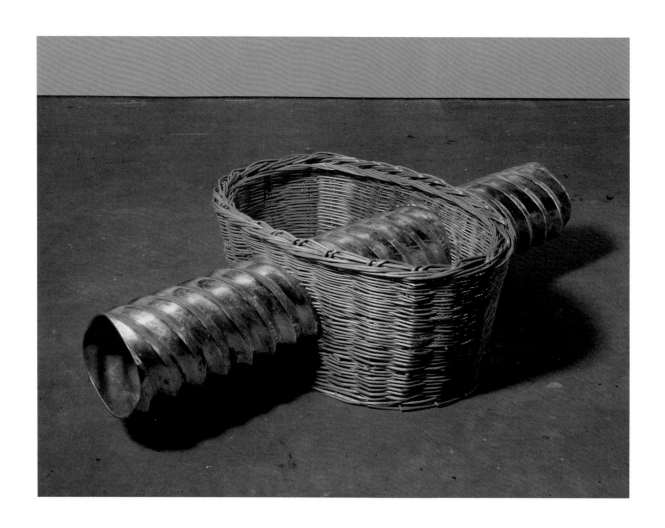

Robert Gober
Untitled, 1998–99
Willow and silver-plated bronze
19 ½ × 70 ½ × 41 ½ inches (49.5 × 179.1 × 105.4 cm)
The Solomon R. Guggenheim Museum,
New York, purchased with funds contributed
by the International Director's Council and
Executive Committee Members, 2000 (2000.113)

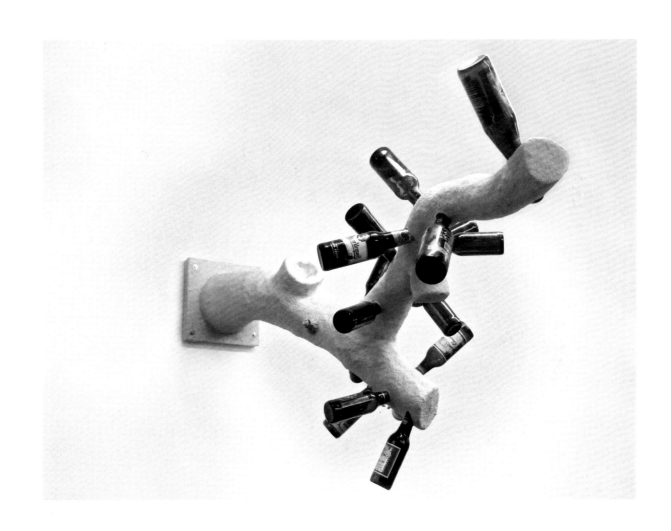

Gary Simmons
Model for *Not Yet Titled*
(from the Bottle Tree series), 2008
Bonded bronze and glass
24 × 74 × 32 inches (61 × 188 × 81.3 cm)
Courtesy of the artist and Metro Pictures,
New York

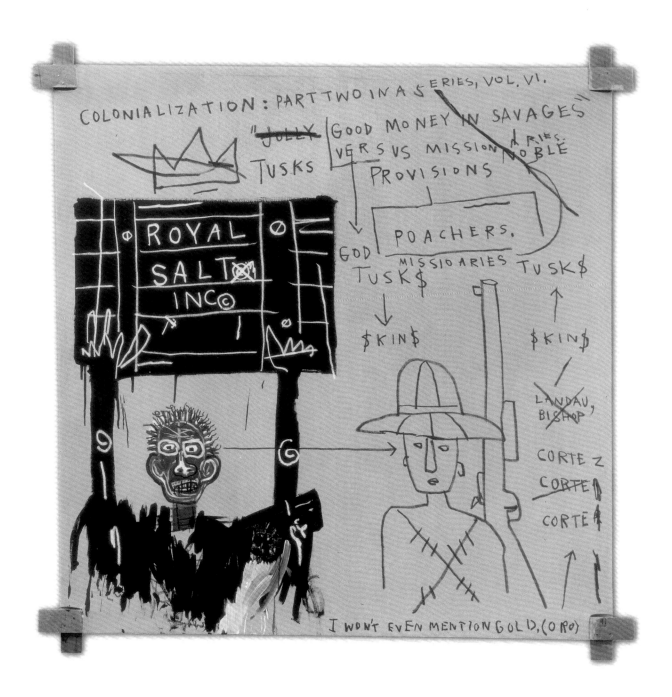

Opposite
James Lee Byars
The Halo, 1985
Gilded brass
Overall: diam. 86½ inches (219.7 cm)
brass ring: diam. 8 inches (20.3 cm)
The Menil Collection, Houston

Above
Jean-Michel Basquiat
Natives Carrying Some Guns, Bibles,
Amorites on Safari, 1982
Acrylic and oil on paper, mounted
on canvas, and exposed wood
72 × 72 inches (182.9 × 182.9 cm)
Collection of Hermes Trust
Courtesy of Francesco Pellizzi

Above
Tania Bruguera
Portraits: A Sound Installation
(detail), 2005–06
Wall text and sound
Dimensions variable
Installation view, Kunsthalle Wien,
Austria, 2006
Courtesy of the artist

Opposite
María Magdalena Campos-Pons
When I Am Not Here / Estoy Allá, 1997
Triptych
Polaroid Polacolor Pro 20 × 24 photographs
Ea. 24 × 20 inches (61 × 50.8 cm)
Courtesy Peg Alston / Peg Alston Fine Arts,
New York

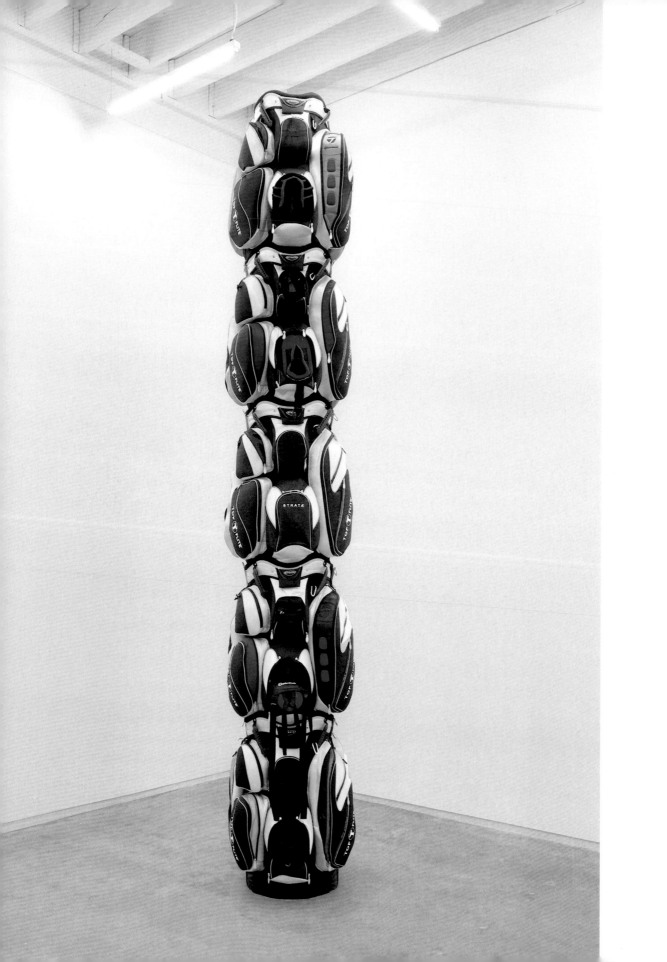

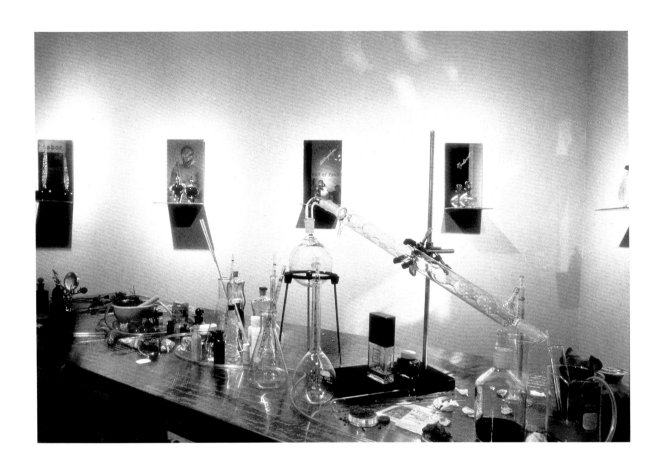

Above
Amalia Mesa-Bains
Perfume Laboratory: The Hall of Science
(detail), 2000
Mixed media
Dimensions variable
Installation view, "El Fin del Siglo:
The Latina World's Fair,"
Bernice Steinbaum Gallery, Miami, 2000
Collection of the artist

Opposite
Brian Jungen
1990, 2007
Golf bags and cardboard tube
154 × 30 × 25 inches (391.2 × 76.2 × 63.5 cm)
Sender Collection, New York
Courtesy Catriona Jeffries Gallery,
Vancouver

Above
William Cordova
*la casa que frank lloyd wright
hiso para atahualpa*, 2008
Ink, graphite, and tin on reclaimed paper
13 × 17 inches (33 × 43.2 cm)
Courtesy of the artist and Arndt & Partner,
Berlin

Opposite
Sanford Biggers
Eclipse, 2006
Painted wood, with two pedestals
Statues: ea. 20 × 3 inches (50.8 × 7.6 cm)
Courtesy of the artist and Mary Goldman Gallery,
Los Angeles

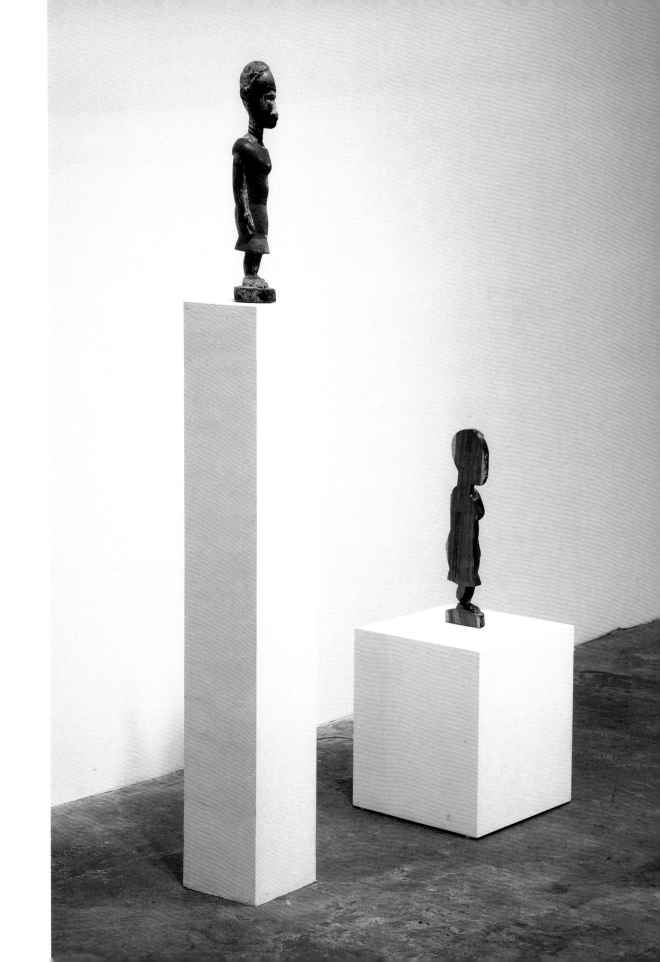

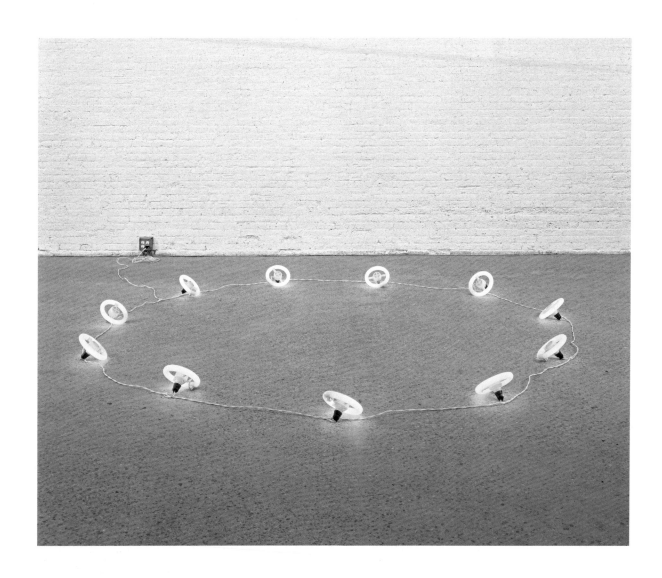

Above
Marepe (Marcos Reis Peixoto)
Auréolas (Halos), 2004
Bulbs, electric wire, and sockets
Diam. 127 inches (322.6 cm)
Courtesy of the artist, Anton Kern Gallery,
New York, and Galeria Luisa Strina,
São Paulo

Opposite
Adrian Piper
Food for the Spirit, 1971, printed 1997
Nos. 3, 5, 7, and 10 from set of 14
Selenium-toned, silver-gelatin prints
on fiberbase paper
Ea. 14 ½ × 15 inches (36.8 × 38.1 cm)
One of an edition of three and
one artist's proof
Collection of Thomas Erben, New York

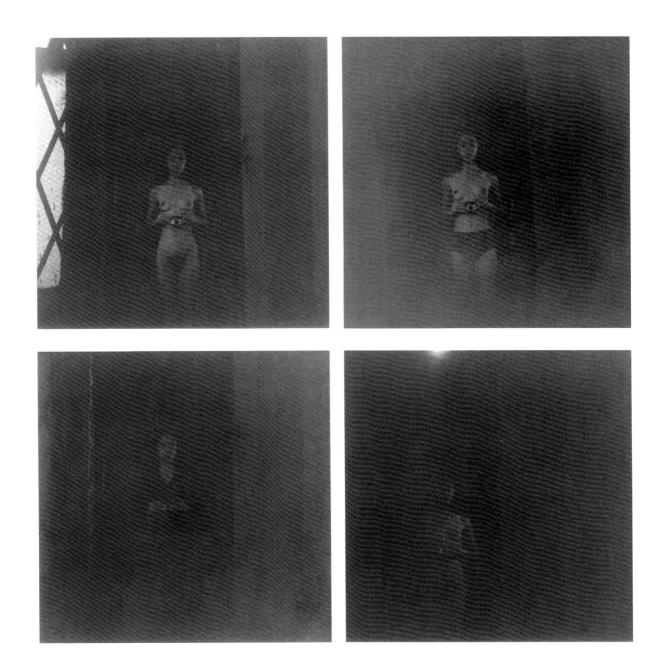

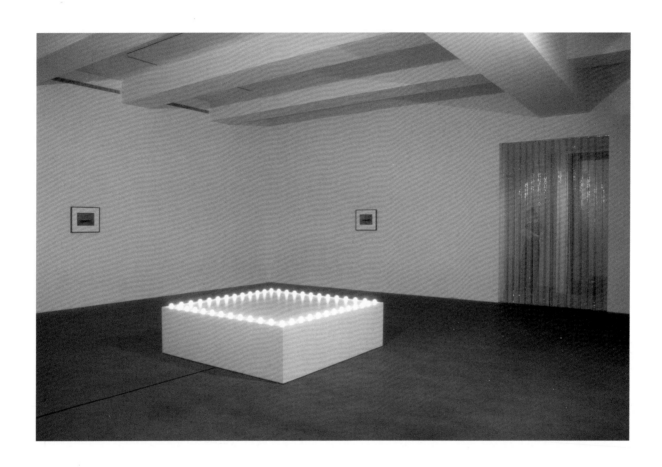

Felix Gonzalez-Torres
"Untitled" (Go-Go Dancing Platform), 1991
Wood, lightbulbs, acrylic, and Go-Go
dancer in silver-lamé bathing suit,
sneakers, and Walkman
Overall dimensions variable
Platform: 21 ½ × 72 × 72 inches
(54.6 × 182.9 × 182.9 cm)
Installation view, "Every Week There Is
Something Different" (week two),
Andrea Rosen Gallery, New York, 1991
Courtesy Andrea Rosen Gallery, New York

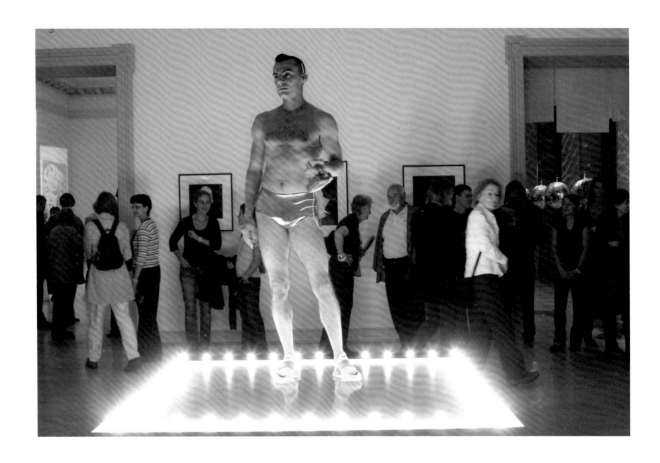

Felix Gonzalez-Torres
"Untitled" (Go-Go Dancing Platform), 1991
Wood, lightbulbs, acrylic, and Go-Go
dancer in silver-lamé bathing suit,
sneakers, and Walkman
Installation view, "Lifestyle —
From Subculture to High Fashion,"
Kunstmuseum St. Gallen, 2006
Courtesy Kunstmuseum St. Gallen,
Switzerland

Michael Joo
Salt Transfer Cycle, 1993–95
Still from eight-minute looped video with sound
Commissioned by the Yerba Buena Center
for the Arts, San Francisco
Courtesy of the artist and Anton Kern Gallery,
New York

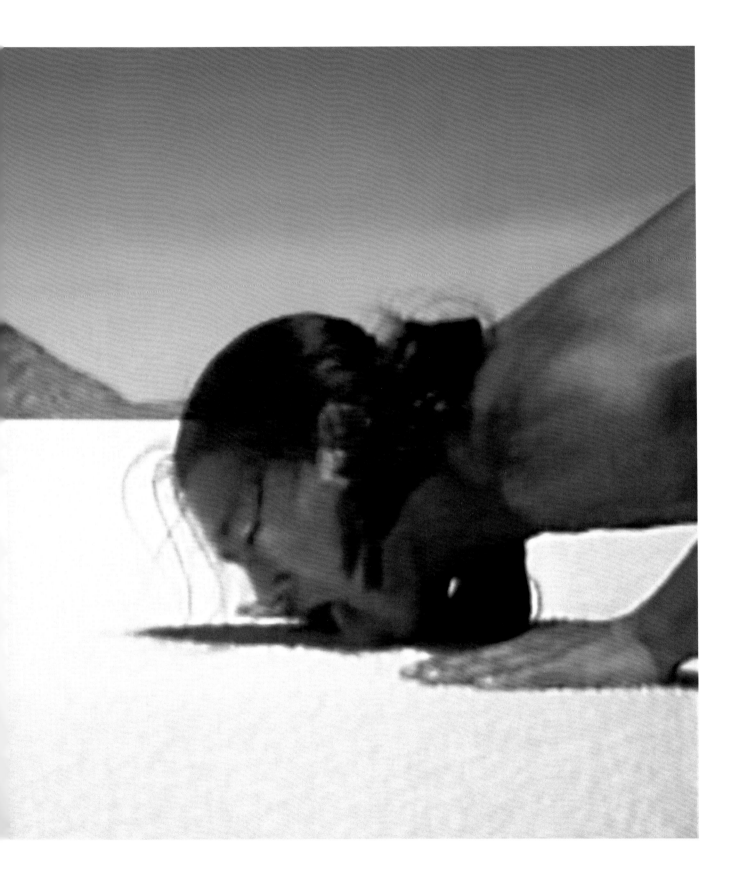

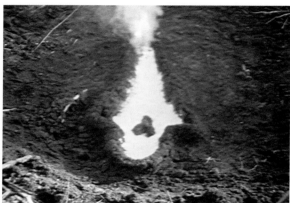

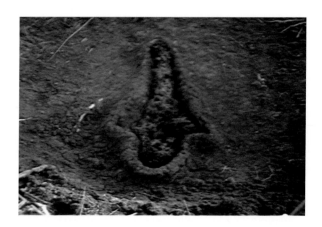

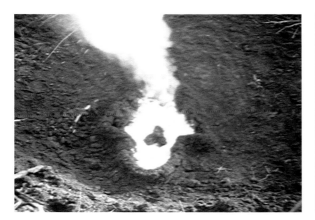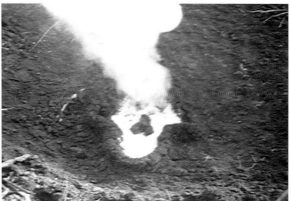

Ana Mendieta
Untitled (Gunpowder Work #1), 1980
Stills from six-minute, fifteen-second,
Super-8 color, silent film, transferred to DVD
Courtesy Galerie Lelong, New York

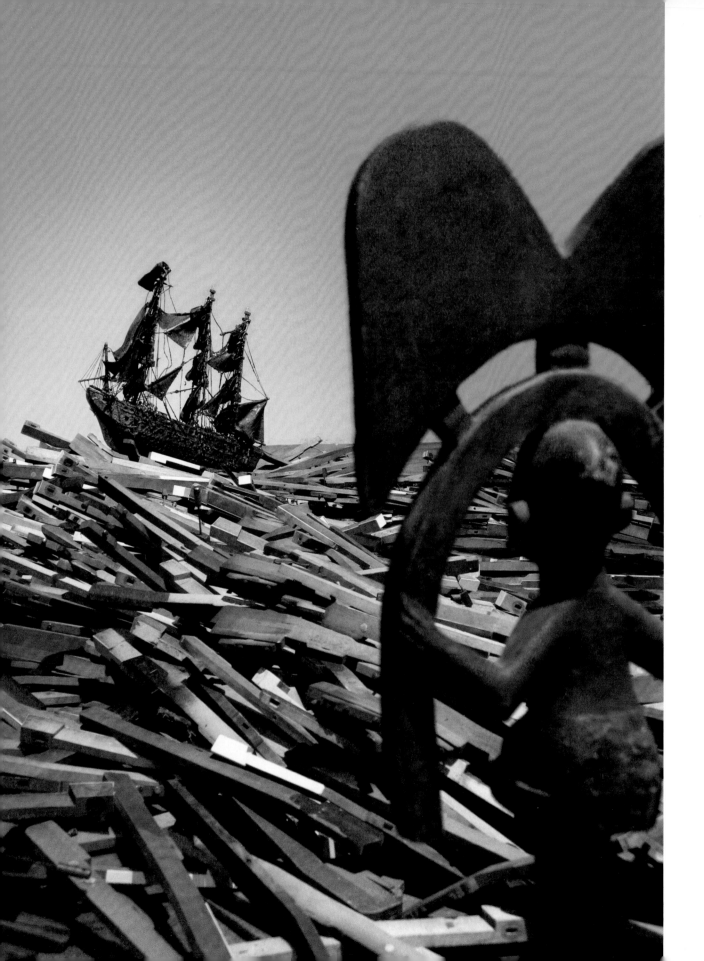

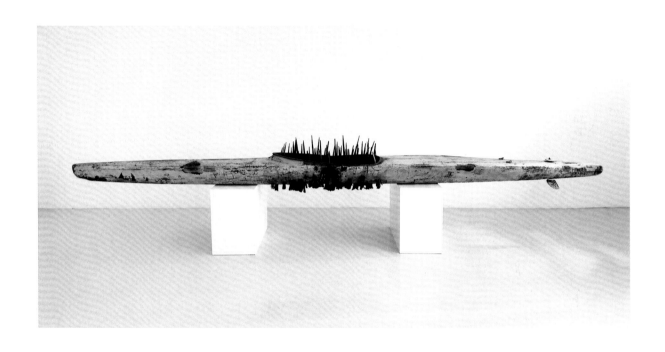

Kcho (Alexis Leyva Machado)
Kayak **(from the Objetos
Peligrosos series)**, 2002
Kayak and marlin swords
22 × 204 × 20 inches (55.9 × 518.2 × 50.8 cm)
Courtesy Pan American Art Projects,
Dallas and Miami

Radcliffe Bailey
Storm at Sea (detail), 2007
Piano keys, African sculpture, model boat,
paper, acrylic, glitter, and gold leaf
212 × 213 inches (538.5 × 541 cm)
Installation view
Courtesy of the artist and
Jack Shainman Gallery, New York

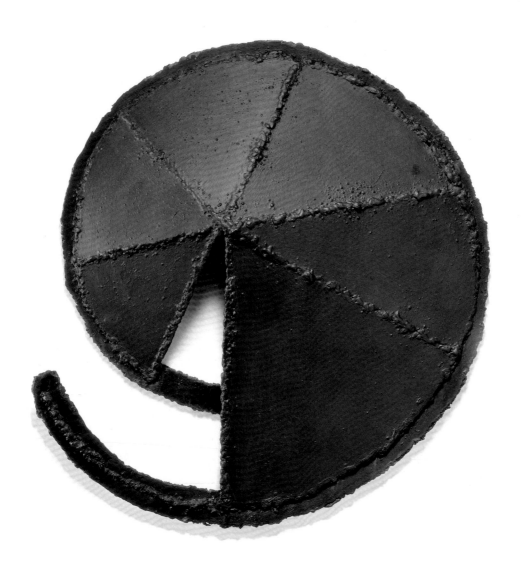

George Smith
Spiral to the Next World, 1990
Painted steel
36 × 23 × 4 inches (91.4 × 58.4 × 10.2 cm)
The Menil Collection, Houston

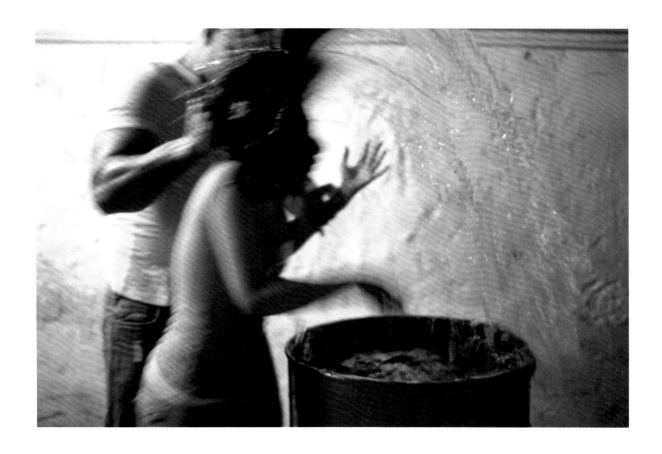

Above
Regina José Galindo
Confesión (Confession), 2007
Performance commissioned by Galería
Caja Blanca, Palma de Mallorca, 2007
Lambda print on Forex
32 1/16 × 49 inches (81.5 × 124.5 cm)
Courtesy of the artist and
Prometeo Gallery di Ida Pisani, Milan

Overleaf (pages 114–15)
Janine Antoni
Bridle (front and back), 2000
Full Ayrshire hide, hardware, and rope
117 × 97 × 14 inches (297.2 × 246.4 × 35.6 cm)
Courtesy of the artist and Luhring Augustine,
New York

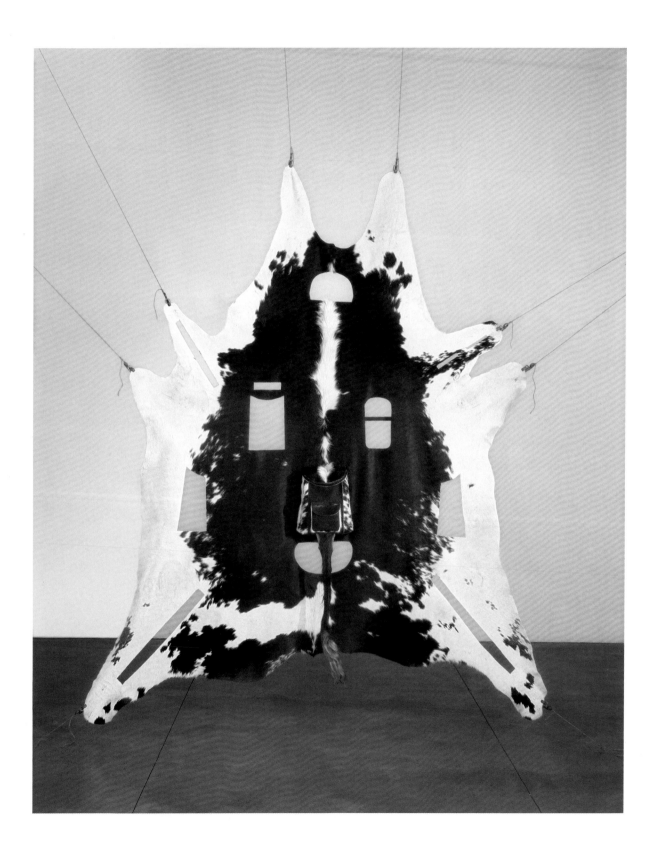

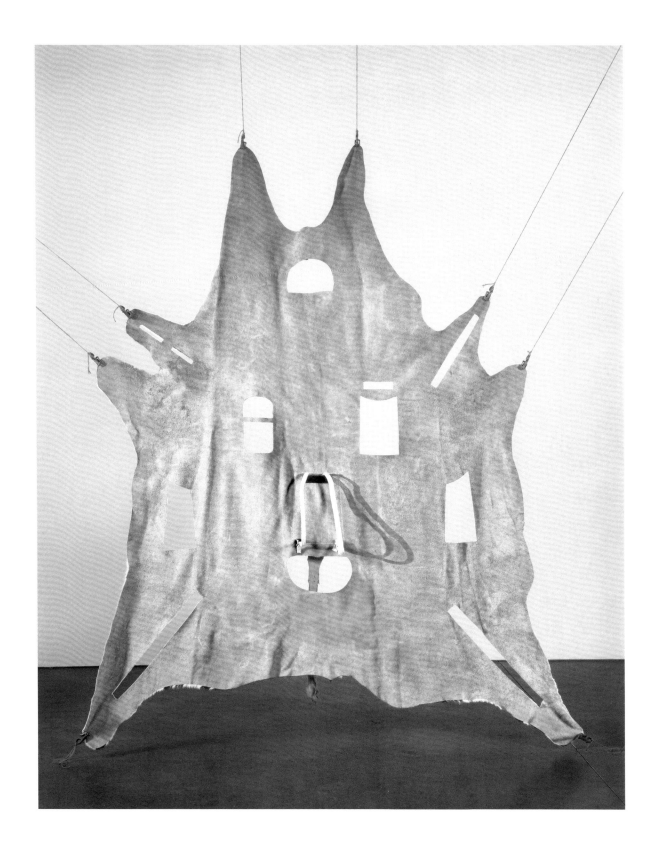

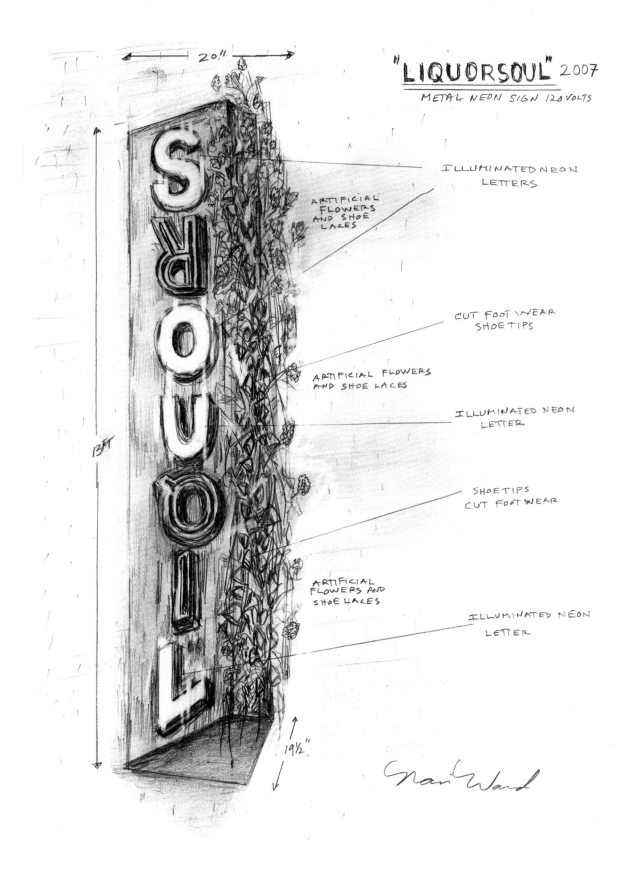

"LIQUORSOUL" 2007
METAL NEON SIGN 120 VOLTS

20"

ILLUMINATED NEON
LETTERS

ARTIFICIAL
FLOWERS
AND SHOE
LACES

CUT FOOT WEAR
SHOE TIPS

ARTIFICIAL FLOWERS
AND SHOE LACES

ILLUMINATED NEON
LETTER

SHOE TIPS
CUT FOOT WEAR

ARTIFICIAL
FLOWERS AND
SHOE LACES

ILLUMINATED NEON
LETTER

13 FT

19½"

Nari Ward

Opposite
Nari Ward
Study for *LiquorsouL*, 2007
Pencil on paper
10 × 8 inches (25.4 × 20.3 cm)
Courtesy of the artist and
Deitch Projects, New York

Right
Nari Ward
LiquorsouL, 2007
Found metal neon sign for
a work in progress that will
include artificial flowers,
shoelaces, and shoe tips
156 × 20 × 19 ½ inches
(396.2 × 50.8 × 49.5 cm)
Courtesy of the artist and
Deitch Projects, New York

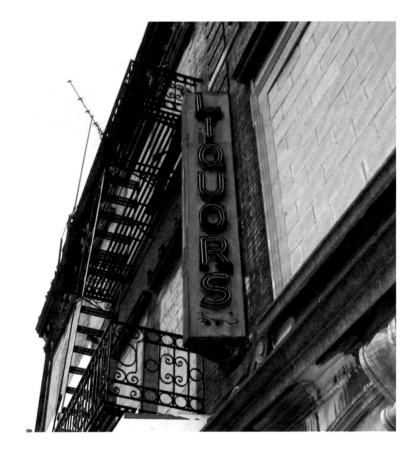

Overleaf page 118
Michael Tracy
Cruz de la Paz Sagrada
(Cross of the Sacred Peace), 1980
Acrylic on rayon wrapped over wood,
with tin and brass *milagros*, rosary beads,
metal swords, spikes and nails, string,
wire, ribbon, human hair, and crown of
cactus needles; wood base with gold leaf
69 × 43 × 31 inches (175.3 × 109.2 × 78.7 cm)
The Menil Collection, Houston

Overleaf page 119
José Bedia
Las Cosas que me Arrastran
(The Things That Drag Me Along), 1996
Mixed media
Dimensions variable
Installation view, Frumkin / Adams Gallery,
New York, 1996
Courtesy of the artist and
George Adams Gallery, New York

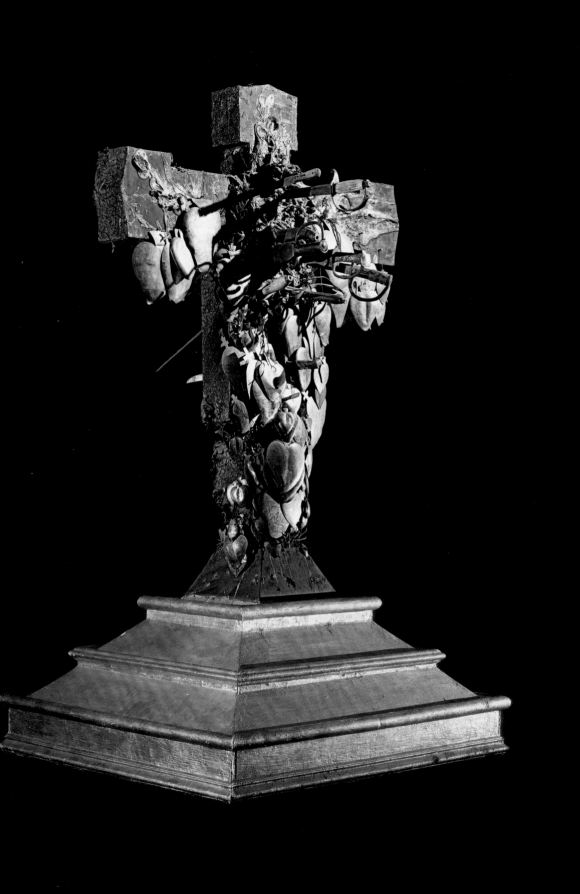

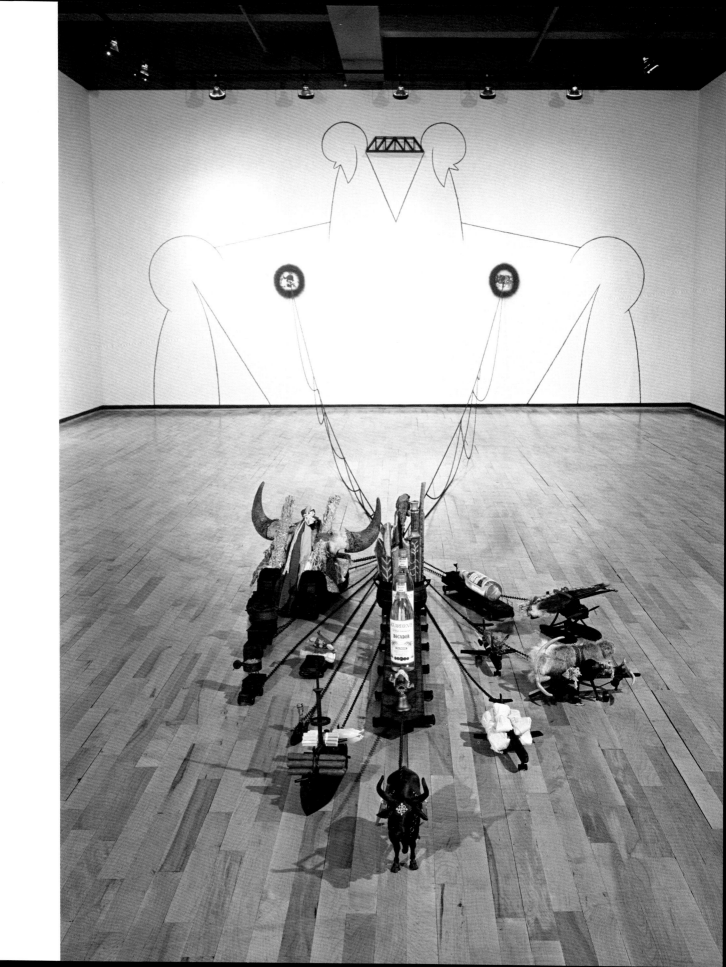

John Cage
River Rocks and Smoke 4/10/90 #11, 1990
Fire and watercolor on watercolor rag paper
72 × 47 ¼ inches (182.9 × 120 cm)
The Menil Collection, Houston

John Cage
River Rocks and Smoke 4/10/90 #16, 1990
Fire and watercolor on watercolor rag paper
72 × 47 ¼ inches (182.9 × 120 cm)
The Menil Collection, Houston

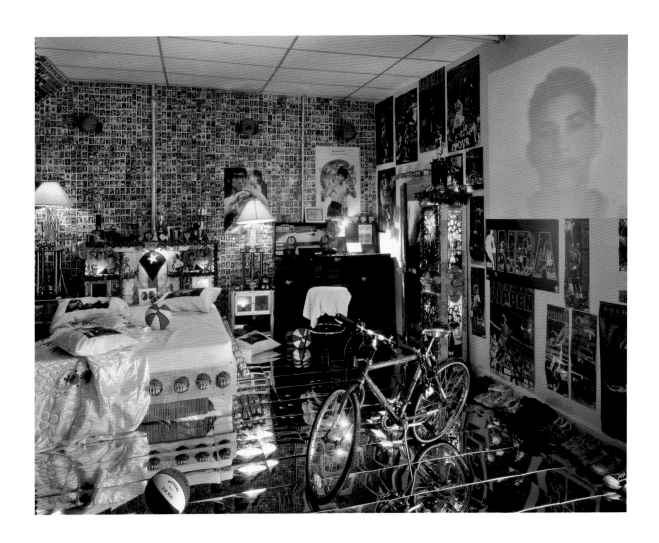

Above
Pepón Osorio
Badge of Honor
(detail, son's bedroom), 1995
Mixed media and video
Dimensions variable
Installation view,
The Newark Museum, New Jersey, 1996
Courtesy Ronald Feldman
Fine Arts, New York

Opposite
Terry Adkins
Signature **from "Songs of Hearth and
Valor — Recital in Eight Dominions,"** 2007
Feathers, leather, and glass
63 × 22 × 16 inches (160 × 55.9 × 40.6 cm)
Courtesy of the artist

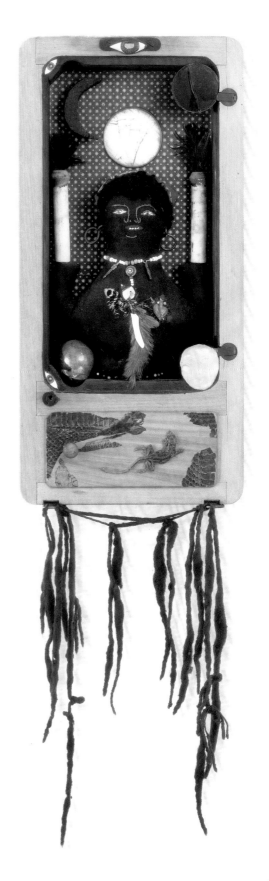

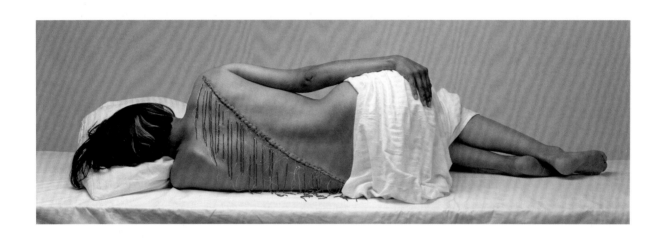

Rebecca Belmore
Fringe, 2007
Photograph for light-box installation
36 × 108 inches (91.4 × 274.3 cm)
One of an edition of three
Courtesy of the artist

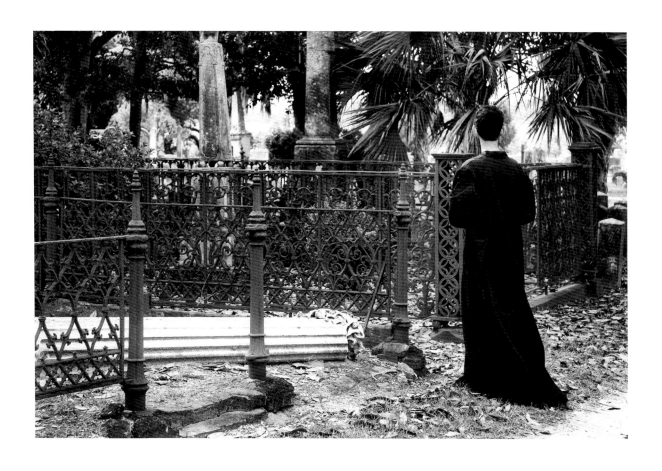

Ernesto Pujol
Fallen Column (from *Walk #1*), 2005—06
Archival digital image
16 × 20 inches (40.6 × 50.8 cm)
Courtesy of the artist

INDEX OF ARTISTS

Below is a list of the thirty-three artists whose works are featured in the exhibition "NeoHooDoo: Art for a Forgotten Faith." Page numbers are listed to indicate where a given artist's work or works appear in the catalogue.

Artists' Biographies

Mary K. Lambrakos

Terry Adkins (b. 1953, Washington, D.C.) Adkins earned his BS from Fisk University, Nashville (1975), and his MFA from University of Kentucky, Lexington (1979). He was awarded an NEA Visual Artists Grant (1986) and a Joan Mitchell Foundation Fellowship (1994). His solo exhibitions include "The Endowed Chair," Franklin Parrasch Gallery, New York (1992); "Later Coltrane," Emerson Gallery, Hamilton College, Clinton, N.Y. (1998); "Relay Hymn," Institute of Contemporary Art, Philadelphia (1999); "Sanctuary," Eastern State Penitentiary, Philadelphia (2003); "Black Beethoven: Recital in Nine Dominions, Terry Adkins after Ludwig Von Beethoven," and "Belted Bronze: Recital in Eight Dominions, Terry Adkins after Bessie Smith," at Pageant: Soloveev, Philadelphia (2004, 2007). Group exhibitions include "Cadences: Icon and Abstraction in Context," New Museum of Contemporary Art, New York (1991); "Western Artists / African Art," Museum for African Art, New York (1994); "Firmament RHA," Whitney Museum of American Art at Philip Morris, New York (1995); "Passages: Contemporary Art in Transition," Studio Museum in Harlem, New York (1999); and "Double Consciousness," Contemporary Arts Museum, Houston (2005). An associate professor of fine arts at the University of Pennsylvania, Philadelphia, Adkins lives in Brooklyn, New York.

Janine Antoni (b. 1964, Freeport, Bahamas) Antoni received her BA from Sarah Lawrence College, Bronxville, N.Y. (1986), and an MFA in sculpture from Rhode Island School of Design, Providence (1989). She received a MacArthur Foundation Fellowship (1998). Her solo exhibitions include "Slip of the Tongue," Centre for Contemporary Arts, Glasgow (1995); "Swoon," Whitney Museum of American Art, New York (1998); "The Girl Made of Butter," Aldrich Museum of Contemporary Art, Ridgefield, Conn. (2001); "Taught Tether Teeter," SITE Santa Fe (2002); "Ready or Not Here I Come," Institute of International Visual Arts, London (2005); and "Janine Antoni," Weatherspoon Art Museum, Greensboro, N.C. (2007). Group exhibitions include "Face-off: The Portrait in Recent Art," Institute of Contemporary Art, Philadelphia (1994); "Regarding Beauty: A View of the Late Twentieth Century," Hirshhorn Museum and Sculpture Garden, Washington, D.C. (1999) (traveled); "Quiet in the Land," Museu de Arte Moderna, Bahia, Salvador, Brazil (2000); "Moving Pictures," Solomon R. Guggenheim Museum, New York (2002); "Into Me / Out of Me," P.S.1 Contemporary Art Center, Long Island City, N.Y. (2006); and "Fractured Figure," Deste Foundation for Contemporary Art, Athens (2007). Her work has been included in the Whitney Biennial and the Venice Biennale (both 1993). Antoni lives in New York.

Radcliffe Bailey (b. 1968, Bridgeton, New Jersey) Bailey earned his BFA from Atlanta College of Art (1991). Solo projects include "The Magic City," Birmingham Museum of Art, Ala., and Blaffer Gallery, University of Houston (2001); "Spiritual Migration," Atlanta College of Art (2001); "Radcliffe Bailey: Tides," Blaffer Gallery, University of Houston (2002); "Memory as Medicine," Solomon Projects, Atlanta (2003); and "From the Cabinet: Reflections of Winding Roads" and "Altered Destiny," Jack Shainman Gallery, New York (2005, 2007). Bailey has participated in such group shows as "Black President: The Art and Legacy of Fela Anikulapo-Kuti," New Museum of Contemporary Art, New York (2003–04) (traveled); "Images of the Spirit," Arts Center, St. Petersburg, Fl. (2003); "The Whole World Is Rotten: Free Radicals and the Gold Coast Slave Castles of Paa Joe," Jack Shainman Gallery, New York (2005) (traveled). Bailey lives in Atlanta.

Jean-Michel Basquiat (b. 1960, Brooklyn, New York; d. 1988, New York) Basquiat became known as a graffiti artist in the late 1970s, and in 1980 his work was included in "The

Times Square Show," New York, followed by other seminal group shows. The poet René Ricard's "Radiant Child," the first extensive article on Basquiat, published in *Artforum* in 1981, preceded six solo and fourteen group exhibitions for the artist in the next year. Over his short, meteoric career, Basquiat was included in Documenta 7 (1982); the Whitney Biennial (1983); "An International Survey of Recent Painting and Sculpture," which reopened the Museum of Modern Art, New York (1984); and numerous shows dedicated to the East Village scene, Neo-Expressionism, and painting's return to the figure. Basquiat's first retrospective was mounted by the Whitney Museum of American Art, New York (1992) (traveled). The Brooklyn Museum, New York, organized a retrospective, "Basquiat" (2005); numerous exhibitions have traveled in the United States, Europe, and South America.

José Bedia (b. 1959, Havana, Cuba) Bedia received degrees from Havana's Escuela de Artes Plásticas San Alejandro, (1976) and the Instituto Superior de Arte (ISA), (1981). In 1994 Bedia was awarded a Guggenheim Foundation Fellowship. His work was included in "Volumen I" at Galería de Arte Internacional, Havana (1981); he has since shown extensively all over the world. His one-person exhibitions include "Mi Esencialismo—My Essentialism," George Adams Gallery, New York (1996); "Crónicas Americanas: Obras de José Bedia," Museo de Arte Contemporáneo (MARCO), Monterrey, Mexico (1997); "Proverbs," Fredric Snitzer Gallery, Miami (2002); "Estremecimientos," Museo de Badajoz and Domus Artium, Salamanca (2004); and a survey of his paintings and works on paper, George Adams Gallery, New York (2007). Group exhibitions include "Face of the Gods: Art and Altars of Africa and the African Americas," Museum of African Art, New York (1993); "Island Nations: New Art from Cuba, the Dominican Republic, Puerto Rico, and the Diaspora," Rhode Island School of Design Museum, Providence (2004); and "Arte, religione, politica," Padiglione d'Arte Contemporanea, Milan (2005). Bedia lives in Miami.

Rebecca Belmore (b. 1960, Upsala, Ontario, Canada) Belmore, a native artist of Anishinabe heritage, studied at Ontario College of Art and Design, Toronto (1984–87), which awarded her an honorary doctorate (2005). Her solo exhibitions include "33 Pieces," Blackwood Gallery, University of Toronto at Mississauga (2001); and "The Named and the Unnamed," Morris and Helen Belkin Art Gallery, Vancouver (2002). Her work featured in the following group exhibitions: "Creation or Death: We Will Win," Havana Biennial (1991); "Land, Spirit, Power," National Gallery of Canada, Ottawa (1992); "Longing and Belonging: From the Faraway Nearby," SITE Santa Fe (1995); and "Global Feminisms," Brooklyn Museum, New York (2007). She represented Canada at the Venice Biennale (2005), where she exhibited her work *Fountain*. Belmore lives in Vancouver.

Sanford Biggers (b. 1970, Los Angeles, California) Biggers earned a BA from Morehouse College, Atlanta (1992). He also studied at the Maryland Institute College of Art, Baltimore (1997), before receiving an MFA from the School of the Art Institute of Chicago (1999). One-person exhibitions include "Creation / Dissipation," Trafo Gallery, Budapest (2002); "Afro Temple," Contemporary Arts Museum, Houston (2002); "Psychic Windows," Matrix Gallery, University of California at Berkeley (2002); "Both / And Not Either / Or," Contemporary Art Center, Cincinnati (2004); "New Work," Triple Candie, New York (2005); "Freedom: And Other Seldom Traveled Roads," Mary Goldman Gallery, Los Angeles (2006); "Blossom," Grand Arts, Kansas City, Mo. (2007); and, most recently, a video installation of *Cheshire* at D'Amelio Terras, New York (2008). Biggers' group exhibitions include "One Planet under a Groove: Hip Hop and Con-

temporary Art," Bronx Museum, New York (2001) (traveled); "Freestyle" and "Black Belt," Studio Museum in Harlem, New York (2001, 2003); the Whitney Biennial (2002); and "Pretty Baby," Modern Art Museum of Fort Worth (2007). Biggers teaches sculpture at Virginia Commonwealth University, Richmond.

Tania Bruguera (b.1968, Havana, Cuba) Bruguera studied at Escuela Elemental de Artes Plásticas and Escuela de Artes Plásticas San Alejandro, and graduated from Instituto Superior de Arte (ISA) (1992), all in Havana. She earned her MFA in performance at the School of the Art Institute of Chicago (2001). She received a Guggenheim Foundation Fellowship in 1998. Her solo shows include "Ingeniero de almas," Palacio de Abrantes, Salamanca (2002); "Dated Flesh," Rhona Hoffman Gallery, Chicago (2004); "Boca a Boca," Galeria Habana, Havana (2005); and "Portraits," Kunsthalle, Vienna (2006). Her group shows include the Venice Biennale (2001, 2005); "The Stone and Water," Helsinki Art Museum, Finland; Documenta 11 (2002); Istanbul Biennial (2003); "The Living Museum," Museum für Moderne Kunst, Frankfurt (2003); Shanghai Biennial (2004); "Global Feminisms," Brooklyn Museum, New York (2007); and "We Are Your Future," Moscow Biennial (2007). An assistant professor of art at the University of Chicago, she lives in Chicago and Havana.

James Lee Byars (b.1932, Detroit, Michigan; d.1997, Cairo, Egypt) Byars studied art and philosophy at Wayne State University, Detroit (1948–56). The Cassandra Foundation, New York, awarded him the William Copley Prize (1960). He had solo exhibitions at the Museum of Modern Art, New York (1958), Westfälischen Kunstverein Münster, Germany (1982), Philadelphia Museum of Art (1984), Whitney Museum of American Art, New York (2004–05); and the Barbican Centre, London (2005). A two-person exhibition, "Louise Bourgeois, James Lee

Byars: Il disparut dans le silence total," appeared at the Centre Pompidou, Paris (2003). Group exhibitions include "The Gold Curb," Metropolitan Museum of Art, New York (1970); Documenta 5–9 (1972–92); and the Venice Biennale (1993).

John Cage (b.1912, Los Angeles, California; d.1992, New York, New York) Cage, a pioneer of chance and electronic music as well as experimental use of instruments, was one of the most important and influential American composers of the last century. He attended Pomona College, Claremont (1928–30), and later studied musical composition with Henry Cowell in New York and with Arnold Schoenberg at the University of Southern California at Los Angeles, and University of California at Los Angeles. He taught at the School of Design, Chicago (1941–42), and New School for Social Research, New York (1942); he was professor of music and composer-in-residence at Black Mountain College, near Asheville, N.C. (1948–52). He received a Guggenheim Foundation Fellowship and was elected to the National Academy of Arts and Letters (both in 1949); he became a member of the American Academy of Arts and Sciences (1978) and received an honorary doctorate from the California Institute of the Arts, Valencia, (1986). Major solo exhibitions include "Rolywholyover, A Circus," Museum of Contemporary Art, Los Angeles (1993), which traveled to The Menil Collection, Houston.

María Magdalena Campos-Pons (b.1959, Matanzas, Cuba) Campos-Pons attended Escuela National de Arte (1980) and Instituto Superior de Arte (ISA) (1980–85) in Havana, as well as the Massachusetts College of Art, Boston, where she studied painting and media arts (1988). In 1985 her first solo exhibition, "Acoplamientos (Couplings)," was held at Gallery L., Havana. Recent one-person shows include "Talking Pictures," Bernice Steinbaum Gallery, Miami (2004); and "Everything Is

Separated by Water," Indianapolis Museum of Art (2007). Her most recent group exhibitions include "Getting Emotional," Institute of Contemporary Art, Boston (2005); "Retratos: 2,000 Years of Latin American Portraits," Museo del Barrio, New York (2005); and "Dispersed," Museum of the African Diaspora, San Francisco (2006). Her work was featured in "Authentic / Ex-centric: Conceptualism in Contemporary African Art," at the Venice Biennale (2001). Campos-Pons lives in Boston.

William Cordova (b. 1971, Lima, Peru) Cordova received a BFA from the School of the Art Institute of Chicago (1996), and an MFA from Yale University, New Haven (2004). He has been awarded residencies at the Studio Museum in Harlem, New York (2004–05); and Three-Walls, Chicago (2007). He has had solo exhibitions at the Institute of Contemporary Art, Winnipeg (2002); Museum of Contemporary Art, Miami (2003); and Arndt & Partner, Berlin (2006). Recent group exhibitions include "Utopia Station" at the Venice Biennale (2003); "Scratch," Studio Museum in Harlem, New York (2005); "Drylongso (Pichqa Suyo)," P.S.1 Contemporary Art Center, Long Island City, N.Y. (2006); "Street Level," Nasher Museum, Duke University, Durham, N.C. (2007); and the Whitney Biennial (2008). Cordova is an artist-in-residence at the Core Program, The Museum of Fine Arts, Houston.

Jimmie Durham (b. 1940, Washington, Arkansas) Durham's career includes his work as a performing artist, writer, and activist for the American Indian Movement. His first solo show was at the University of Texas at Austin (1967). In 1969 he moved to Geneva, Switzerland, where he performed street pieces and earned a BFA from the École des Beaux-Arts (1973). His work has been included in the Venice Biennale (1999–2005); the Gwangju Biennial (2004); Kunstwerke Berlin; the Sydney, Tirana, and Whitney biennials (all in 2005);

and Documenta 12 (2007). His poetry and essays have been widely published. Durham lives in Berlin.

Regina José Galindo (b. 1974, Ciudad de Guatemala, Guatemala) Galindo is known for her politically incisive performance art. At the Venice Biennale (2005), where she performed *279 Golpes (279 Blows)*, and was represented by three videos, she won the Golden Lion as best emerging artist. She performed *Himenoplastia (Hymenoplasty)* for the exhibition "Cinismo" at Galeria Contexto, Guatemala (2004); *Recorte por la Línea (Cut by the Line)*, Primer Festival de Arte Corporal, Caracas (2005); and *Perra (Bitch)*, Prometeo Gallery di Ida Pisani, Milan (2005). Group exhibitions include "Il Potere delle Donne," Galeria Civica di Arte Contemporanea, Trent (2006); "Into Me / Out of Me," P.S.1 Contemporary Art Center, Long Island City, N.Y. (2006); "Global Feminisms," Brooklyn Museum, New York (2007); and "Kiss Kiss Bang Bang: 45 Years of Art and Feminism," Museo de Bellas Artes, Bilbao (2007). Currently a resident at Artpace, San Antonio (2008), Galindo lives in Guatemala City.

Robert Gober (b. 1954, Wallingford, Connecticut) Gober attended classes at the Tyler School of Art's center in Rome and earned a BFA from Middlebury College (1976). He was the recipient of the Larry Aldrich Foundation Award (1996) and the Skowhegan Medal for Sculpture (1999). In 2005 he curated "Robert Gober: The Meat Wagon" for The Menil Collection, Houston, juxtaposing his own sculpture with work from the museum's permanent collection. He represented the United States in the Venice Biennale (2001). In 2007 a major retrospective, "Robert Gober: Work 1976–2006," was mounted at the Schaulager, Basel. Recent group exhibitions include "Strangely Familiar: Approaches to Scale in the Collection of the Museum of Modern Art," New York State Museum, Albany, and Museum of Modern Art, New York (2003);

"The Eighth Square: Gender, Life, and Desire in the Visual Arts since 1960," Museum Ludwig, Cologne (2006); and "The Shapes of Space," Solomon R. Guggenheim Museum, New York (2007). Gober lives in New York.

Felix Gonzalez-Torres (b. 1957, Guáimaro, Cuba; d. 1996, Miami) In 1971, eight years after Gonzalez-Torres left Cuba for Madrid, he emigrated to New York. He graduated from the Pratt Institute of Art, Brooklyn, New York (1981). He attended the Independent Study Program at the Whitney Museum of American Art, New York (1983). He received an MFA from the International Center of Photography, New York, and New York University (1987). In 1988 he had his first solo exhibitions, at the Intar Latin American Gallery and the Rastovski Gallery, New York. *"Untitled" (Go-Go Dancing Platform)* was installed during the second and third weeks of the artist's four-part exhibition "Every Week There Is Something Different," Andrea Rosen Gallery, New York (1991). Other solo exhibitions include "Felix Gonzalez-Torres," Musée d'Art Moderne de la Ville de Paris (1993); "Felix Gonzalez-Torres (Girlfriend in a Coma)," Solomon R. Guggenheim Museum, New York (1996); and "Felix Gonzalez-Torres: Early Impressions," Museo del Barrio, New York (2005). Notable group exhibitions include "Longing and Belonging: From the Faraway Nearby," SITE Santa Fe (1995); and "...it's how you play the game...," Exit Art, New York (1995). Gonzalez-Torres's art was featured in the 1991, 1997, and 2006 Whitney Biennials. His work represented the United States at the Venice Biennale in 2007.

David Hammons (b. 1943, Springfield, Illinois) Hammons studied in Los Angeles at the Trade Technical City College, Chouinard Art Institute, and Otis Art Institute (1964–72). He is a recipient of both the Rome Prize in visual arts (1990) and a MacArthur Foundation Fellowship (1991). His solo exhibitions include "David Hammons," Exit Art, New York (1989); "David Hammons: Rousing the Rubble," P.S.1 Contemporary Art Center, Long Island City, N.Y. (1991); "Yardbird Suite, Hammons 93," Williams College Museum of Art, Williamstown, Mass. (1994); and "David Hammons: Selected Works," Zwirner & Wirth, New York (2006). Group exhibitions include "Dislocations," Museum of Modern Art, New York (1991); "Eclipse," White Cube, London (2004); "Bottle: Contemporary Art and Vernacular Tradition," Aldrich Contemporary Art Museum, Ridgefield, Conn. (2004); "Double Consciousness: Black Conceptual Art since 1970," Contemporary Arts Museum, Houston (2005); "Los Angeles, 1955–1985: Birth of an Art Capital," Centre Pompidou, Paris (2006) (traveled); and "Multiplex: Directions in Art, 1970 to Now," Museum of Modern Art, New York (2007). Hammons lives in New York.

Michael Joo (b. 1966, Ithaca, New York) Joo earned a BFA from Washington University, St. Louis (1989), and an MFA from Yale University, New Haven (1991). He has received a Guggenheim Foundation Fellowship (1998), a Joan Mitchell Foundation Painters' and Sculptors' Grant (2000), and a Grand Prize at the Gwangju Biennial (2006), and was named a United States Artists Nimoy Fellow (2006). His *Salt Transfer Cycle* was first shown at the Yerba Buena Center for the Arts, San Francisco, in 1993. The first major survey of his art was organized by the List Visual Arts Center (LVAC) at M.I.T., Cambridge, Mass. (2003). Group exhibitions include "Institute of Cultural Anxiety," Institute of Contemporary Art, London (1995); "Koreamericakorea," Artsonje Center, Seoul, and Sonje Museum, Kyongju, Korea (2000); the Whitney Biennial (2000); "Black Belt," Studio Museum in Harlem, New York (2003); and "In the Darkest Hour There Will Be Light," Serpentine Gallery, London (2006). He represented Korea at the Venice Bienniale in 2001. Joo lives in New York.

Brian Jungen (b. 1970, Fort St. John, British Columbia, Canada) Jungen graduated from the Emily Carr Institute of Art and Design, Vancouver (1992). Recent solo exhibitions have been held at the New Museum of Contemporary Art, New York (2005); the Tate Modern, London (2006); and the Catriona Jeffries Gallery, Vancouver (2007). Jungen has participated in such group exhibitions as "Baja to Vancouver: The West Coast in Contemporary Art," Museum of Contemporary Art San Diego (2004); "Material Time / Work Time / Life Time," Reykjavík Arts Festival (2005); "Shapeshifters, Time Travellers and Storytellers," Royal Ontario Museum, Toronto (2007); and "The Martian Museum of Terrestrial Art," Barbican Centre, London (2008). His work has been included in the Gwangju (2004), Lyon (2007), and Sydney (2008) biennials. Jungen lives in Vancouver.

Kcho (Alexis Leyva Machado) (b. 1970, Nueva Gerona, Cuba) Kcho moved to Havana in 1984 to study at Escuela National de Arte, where he received a degree in 1990. He has won many awards, such as a UNESCO Prize for Promotion of the Arts (1995), Grand Prize at the Gwangju Biennial (1995), and Honor Prize from the Instituto Superior de Arte, Havana (2007). Solo exhibitions include "Kcho: Drawings and Sculptures," Galeria Plaza Vieja, Fondo Cubano de Bienes Culturales, Havana (1993); "Archipiélago de mi pensamiento: American Series–I Kcho," Galerie Nationale du Jeu de Paume, Paris (1998); "Kcho: un hombre de isla," New World Museum, Houston (2005); and "Retrasando lo inevitable," Galeria Marlborough, Madrid (2007). His works have also featured in such exhibitions of contemporary Cuban and Latin American art as: "Así está la cosa / That's the Way It Is: Installation and Art Object in Latin America," Contemporary Art Cultural Center, Mexico City (1997); "Contemporary Art from Cuba: Irony and Survival in the Island of Utopia," Arizona State University Art Museum, Tempe (1998); and "Cuba Avant-Garde:

Contemporary Cuban Art from the Farber Collection," Samuel P. Harn Museum of Art, University of Florida, Gainesville (2007). Kcho lives in Havana.

Marepe (Marcos Reis Peixoto) (b. 1970, San Antônio de Jesus, Bahia, Brazil) Marepe's solo exhibitions include "Sinho," Anton Kern Gallery, New York; "Upletivo Manual e Natal," Galeria Luisa Strina, São Paulo (2002); and "Vermelho Amarelo Verde Azul," Centre Pompidou, Paris (2005–06). His work was included in the group exhibition "The Thread Unraveled: Contemporary Brazilian Art," Museo del Barrio, New York (2001); "Fragments and Souvenirs Paulistanos—Vol. 1," Galeria Luisa Strina, São Paulo (2004); "How Latitudes Become Forms: Art in a Global Age," Walker Art Center, Minneapolis (2003); and "Alien Nation," Institute of Contemporary Arts, London (2006–07). He has participated in numerous biennials, including those of Pontevedra (2000), Istanbul (2003), and Venice (2003). In May 2007, Marepe installed *Veja meu Bem*, a carousel in the Turbine Hall at the Tate Modern, London. Marepe lives in San Antônio de Jesus, Bahia.

Ana Mendieta (b. 1948, Havana, Cuba; d. 1985, New York) In 1961 Mendieta left Cuba for the United States. She earned both her BA (1969) and her MA (1972) from the University of Iowa, Iowa City. She received numerous awards, including three NEA Visual Artists Grants, a Guggenheim Foundation Fellowship (1980), and the Rome Prize (1984). Her first one-person show, "Silueta Series," took place in 1971 at the Corroboree Gallery at the University of Iowa. She returned to Havana in 1984 for the opening of "Ana Mendieta: Geo-Image," Museo Nacional de Bellas Artes. She co-curated "Dialectics of Isolation: An Exhibition of Third-World Women Artists of the United States," in which her work was included, at A.I.R. Gallery, New York (1980). She also participated in "Women of the Americas: Emerging Perspectives,"

Konkos Gallery, New York (1982); and "Seven Women: Image / Impact," P.S.1, Institute for Art and Urban Resources, Long Island City, N.Y. (1983). Despite her short-lived career, her work's impact continues through posthumous retrospectives and the inclusion of her art in numerous group shows. Among these are "Ana Mendieta: A Retrospective," New Museum of Contemporary Art, New York (1987); and "Cuba—USA: The First Generation," Museum of Contemporary Art, Chicago (1991). Most recently the Hirshhorn Museum and Sculpture Garden, Washington, D.C., organized "Ana Mendieta: Earth Body" (2005).

Amalia Mesa-Bains (b.1943, Santa Clara, California) Mesa-Bains earned a BA in painting in 1966 from San Jose State University (1966) and a PhD in clinical psychology from the Wright Institute in Berkeley, Calif. Among her numerous awards are two that she received in 1992: a MacArthur Foundation Fellowship and a Service to the Field Award from the Association of Hispanic Artists, New York. Mesa-Bains has participated in many national group exhibitions, including "Other Gods: Containers of Belief," Everson Museum of Art, Syracuse (1986); "The Road to Aztlan: Art from a Mythic Homeland," Los Angeles County Museum of Art (2001); and "Day of the Dead," Galeria de la Raza, San Francisco (2006). Among the shows she has curated are "Ceremony of Memory," Center for Contemporary Arts of Santa Fe, N.M. (1988); "Chicano Art: Resistance and Affirmation, 1965–1985," UCLA Wight Art Gallery, Los Angeles (1991); and "Ceremony of Spirit," Mexican Museum, San Francisco (1993) (traveled). She directs the Department of Visual and Public Art, California State University, Monterey Bay. Mesa-Bains lives in Marina, California.

Pepón Osorio (b.1955, Santurce, Puerto Rico) Osorio received a BS from Herbert H. Lehman College, Bronx, New York (1978), and an MA from Columbia University,

New York (1985). He has received numerous awards, including an NEA Visual Artists Grant (1988), a Joan Mitchell Foundation Fellowship (1996), and a MacArthur Foundation Fellowship (1999). His solo exhibitions include "Pepón Osorio: Transboricua," Museo del Barrio, New York (1999); and "Face to Face," Bernice Steinbaum Gallery, Miami (2003). A three-year residency at Philadelphia's Department of Human Service researching the foster-care system culminated in the solo exhibition "Trials and Turbulence," Institute of Contemporary Art, Philadelphia (2004). Group exhibitions include "Ceremony of Spirit," Mexican Museum, San Francisco (1993) (traveled); "Other Narratives" and "8 Artists in an Archive," Contemporary Arts Museum, Houston (1999, 2000); "A Painting for over the Sofa (that's not necessarily a painting)," Bernice Steinbaum Gallery, Miami (2001) (traveled); "FACE OFF," Ronald Feldman Fine Arts, New York (2004); and "Collection Remixed," Bronx Museum of the Arts, New York (2005). His work has been included in the Whitney (1993), Johannesburg (1997), and São Paulo (2007) biennials. Osorio lives in Philadelphia.

Adrian Piper (b.1948, Harlem, New York) A philosopher and an artist, Piper received a BA in philosophy from the City College of New York (1974), followed by an MA (1977) and PhD (1981) from Harvard University, Cambridge, Mass., also in philosophy. She has received many prestigious awards, including two NEA Visual Artists Grants (1979, 1982), a two-year Mellon Foundation Post-Doctoral Fellowship to continue her research in philosophy at Stanford University (1982), and a Guggenheim Foundation Fellowship in conceptual art (1989). Her artwork developed alongside her academic pursuits. In 1971 she produced *Food for the Spirit*, inspired by the philosophy of Immanuel Kant, as a private loft performance. The Fine Arts Gallery, University of Maryland, Baltimore County, organized "Adrian Piper: A Retrospective," which traveled to the New Museum of Contemporary Art, New

York, in 2001. Selected group exhibitions include "Out of Action: Between Performance and the Object, 1949–1979," Museum of Contemporary Art, Los Angeles (1998); "Double Consciousness: Black Conceptual Art Since 1970," Contemporary Arts Museum, Houston (2005); and "Wack!: Art and the Feminist Revolution," P.S.1 Contemporary Art Center, Long Island City, N.Y. (2008). She has also published the two-volume collection *OUT OF ORDER, OUT OF SIGHT: Selected Writings in Meta-Art and Art Criticism 1967–1992* (Cambridge, Mass.: M.I.T. Press, 1996). A professor of philosophy at Wellesley College, Mass., Piper currently lives in Berlin.

Ernesto Pujol (b. 1957, Havana, Cuba) Pujol received a BA from Universidad de Puerto Rico, San Juan (1979), and is an MFA Candidate in Interdisciplinary Studio Practice, School of the Art Institute of Chicago. He earned a Philosophy and Theology Certificate from St. John Vianney Seminary (1980), Miami, and did graduate work at Hunter College, New York; Pratt Institute of Art, Brooklyn, New York; and Universidad Interamericana, San Juan. Pujol's numerous awards and fellowships include a Joan Mitchell Foundation Fellowship (1997), and two Pollock-Krasner Foundation Visual Arts Fellowships (1993, 1998). Pujol's solo exhibitions include "Hagiographia," Museo Rufino Tamayo, Mexico City (2000); "Loss of Faith," Ramis Barquet Gallery, New York (2001); and "Walk #1," McNay Museum of Art, San Antonio (2005). Pujol has participated in such group exhibitions as "Reaffirming Spirituality," Museo del Barrio, New York (1995); "Memory and Mourning: Shared Cultural Experience," Art Museum, State University of New York, Albany (1997); "Maps of Desire," Kunsthalle, Vienna (1999); and "Whiteness: A Wayward Construction," Laguna Art Museum, Laguna Beach, Calif. (2003). His Memminger Memorial Garden, designed for the Spoleto Festival / USA in Charleston, S.C., opened in spring 2008. Pujol lives in New York.

Dario Robleto (b. 1972, San Antonio, Texas) Robleto received his BFA from the University of Texas at San Antonio (1997). His solo exhibitions include "Deep Down I Don't Believe in Hymns," ACME Gallery, Los Angeles (2002); and "Say Goodbye to Substance," Whitney Museum of American Art at Altria, New York (2003). A two-person exhibition, "Dario Robleto / Silvia de la Rosa," was held at Main Gallery, University of Texas at El Paso (1998). Group exhibitions include "A Work in Progress: Selections from the New Museum Collection," New Museum of Contemporary Art, New York (2001); "International Abstraction," Seattle Art Museum (2003); the Whitney Biennial (2004); "A Thousand Words," Inman Gallery, Houston (2005); and a collaborative project, "The Gospel of Lead," with Jeremy Blake, at Arthouse, Austin, Tex. (2006). Robleto lives in San Antonio.

Betye Saar (b. Los Angeles, 1926) Saar received her BA from the University of California at Los Angeles (1949); she did graduate work in printmaking at the University of Southern California, Los Angeles (1962), and in film at the Pasadena School of Fine Arts (1970). She has received numerous awards, including two NEA Visual Artists Grants (1974, 1984), a J. Paul Getty Fund for the Visual Arts Fellowship (1990), and a James Van Der Zee Award (1992). Her solo exhibitions include "Rituals: The Art of Betye Saar," Studio Museum in Harlem, New York (1980); "Sanctified Visions," Museum of Contemporary Art, Los Angeles (1990); "Ritual and Remembrance," Tacoma Art Museum (1997); and "The Time in Between," University of Michigan Museum of Art, Ann Arbor (2005). She participated in a three-part group exhibition, "African American Artists in Los Angeles," Los Angeles Municipal Art Gallery (2001–05). Work by her daughters and herself was the focus of "Family Legacies: The Art of Betye, Alison, and Lezley Saar," Ackland Art Museum, University of North Carolina, Chapel Hill (2005). She was represented in "Los Angeles, 1955–1985:

Birth of an Art Capital," Centre Pompidou, Paris, France (2006) (traveled). Saar lives in Los Angeles.

Doris Salcedo (b. 1958, Bogotá, Colombia) Salcedo received her BFA from the Universidad de Bogotá Jorge Tadeo Lozano (1980) and an MA in sculpture from New York University (1984). She has been awarded a Guggenheim Foundation Fellowship (1995), and, most recently, the Ordway Prize from the Penny McCall Foundation (2005). Her solo exhibitions include "Unland / Doris Salcedo," New Museum of Contemporary Art, New York (1999); and "La Casa Viuda VI" and "Neither," White Cube, London (1995, 2004). Among her group exhibitions are "Currents 92: The Absent Body," Institute of Contemporary Art, Boston (1992), which included an early iteration of *Atrabiliarios*; "Distemper: Dissonant Themes in the Art of the 1990s," Hirshhorn Museum and Sculpture Garden, Washington, D.C. (1996); "The Unthought Known: Miroslaw Balka, Doris Salcedo, Clay Ketter, Robert Gober, Luc Tuymans," White Cube, London (2002); and "MoMA at El Museo: Latin American and Caribbean Art from the Collection of The Museum of Modern Art," Museo del Barrio and Museum of Modern Art, New York (2004). Her piece *Shibboleth* was installed in the Turbine Hall at the Tate Modern, London, in 2007. Salcedo lives in Bogotá.

Gary Simmons (b. 1964, New York) Simmons earned a BFA at the School of Visual Arts, New York (1988), and an MFA at the California Institute of the Arts, Valencia (1990). His recent one-person shows include "Ghost House," SITE Santa Fe (2001); "Diggin' in the Crates," Margo Leavin Gallery, Los Angeles (2005); and "House of Pain," Simon Lee Gallery, London (2007). "Gary Simmons," a survey of work from 1995 to 2002, was organized by the Studio Museum in Harlem, New York, and the Museum of Contemporary Art, Chicago (2002). Simmons has participated in such group shows as the

Whitney Biennial (1993); "One Planet under a Groove: Hip Hop and Contemporary Art" at the Bronx Museum, New York (2001) (traveled); "Social Studies," Krannert Art Museum, Champaign, Ill. (2004); "Double Consciousness: Black Conceptual Art since 1970," Contemporary Arts Museum, Houston (2005); and "Comic Abstraction: Image-Breaking, Image-Making," Museum of Modern Art, New York (2007). Simmons lives in New York.

George Smith (b. 1941, Buffalo, New York) Smith earned a BFA in sculpture from the San Francisco Art Institute (1969) and an MA from Hunter College, New York (1972). He was awarded a Guggenheim Foundation Fellowship in Sculpture (1971). Smith's sculptures have been exhibited in galleries and museums throughout the United States. Among his many permanent sculptural commissions are Lubben Plaza, Dallas, for the A.H. Belo Foundation (1992); Niagara Frontier Transit Authority, Buffalo (1981); and Metropolitan Rapid Transportation Authority, Atlanta (1982). He has had solo shows at the Studio Museum in Harlem, New York (1980); the Fleming Museum of Art, Burlington, Vt. (1999); the Kenkeleba House, Wilmer Jennings Gallery, New York (2006); and the Station Museum, Houston (2007). His work has been included in, among others, the following group exhibitions: the Whitney Biennial (1970); "American Vision: African American Sculptors of the 19th–21st Century," African American Museum, Dallas (2004); "Chance Encounters," The Menil Collection, Houston (2006); and "Nexus Texas," Contemporary Arts Museum, Houston (2007). Smith is a professor of sculpture at Rice University, Houston, where he lives.

Michael Tracy (b. 1943, Bellevue, Ohio) Tracy received a BA from St. Edward's University, Austin (1964), and studied at the Cleveland Institute of Art (1964-67), before earning an MFA at the University of Texas at Austin (1969). His

one-person shows include "Requiem Para los Olvidados," Contemporary Arts Museum, Houston (1983); his retrospective, "Terminal Privileges," P.S.1 Contemporary Art Center, Long Island City, N.Y. (1987), which traveled to The Menil Collection, Houston; the installation *Mirror of Justice / House of Gold* at San Francisco Artspace (1990); and a multipart installation, *Chapel: In the Mexican War Streets*, Mattress Factory, Pittsburgh (1994). He participated in a number of group shows, such as "12 / Texas," Contemporary Arts Museum, Houston (1974); "Off the Wall," San Antonio Art Museum (1979); and "Works on Paper: Eleven Houston Artists," Museum of Fine Arts, Houston (1985). Also in 1985 he collaborated with the architect James Rome on the Emmanuel Chapel for the Corpus Christi Cathedral. Tracy lives in San Ygnacio, Texas.

Nari Ward (b. 1963, St. Andrews, Jamaica) Ward earned his BA from Hunter College, New York (1991), and his MFA from Brooklyn College, New York (1992). He has received numerous awards and fellowships, including a Guggenheim Foundation Fellowship (1992), a Wheeler Foundation Merit Fellowship (1994), an NEA Visual Artists Grant (1994), and a grant from the Penny McCall Foundation (1997). His solo exhibitions include "Happy Smilers: Duty Free Shopping" and "Saint Peter's Odyssey Salon," Deitch Projects, New York (1996, 2004); and "Attractive Nuisance," Galleria Civica d'Arte, Turin (2001). In 2000 the Walker Art Center, Minneapolis, commissioned two pieces, *Circular Bottle Curtain* and *Rites of Way*, for its lobby and sculpture garden, respectively. Group exhibitions include "Edge of Awareness," World Health Organization, Geneva (1998) (traveled); "Streetlife," Project Row House, Houston (1999); "In Honor Of," Arte Continua, San Gimignano, Italy (2002); and "Double Consciousness: Black Conceptual Art since 1970," Contemporary Arts Museum, Houston (2005). Ward lives in New York.

Contributors

Jen Budney is Associate Curator at the Mendel Art Gallery in Saskatoon, Saskatchewan, and was Curator at the Kamloops Art Gallery in British Columbia from 2005 to 2006. Budney previously served as the artistic director of the artist-run center Gallery 101, Ottawa, and news editor of *Flash Art International*. Her writing has appeared in *Art Asia Pacific, Parkett, Third Text, World Art*, and other magazines, books, and catalogues.

Arthur C. Danto is an analytical philosopher who has spent his academic career at Columbia University, New York, where he is Johnsonian Professor Emeritus of Philosophy. He has authored a multivolume systematic study—published by Cambridge University Press—on representation, beginning with *Analytical Philosophy of History*. The fourth volume, *The Transfiguration of the Commonplace: A Philosophy of Art*, led to a second career, beginning in 1984, as art critic for *The Nation*.

Julia P. Herzberg, a Fulbright Senior Specialist, is an art historian and independent curator who focuses on Latin American, Latino, and multicultural contemporary art. In 2007 she was visiting professor at the School of Art, Pontifica Universidad Católica, Santiago. She has organized exhibitions of the work of such artists as Sandra Bermudez, Leandro Katz, Wifredo Lam, Pepón Osorio, and Ernesto Pujol. Her PhD dissertation, *Ana Mendieta: The Iowa Years, A Critical Study, 1969–1977*, was published in 2000. She lives in New York.

Franklin Sirmans is Curator of Modern and Contemporary Art at The Menil Collection, Houston, for which he recently organized "Robert Ryman, 1976." Since 2005 he has been a curatorial advisor for P.S.1 Contemporary Art Center, Long Island City, N.Y., where he has organized numerous shows. A former editor of *Flash Art International* and *Art Asia Pacific* magazines, he has also taught art history at the Maryland Institute College of

Art, Baltimore, and Princeton University. He is the 2007 recipient of the David C. Driskell Prize awarded by the High Museum of Art, Atlanta.

Greg Tate is a writer and musician who lives in Harlem, New York. His books include *Flyboy in the Buttermilk: Essays on Contemporary America, Everything but the Burden: What White People Are Taking from Black Culture*, and *Midnight Lightning: Jimi Hendrix and the Black Experience. Flyboy 2: The Greg Tate Reader* will be published by Duke University Press in 2008. Tate leads a large improv ensemble, Burnt Sugar The Arkestra Chamber, which released its sixteenth album, *Making Love through the Dark Ages* (TruGROID), in spring 2008.

Robert Farris Thompson earned his undergraduate and graduate degrees at Yale University, New Haven, where he is currently Master of Timothy Dwight College and Professor of African and Afro-American history. He has devoted his life to the study of African and Afro-American art, dance, and music, and the living legacies of Africa in the Americas. His groundbreaking publications include *African Art and Motion, Flash of the Spirit: African and Afro-American Art and Philosophy, Face of the Gods: Art and Altars of Africa and the African Americas*, and *Tango: The Art History of Love*.

Quincy Troupe is former Poet Laureate of California and author of seventeen books, including eight volumes of poetry. He has received two American Book Awards: for *Snake-Back Solos* and *Miles: The Autobiography*, which he wrote with Miles Davis. His 2002 collection of poetry, *Transcircularities: New and Selected Poems*, won the 2003 Milt Kessler Poetry Award. Presently, he is Professor Emeritus at the University of California, San Diego, and editor of the journal *Black Renaissance Noire*, published by New York University's Institute of African American Affairs. He lives in New York and Goyave, Guadalupe.

CREDITS

Photography: Bart Barlow: 50; Dawoud Bey: 32; Michael Beynon: 37; Angela Conant: 93; Brian Forrest:127; Colt Hausman: 31; David Heald: 92; Paul Hester: 33,112; Hester and Hardaway, Houston: 51; Hickey-Robertson, Houston: 26, 57,69,79,118; George Hixson: 45; Bob Hsiao: 18; Larry Lamay: 114-15; Jason Mandella: frontispiece; Chris Mansfield: 104; Scott Massey: 98; Stephanie Maze / National Geographic / Getty Images: 38, 71; Trevor Mills, Vancouver Art Gallery: 15, 43; Tim Mosenfelder / ImageDirect: 73; Peter Muscato: 105; Tara Nicholson: 48, 90; Charo Oquet: 72; David Pérez: 63; Robert Pettus: 124-25; Adam Reich: front cover,17, 102; Margarete Roeder Gallery, New York: 120-21; Ken Showell: 58,119; Oren Slor: 11; Julian Stallabrass: 19,113; Lee Stalsworth: 91; Frank Stewart: 46; Tate, London / Art Resource, NY: 28; Taylor & Dull: 40; Robert Farris Thompson: 70; Quincy Troupe: 77; Michael Werner Gallery, New York and Cologne: 94; Joshua White: 34, 101; Stephen White: 27, 28; Janet Woodard: 71; and Zindman / Fremont: 64.

Copyright: Terry Adkins © 2008 Terry Adkins; Tarsila do Amaral © 2008 Tarsila do Amaral; Janine Antoni © 2008 Janine Antoni; Radcliffe Bailey © 2008 Radcliffe Bailey; Jean-Michel Basquiat © 2008 The Estate of Jean-Michel Basquiat / ADAGP, Paris / ARS, New York; José Bedia © 2008 José Bedia; Rebecca Belmore © 2008 Rebecca Belmore; Joseph Beuys © 2008 Artists Rights Society (ARS), New York / VG Bild-Kunst, Bonn; Sanford Biggers © 2008 Sanford Biggers; Tania Bruguera © 2008 Tania Bruguera; James Lee Byars © 2008 Estate of James Lee Byars; John Cage © 2008 The John Cage Trust; María Magdalena Campos-Pons © 2008 María Magdalena Campos-Pons; William Cordova © 2008 William Cordova; Jimmie Durham © 2008 Jimmie Durham; Regina José Galindo © 2008 Regina José Galindo; Robert Gober © 2008 Robert Gober; Felix Gonzalez-Torres © 2008 The Felix Gonzalez-Torres Foundation; David Hammons © 2008 David Hammons; Romuald Hazoumé © 1997-2004 Romuald Hazoumé; Michael Joo © 2008 Michael Joo; Brian Jungen © 2008 Brian Jungen; Kcho (Alexis Leyva Machado) © 2008 Alexis Leyva Machado; Yves Klein © 2008 Artists Rights Society (ARS), New York / ADAGP, Paris; Jeff Koons © 2008 Jeff Koons; Willem de Kooning © 2008 The Willem de Kooning Foundation / Artists Rights Society (ARS), New York; Marepe (Marcos Reis Peixoto) © 2008 Anton Kern Gallery; Ana Mendieta © 2008 The Estate of Ana Mendieta; Amalia Mesa-Bains © 2008 Amalia Mesa-Bains; Bruce Nauman © 2008 Bruce Nauman / Artists Rights Society (ARS), New York, licensed 2008; Chris Ofili © 2008 Chris Ofili; Charo Oquet © 2008 Charo Oquet; Pepón Osorio © 2008 Pepón Osorio; Joe Overstreet © 2008 Joe Overstreet; Pablo Picasso © 2008 Estate of Pablo Picasso / Artists Rights Society (ARS), New York; Pablo Picasso© 2008 The Museum of Modern Art / Licensed by SCALA / Art Resource, New York; Ernesto Pujol © 2006 Ernesto Pujol; Marc Quinn © 2008 Marc Quinn; Dario Robleto © 2008 Dario Robleto; Betye Saar © 2008 Betye Saar; Doris Salcedo © 2008 Doris Salcedo; Gary Simmons © 2008 Gary Simmons; George Smith © 2008 George Smith; Michael Tracy © 2008 Michael Tracy; and Nari Ward © 2008 Nari Ward.